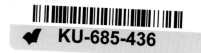

THE TIMES

A CENTURY IN PHOTOGRAPHS

TRAVEL

THE TIMES

A CENTURY IN PHOTOGRAPHS

TRAVEL

TED SMART

Researched and written by
Ian Harrison

Layout design
Anita Ruddell

This edition produced for
The Book People Ltd, Hall Wood Avenue,
Haydock, St Helens WA11 9UL

First published in 2000 by
Times Books
HarperCollins*Publishers*
77-85 Fulham Palace Road
London W6 8JB

Compilation copyright
© HarperCollins*Publishers* 2000

The Times is a registered trade mark of
Times Newspapers Limited, a subsidiary of
News International plc

ISBN 0 00 763439 0

British Library Cataloguing in Publication
Data: A catalogue record for this book is
available from the British Library

Printed and bound in Spain

Acknowlegements
The Publishers are grateful to the following
people and organizations for their help in the
compilation of this book:

Andrea Wisden, AA
BAA Heathrow
BMW
Caroline Goodfellow, Bethnal Green
 Museum of Childhood
British Railways Board
Pat and Hazel Constance, Camping and
 Caravaning Club
Professor Stanley Gelbier
The Hulton Getty Picture Library
Nigel Mackenzie, the Hungry Monk
 restaurant
News Team International
Veronica Sheppard, Pollock's Toy Museum
Poperfoto
Raleigh International
Moira Lewis, RAC
RoSPA
Esther Tibbs, Sail Training Association
Mandy Pursey, Sainsbury's Supermarkets
 Ltd
The Science Museum, London
Jill Lomer, Thomas Cook
The Times Picture Library
The Ulster Folk & Transport Museum
Vosper Thornycroft (UK) Ltd

Foreword

The 20th century, especially the first half, saw a development of travel unparalleled in history. In Queen Victoria's final year the motor car was regarded as a noisy luxury that only the rich could afford; by the mid-1950s it was the proud possession of every middle-class family and changed the way Britain lived. The Wright brothers launched their biplane in 1903; a mere 66 years later Neil Armstrong took his 'giant leap for mankind' on the moon. By 1999 Britons took it for granted that they could drive halfway across the country for a business meeting, fly to the Mediterranean on holiday, or take a train under the Channel.

The first half of the century belonged to steam; the internal combustion engine dominated the second half. But steam hung on tenaciously: the first electric Underground ran in 1904, but British Rail did not dispense with steam on its network until 1968. Even in the 1920s it seemed as though the steam lorry had a future. And yet electric trams disappeared rapidly in the early 1950s, victims of the competition with cars for space in the streets. It took another 40 years before they were to return to British cities. Daily travel has become more hectic but also much safer. A deadly toll of 14 people a day were killed on the roads in 1928. Two wars imposed their constraints: petrol reached the astonishing price of 3s.6d in 1919, and in 1942 leisure travel by car was forbidden altogether. But would jet travel have been developed as quickly or rocketry got off the ground without the demands of war?

Looking back, the transport systems of 1960 appear familiar at the end of the century, compared with the momentous changes between 1920 and 1960. But what must amaze us is how quickly we forget the way we once travelled: crowding on the trams, shutting steam train windows in tunnels, touring in charabancs. These wonderful snapshots bring it all back, a vivid record of our daily excitement at the ever-changing world of mass travel, the greatest liberation in history.

Michael Binyon
The Times

Introduction

IAN HARRISON

At the beginning of the 20th century the world's fastest travellers were looking out of the windows of steam trains and marvelling at the sight of the countryside rushing past at 80mph. Powered flight was still a seemingly impossible dream, the new-fangled motor car was seen as an unreliable, noisy nuisance and the world's most luxurious ocean liners still relied on stokers shovelling coal into a furnace. One hundred years later transatlantic liners have been largely replaced by aeroplanes, supersonic flight is old hat, the motor car is still seen as a noisy nuisance, and the sight that greets the world's fastest travellers, as they look out of their windows at speeds of over 17,000mph, is planet earth in the distance. At the beginning of the 20th century Thomas Cook had just popularized package tours to Spain and Portugal; by three quarters of the way through the same century the surface of the moon was littered with the debris of humankind's visits to a place which is no longer deemed interesting enough to bother with.

Travel came a long way in the 20th century. But how does one define travel? To some people, the word conjures up images of palm trees and beaches; it means luxuriating on holidays in faraway places. To others travel is backpacking around exotic destinations, roughing it, and seeing how the locals live; to these people the essence of travel is being on the move. To a few it means exploring the unknown, and to many travel is simply the daily grind of getting to work. Travellers are tourists, salesmen, explorers, commuters, holidaymakers, day trippers and people just out for a ride in the country. The photographs of 'travel' that appear in this book have been chosen for the individual stories they tell rather than as an attempt to chart the through line of the development of travel. But the individual stories *are* the through line, and so the wider picture emerges as the pages turn.

A Century in Photographs: Travel tells the stories of the Wright brothers' first flight in 1903, and the exploits of pioneer pilots in their flimsy biplanes; the story of Britain's triumph and failure in producing the world's first jet airliner and the country's part in the advent of supersonic passenger travel. In telling these stories the book also charts the development of air travel. In the same way, the ongoing story of travelling by road is built up from photographs of horse-drawn buses, motor charabancs and the Ford Model T, to the introduction of parking meters, the launch of the Mini, and the rise to power of Japanese car manufacturers.

The 20th century saw more changes than any other period of history, and not least in the field of transport and travel. It was a century that saw Britain lose its status as an island – when it was joined to mainland Europe by the Channel Tunnel, and a century that saw the Atlantic Ocean shrink to a three-hour plane journey. It was also a century that disproved with a vengeance the words of Charles H. Duell at the US Office of Patents, who was rash enough to say in 1899, 'Everything that can be invented has been invented.' But this book doesn't just show the technological developments in travel, from horse and steam to internal combustion, from balloon and glider to rocket science. It also shows how such momentous events as two world wars affected travellers and the transport industry, forcing some people to travel and preventing others from doing so, emancipating some workers and restricting others. And the book shows how people's travelling habits reflected changes in a society that was becoming more democratic: how private transport shifted from being a privilege of the wealthy to a right of the masses; how foreign travel was a jealously guarded indulgence of the upper classes and became a pleasure to be enjoyed by all; how

the introduction of paid holidays affected ordinary people; and how speed and shortened journey times led to 'suburbs' and 'commuter belts'. And the little details are just as fascinating, changes in the fashion of travel dress and luggage, the appearance of post cards, and the establishment of something that is now taken completely for granted – the garage.

A Century in Photographs: Travel also reflects changing attitudes towards travel during the last 100 years, some of which have come full circle. The first photograph in the book is of cars taking part in a 1,000-Mile Trial, which was organized in an effort to dispel the prevailing anti-car feeling. The rally succeeded in popularizing the car, and subsequent developments in road travel were greeted as positive achievements, reaching their peak with the excitement surrounding the opening of the M1 in 1959. But by the time Spaghetti Junction was opened a little over ten years later road building was already becoming controversial, and in 1996 the building of the Newbury bypass provoked direct action from environmentalists, setting the tone for road protests at the turn of the millennium – 100 years later the car had once again become the villain of the piece, and even many of those who relied on cars for transport were looking for an alternative. Environmental concerns were also behind the commercial failure of Concorde, whose four noisy turbojet engines burned twice as much fuel as conventional airliners. At one point Concorde boasted projected sales of over 400 aircraft but in the end only 16 were built.

Attitudes towards the purpose of travel have also changed. The Victorians saw foreign travel and the 'Grand Tour' as a means of education and self-improvement, and Thomas Cook's first tours were set up for that very purpose. But by the turn of the century these attitudes were becoming more relaxed, and those who could afford it began to travel purely for pleasure. By the end of the century, travelling for pleasure was available to almost everyone and foreign holidays were the norm. But there were exceptions – people who still travelled for adventure, excitement, education or self-improvement: explorers such as Sir Ranulph Fiennes, journalists like Alan Whicker, and organizations for young travellers, which include Raleigh International and the Sail Training Association, organisers of the Tall Ships' Races.

Many of the early photographs were taken because their subjects were firsts, new developments or milestone achievements: the first flight, first mass-produced car, first Atlantic crossing by plane, the electrification of the railways. The first half of the century was all about invention and innovation, the excitement of reaching new boundaries and developing new methods of travel – but the second half also had its pioneering firsts, with the jet set, pressurized cabins, the hovercraft, space exploration, and supersonic passenger travel. Among the later photographs there are a number of disasters. The years towards the end of the century saw the explosion of the space shuttle *Challenger*, the King's Cross fire, the *Herald of Free Enterprise* Zeebrugge ferry disaster, an explosion on the *Piper Alpha* oil rig, the Clapham rail crash and the Lockerbie bombing. And, in the year 2000, Concorde plunged to the ground with much loss of life. This may seem to be the payback for a dream gone sour but travel is actually becoming safer: sadly, the first half of the century also had its disasters, including the sinking of the *Titanic* which claimed more than twice as many lives as the entire litany of disasters above.

The development of new means of travel during the last century has had an enormous impact both on people's everyday lives and in the rarer opportunities it has provided for people to go white water rafting, walking on glaciers or trekking through jungles. But what horizons will travel open up during the next 100 years? Astronaut John Glenn, who in 1998 became the oldest man to travel in space, hopes that day-trips into space for private citizens will become a reality in the near future, and social commentators are discussing the fact that the first human to walk on Mars may already have been born. At one time flight and space travel were science fiction just as matter transportation and time travel are now. But one thing is certain: not everything that can be invented has yet been invented. Constant change is here to stay.

You take the high road...

Motor cars were treated with great suspicion in 1900, and were regarded generally as a noisy and dangerous nuisance, something which has come full circle in 100 years. In order to help prove their worth, cars took place in reliability trials to show that they were a safe, reliable and practical means of transport, even over long distances. The cars in this photograph are taking part in the 1,000-Mile Trial, which succeeded in winning over the public and the government to the advantages of the car; the picture also shows that tailgating is not an exclusively modern phenomenon. The 1,000-Mile Trial was the inspiration of Claude Johnson, then the secretary of the Automobile Club of Great Britain and Ireland. The club was founded in 1897 with 163 members, and gained its more familiar title in 1907 when it became the Royal Automobile Club; the RAC now has over 5 million members.

The trial lasted 14 days during April and May of 1900, with 65 cars taking part. The route started in London and then went to Edinburgh via Bristol, Birmingham, Manchester, Kendal and Carlisle; the return journey was via Newcastle, Leeds, Sheffield and Nottingham. Not the most direct route, but the idea was to visit as many cities as possible to show off the virtues of the car. There were exhibitions along the way which ranged from an hour or two during meal breaks to full-day stops at exhibition centres in the bigger cities. At the end of the trial, the cars were exhibited for a week at Crystal Palace in London. The 1,000-Mile Trial was deemed a huge success both in publicizing the car and for the technological developments which followed from observations made during the drive. Forty-nine of the 65 cars completed the route, and the event was won by the Honourable Charles Stuart Rolls, who later became one half of the most famous partnership in motoring history. On this occasion he was driving a 12hp Panhard powered by a Daimler engine.

The 1,000-Mile Trial was re-enacted by the Veteran Car Club in May 2000, following the original route as closely as possible. Some of the original vehicles took part a century after their first run.

Also this year...

The first long-distance bus service begins; the weekly 200-mile journey from London to Leeds takes two days

The Central Railway's 'Tuppenny Tube' from Shepherd's Bush to Bank opens

The Paris metro opens

Count Ferdinand von Zeppelin tests the first of his rigid airships

The first electric omnibus is installed in New York City

The new Royal Yacht, Victoria and Albert, *capsizes as soon as it undocks at Southampton*

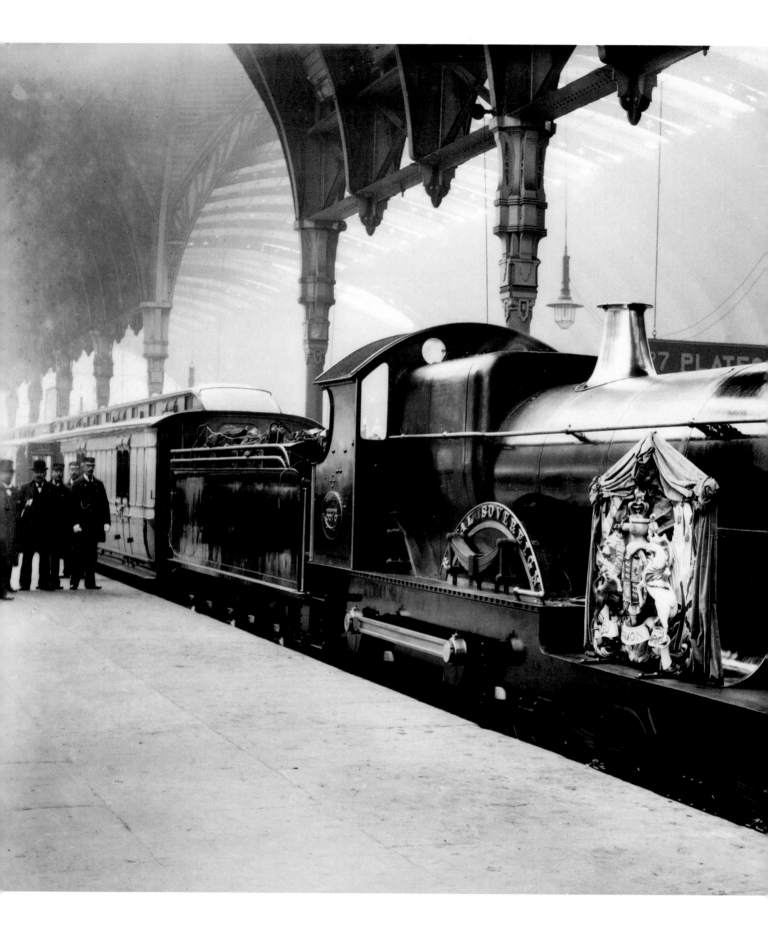

The Queen is dead, long live the King

A gleaming Great Western Railway locomotive, the *Royal Sovereign*, waits to carry Queen Victoria on her final journey. On Saturday 2 February her coffin was taken by train from Portsmouth to Victoria Station; the funeral procession then travelled through the streets of London to Paddington Station before continuing to Windsor by train. It was fitting that the railway should play such a significant part in Victoria's last journey, as she had been the first monarch to travel by train. Although it had taken some persuasion for her to board a train for the first time in 1842, afterwards she described her trip as 'delightful' and so began a new era of royal travel.

When Queen Victoria came to the throne the fastest mode of travel was by horse but by the end of her long reign the mighty trains were already being challenged by the motor car. Victoria, and monarchs before her, had previously travelled by horse-drawn carriages, which rocked violently from side to side and had to be driven quickly to avoid over-enthusiastic or ill-intentioned crowds. Travelling by train was a great improvement, for it allowed Victoria to show herself, Albert and her family to the nation through the large windows of her royal carriage. Trains were also steadier than carriages, and a further advantage was that crowds could be controlled relatively easily at stations.

The first royal train was provided by the Great Western Railway, and other railway companies soon followed suit. The Queen disliked travelling at more than 40mph, and protested vehemently if trains were driven fast to make up for lost time. Royal trains caused enormous disruption to ordinary rail traffic: they were preceded by a pilot train travelling 15 minutes ahead to test the track and warn of any danger, and both trains had to be allotted a path in the regular timetable. Also, no rail traffic could pass the royal train in the opposite direction except for mail trains and, even in Victoria's reign, precautions had to be taken against Irish terrorists. Victoria used the train regularly to visit her country estates of Osborne and Balmoral, and it was at Osborne House on the Isle of Wight that she died on 22 January, 1901.

Also this year...

Electric trams are introduced in London

Daimler builds a car for Austro-Hungarian statesman Emile Jellinek, who launches a memorable marque by naming it after his daughter, Mercedes

The first diesel motor goes on show

The first British submarine is launched, at Barrow-in-Furness

Eli Ransom Olds manufactures the first mass-produced car, the 3hp Oldsmobile

Brazilian Alberto Santos-Dumont wins a cash prize by flying an airship around the Eiffel Tower

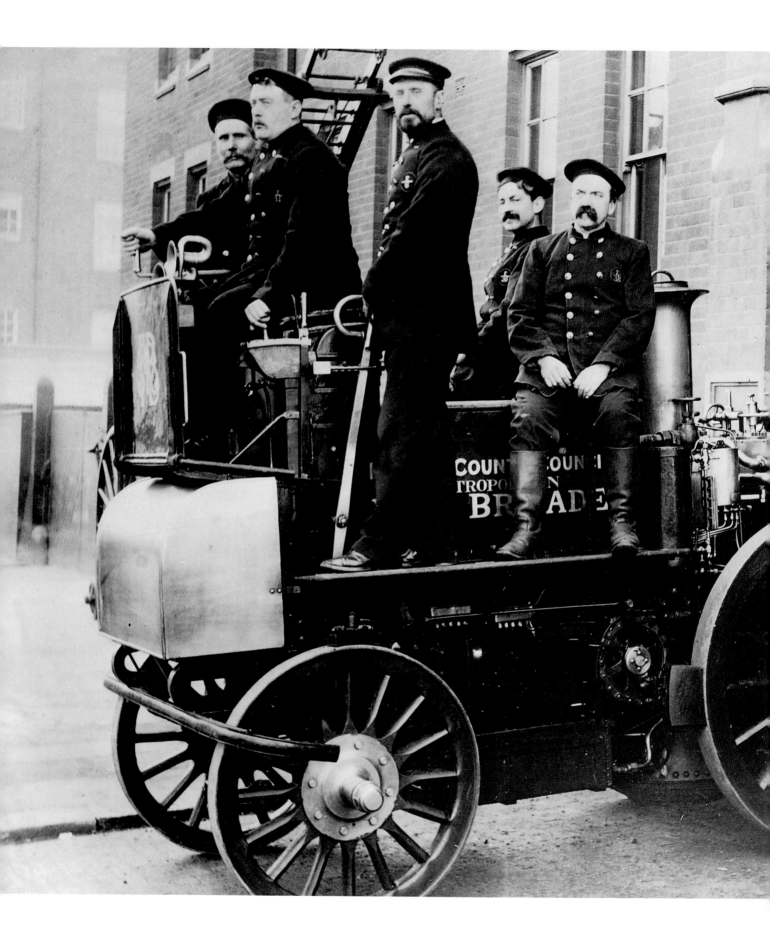

12

London's burning

A London fire crew sits on board a steam-driven fire engine, the best available in 1902 but soon to be superseded by the petrol-driven fire engine; the first one was used in Tottenham only a year later. The word 'engine' refers not to the means of propulsion but to the water pump, and at one time these pumps were all operated manually. The first steam fire engines were horse-drawn vehicles with steam-operated pumps; early models could pump 150 gallons of water per minute to a height of 90 feet. This was all very useful for putting out fires but met with fierce opposition from people who thought, quite rightly, that they would lose the beer money previously paid to those who helped operate the manual pumps. Other complaints were that the water mains would not be able to supply such an engine, that it was too heavy, too expensive and that it would cause too much water damage. Sadly these reservations held sway; only five of these early engines were built and the idea was not revived for another 30 years.

In 1863 a trial of fire engines was held at Crystal Palace – ironic, as Crystal Palace was to burn to the ground in 1936 despite the attentions of no fewer than 90 modern fire appliances. The first prize for large fire engines at the trial went to a British manufacturer called Merryweather; one of the company's most successful models was the 'County Council', whose name can be seen in this photograph, partly obscured by one fireman's boots. In 1902 many steam fire engines were still horse-drawn, although the photograph shows a drive wheel and chain in front of the rear wheel, which indicate that in this model the steam engine provided power to the rear wheels as well as to the pump.

Many manual fire engines, as well as 'steamers' such as this one, were sold to royalty, nobility and the upper classes to protect their country houses and estates. Most municipal fire brigades used steamers, and when a town took delivery of a new engine there were often festivities and a special naming ceremony. Today's red fire engines make heads turn when they are on call but a steam-driven machine going at full tilt with smoke pouring from its funnel and bells ringing must have been a fine sight indeed.

Also this year...

Disc brakes are patented by English car manufacturer Frederick Lanchester

First production cars with electrical self-starters as standard, rather than a crank handle, go on sale

Marcel Renault wins the Paris to Vienna motor race

Charles Lindbergh is born

The American Automobile Association is founded

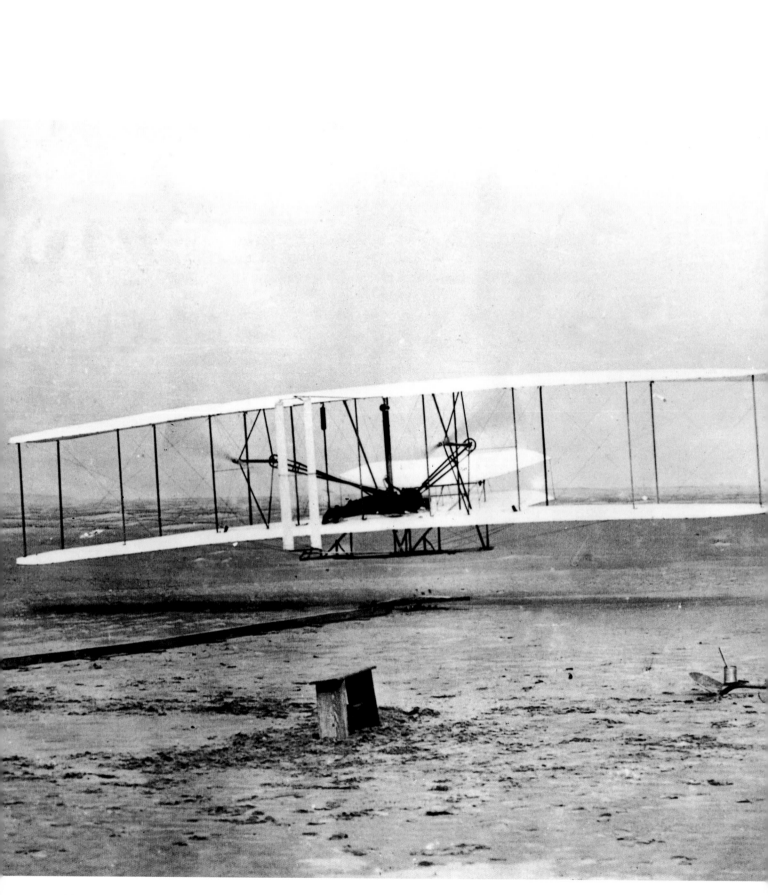

A Wright pair

This photograph shows what is arguably the single most significant moment in the history of travel, and was taken using a camera set up by Orville Wright before his historic first flight on 17 December, 1903. Orville is at the controls of the Wright brothers' plane, *Flyer*, during the world's first powered flight, with his brother, Wilbur, alongside. For four years the two brothers had researched the possibility of powered flight, using a home-made wind tunnel and a succession of gliders. Finally they were ready for the challenge and made aviation history in their biplane with a flight at Kitty Hawk, North Carolina. Just after 10.30a.m., 32-year-old Orville strapped himself into a harness, which allowed him to control the rudder and wing flaps with movements of his body while his hands operated the engine controls, and the plane took off. The pioneering flight lasted 12 seconds and covered a distance of 120 feet, which is less than the wingspan of a Boeing 747.

The *Flyer* succeeded where others had failed because it had moveable wingtips to help control the flight and because of its 12hp engine, which had a much better power-to-weight ratio than previous engines. It powered two propellers which faced backwards and pushed the plane along. The biplane weighed 605 pounds and was launched from a trolley which was propelled along a 60-foot greased wooden launch-rail.

In the years before the Wright brothers' achievement there were claims by many other people to have made the first flight. The most plausible of these were one by Richard Pearse, who claimed to have flown a monoplane in New Zealand in March 1903, and another by Gustave Whitehead, who reportedly flew half a mile in a steam-powered aircraft in 1901 and 7 miles in a flying boat in January 1903. Neither of these flights was officially recognized, possibly through a lack of publicity. However, photographs such as this one substantiated the Wright brothers' claim to have made the world's first controlled, powered flight in a heavier-than-air craft. They made a total of four flights on 17 December, the last one covering 852 feet and lasting 59 seconds.

Also this year...

The Ford Motor Company is formed

Edward VII inaugurates London's first electric tram

Motorized cabs are used in London for the first time

William Harley and the three Davidson brothers begin making motorbikes in Wisconsin

Six people are killed on the opening day of the Paris-Madrid motor race

The Motor Car Act lays down a top speed of 20mph

Driving licences are made compulsory in Britain

Vehicle number plates are introduced in Britain

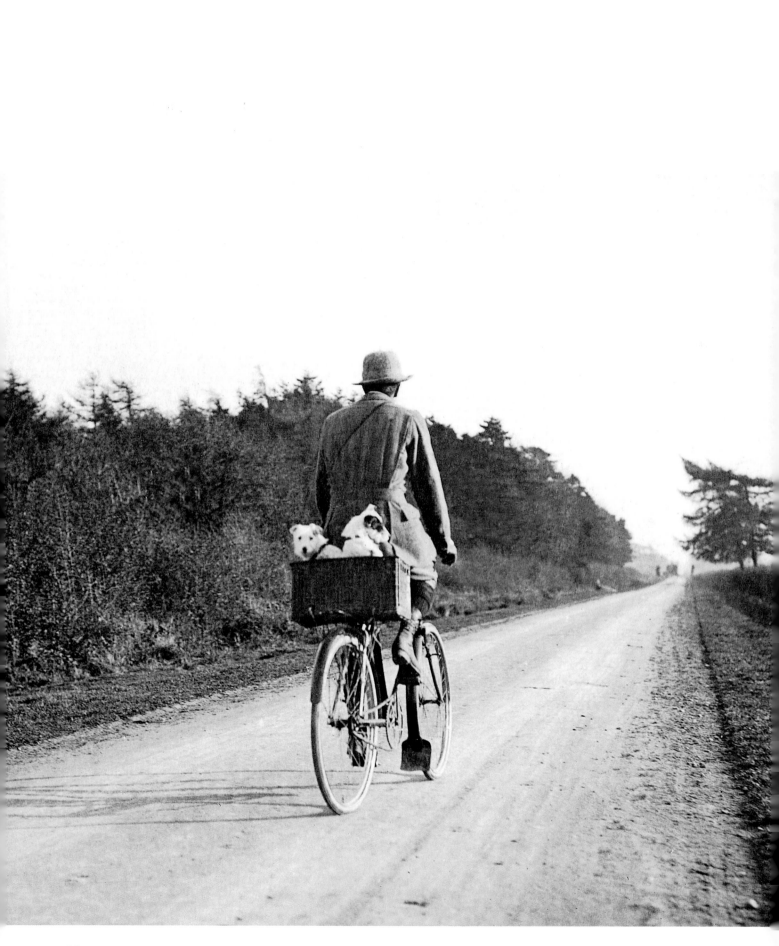

Tally-ho!

The terrier man cycles along a quiet country lane, carrying his dogs to a fox hunt. These fox terriers do not look like the hounds usually associated with fox hunts, because they were originally bred not for the chase but to drive foxes out of their holes. The huntsmen would cry 'Tally-ho!' as they caught sight of the fox and the chase began. Tally-ho is the Anglicized version of an old French word *taïaut*, which was used in deer-hunting both when the deer was sighted and as a cry to the hounds when they were thrown their share of the disembowelled stag.

Fox-hunting developed in England during the 17th century, at a time when bear-baiting, cockfighting, beheading royalty and burning people at the stake for their religious beliefs were all still popular, although fox-hunting is the only one of these sports to have survived into the 21st century. Initially the aristocracy would hunt deer and it was left to farmers and labourers to kill foxes as vermin, which they did with little ceremony. Only when guns and diminishing woodland led to a scarcity of deer did the aristocracy begin to bother with foxes, which they did with a relish that led to the development of various rituals and elaborate costumes. Since 1949 there has been an ever-growing movement to make this sport illegal and in recent years animal rights activists have been more and more successful in disrupting hunts and bringing attention to the plight of the fox. Despite these objections there were actually more packs of foxhounds at the end of the 20th century than at the beginning.

The arrival of the railways greatly affected fox-hunting but not in the way that the sport expected. There had been predictions that railway tracks through the fields would kill off hunting, but instead it increased its popularity and accessibility. The arrival of the rail horsebox meant that huntsmen could take their own horses much further afield, breakfasting in London and hunting later the same day in the country. And it was suddenly feasible to stay in a country house for a long weekend instead of for a month, which meant that many more hunts were within reach for those who used the trains.

Also this year...

London's first electric underground train goes into service, leaving Baker Street for Uxbridge on the Metropolitan line

Charles Rolls and Henry Royce form Rolls-Royce

Britain's first motorized double-decker bus goes into service in London

The 4607-mile Trans-Siberian railway is completed after 13 years of construction

Mad dogs and Englishmen

Edwardian sightseers in the Canary Islands, complete with tourist trappings such as a compact camera. The idea of travelling abroad had arisen partly from social changes in England, where at the beginning of the 19th century even trips to the English coast had been the preserve of the rich. The coming of the railways, and the passing of the Bank Holidays Act of 1871 and the Holidays Extension Act of 1875, meant that more and more ordinary people had the means and the time to visit the seaside. This 'invasion' of coastal resorts meant that the wealthy and the aristocracy began to travel abroad, and by 1905 foreign travel was already becoming available to the middle classes.

It was Thomas Cook who brought foreign travel within the reach of ordinary people with his revolutionary idea of package holidays. His tours became so famous that travellers to the Middle East were known to the Arabs not as tourists but as 'Cookii', and were referred to disparagingly in English magazines as 'i Cucchi'. Detractors asserted that package tours sapped the British spirit of independence, and the wealthy complained that 'places of rare interest should be excluded from the gaze of common people'. Despite all this, Thomas Cook's business thrived and the package holiday became ever more popular. In 1890 half a million English people went abroad and only 10 years later this figure had doubled, with Cook's offering cheap tours to Spain and Portugal throughout the 1890s.

Working-class holidaymakers had to wait a while longer before foreign travel came within their reach. Although the coming of the railways allowed them to travel into the country or to the coast, these holidays were usually unpaid and families saved throughout the year in special clubs to be able to afford them. The Bank Holiday Acts, which guaranteed four free Mondays in the year, did not make much difference to extended holidays, and the Holidays With Pay Act was not passed until 1938. This Act did not come into effect until after the Second World War, when English seaside resorts had their most prosperous period; but it wasn't until the advent of cheap air travel that foreign holidays for the working class truly became a reality.

Also this year...

Car bumpers are introduced

London's first motorized ambulance service is set up for the victims of traffic accidents

The Aero Club of America and the Federation Aeronautique Internationale *(FAI) in France are both founded*

Two French aviators land a balloon at Crystal Palace after flying across the channel

The roof of Charing Cross station collapses, killing six people

The Automobile Association is founded

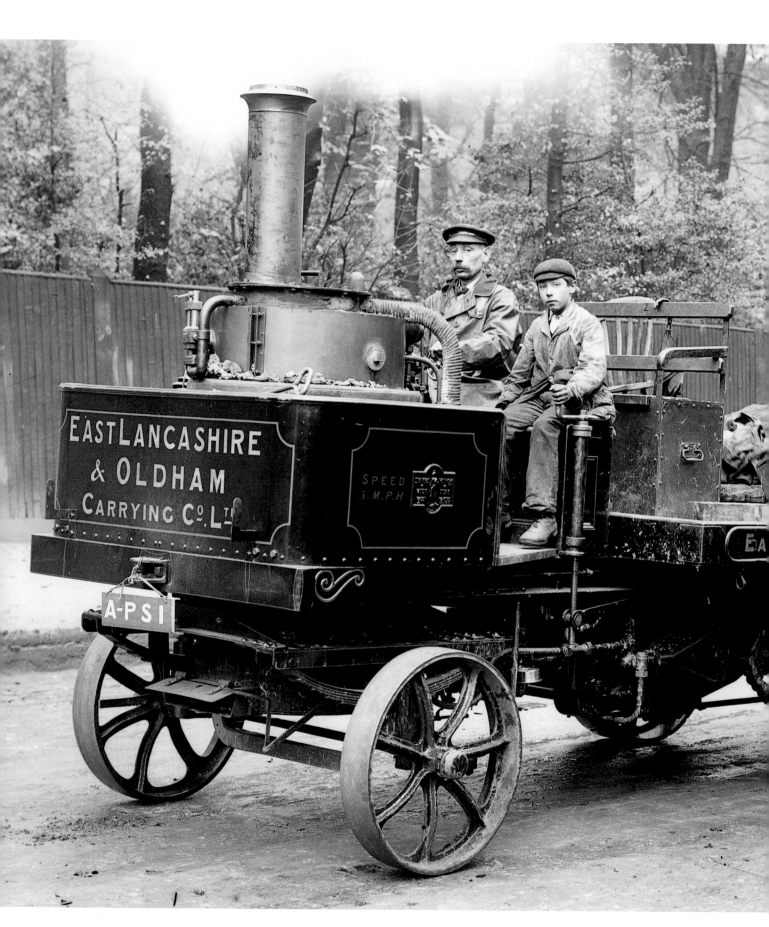

EAST LANCASHIRE
& OLDHAM
CARRYING Cº Lᵀᴰ

SPEED
5. M.P.H

A-PSI

EA

Full steam ahead

This flat-bed steam lorry belonging to the East Lancashire & Oldham Carrying Company is typical of the wagons used in the first decade of the 20th century. Before the advent of the internal combustion engine, engineers had dreamt that steam vehicles would rival the horse-drawn carts and carriages of the day; one Italian designer simply added a steam engine to an existing landau and dispensed with the horses. In Britain the development of steam vehicles was hindered by the Locomotive Act of 1865, which classified mechanical road vehicles as road locomotives, and accordingly early development of steam haulage vehicles was along the lines of heavy traction engines rather than steam carriages or lightweight lorries and wagons such as this one.

Surprisingly, the use of steam wagons in Britain reached its peak as late as 1925, and some 'steamers' were still in use in the 1960s, many having been recommissioned in the wake of petrol shortages after the Suez Crisis. The problems confronting early steam wagons included the prevailing standards of wheels – the traditional wooden-spoked wheel was not designed for the weight or traction of steam vehicles, and had to be redesigned. Another problem was in maintaining an adequate supply of steam, because boilers were made as small as possible to keep costs down and to meet weight restrictions for road use. This meant that many of the early wagons struggled to make it up hills or to start from cold. A further problem for road vehicles was the distance from the boiler to the cylinder block, which meant that the steam had begun to condense before it had done its work, making it wet and reducing the pressure, and thereby the power output of the engine.

The 1904 Heavy Motor Car Order, which raised the maximum weight to 5 tons, allowed many manufacturers to design wagons with bigger and more efficient boilers. A wagon similar to the one seen here was designed by James and Frederick Howard of Bedford, who had made their name designing ploughs and agricultural machinery. Their lorry took advantage of the new weight regulations but unfortunately fell prey to the earlier design problems and proved to be 'a sluggish and wet runner, liable to be winded by sudden steam demands'.

Also this year...

Parliament rejects plans to build a 'fast motor highway' between London and Brighton

An underground tube line opens from Baker Street to Waterloo and becomes known as the Bakerloo line

Winston Churchill leads a protest

against noise caused by motor vehicles

The Lusitania *is launched in Glasgow; her sister ship* Mauretania *is launched later the same year*

Seven balloons take part in Britain's first hot air balloon race

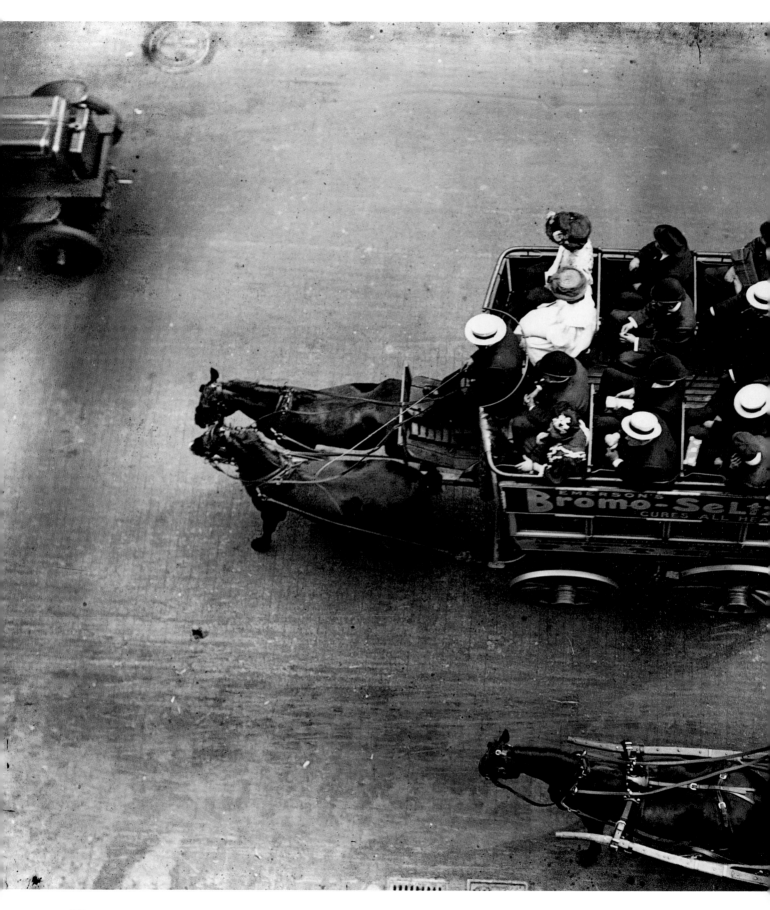

Fare-weather friends

This apparently simple photograph of passengers on a horse-drawn bus tells quite a story about travel in the first decade of the last century. A motor car is just entering the picture, literally and metaphorically – horse-drawn vehicles were already being challenged by motor transport and it would be less than 10 years before motorized buses and trams replaced buses such as this one. The horse and trap in the foreground is driverless, waiting at the kerb unhindered by parking restrictions or yellow lines, which were not introduced until 1958. The perspective of the photograph means that it takes a second glance to realize that the bus is a double-decker and that already by 1907 advertisers were making the most of buses as moving billboards.

The word omnibus was introduced to Britain by George Shillibeer when, in 1829, he established a carriage service between Paddington and Bank in London. Shillibeer's service justified the name omnibus (meaning 'for all' in Latin) because passengers could join the vehicle along the route, but although he was the first to import the word, he was beaten to the idea by John Greenwood, who set up Britain's first bus service in Manchester using 12-seater coaches.

Before long buses were so popular that there wasn't enough room inside for all the passengers, so some took to sitting on the roof. This became so common that by the 1850s seats were provided for them and the roof became a top deck. At first the seats were simply benches running along the middle of the roof, on which passengers sat back-to-back facing outwards; these were known as 'knifeboards'. The arrangement seen in the picture came 30 years later, and was known as a 'garden seat' double-decker. Already by that time 'decency boards' were a common feature of double-deckers, placed along the side of the roof to stop young men from glimpsing the ankles of any ladies riding on the top deck; their secondary purpose was to stop people sliding off if the bus braked suddenly. Before long, decency boards became larger and companies began to advertise on them. Surprisingly it was a full 70 years after people first began to sit on the roofs of buses that closed-top double-deckers appeared.

Also this year...

The British liner Lusitania *enters service*

Bleriot flies his monoplane 10 yards

The British Army flies its first airship, Nulli Secundus, *with a three-man crew that includes Samuel Cody, later the first man to fly an aeroplane in the British Isles*

A dirigible circles St Paul's in the first public display of an airship in Britain

Lloyd George approves plans for a cross-channel ferry from Dover to Calais

Sir Frank Whittle, inventor of the jet engine, is born

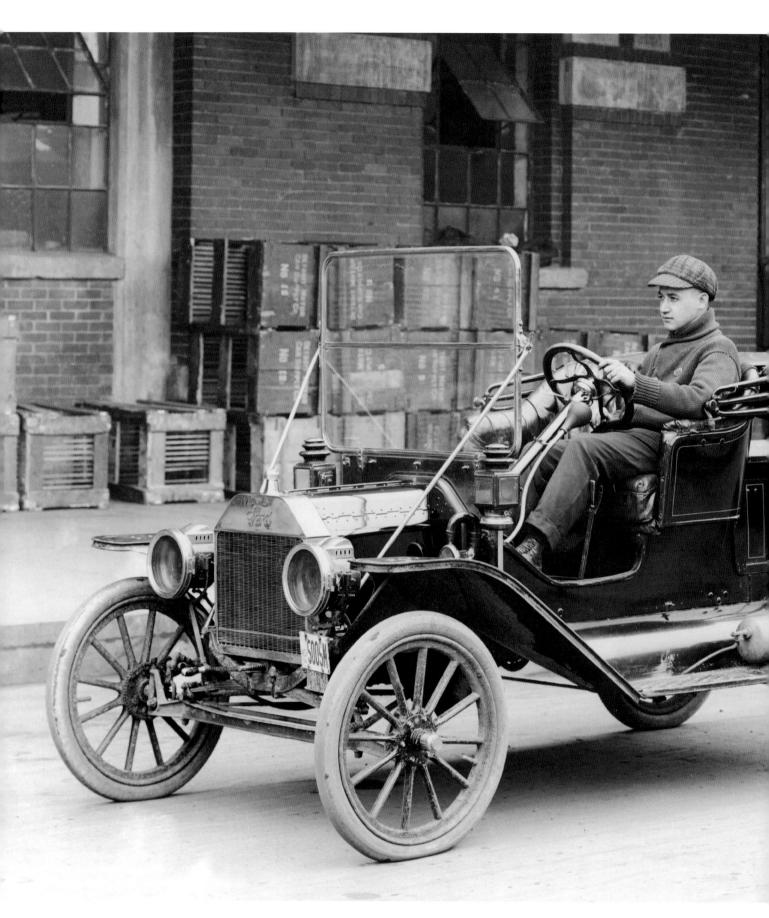

Any colour you like, so long as it's black

1908 was the year that Ford launched the legendary Model T, which has been described as one of the most significant landmarks in motoring history. The previous year Henry Ford had promised to produce 'a motor car for the great multitude', a car cheap enough for anyone on a reasonable salary to buy, made from the best materials and 'the simplest designs that modern engineering can devise'. It was this simplicity of design that enabled Ford to set up his mass-production line in 1913 and revolutionize the car manufacturing industry. Until then cars had been individually built from the wheels up, and it was the relative inflexibility of the mass-production method that led to Henry Ford's comment that the Model T was available in 'any colour you like, so long as it's black'.

Henry Ford completed his first car, which he called a quadricycle, in 1896. A second version so impressed his financiers that together they formed the Detroit Automobile Company, but differing ideas led Ford to leave the company. He concentrated instead on racing, where more success enabled him to set up the Henry Ford Company in 1901. Once again, personal differences led him to leave the company, this time after just three months and with the agreement that the company change its name – it did, to Cadillac. More racing success put Ford in a much stronger position so that he was able to set up a company based on his own ideas, and in 1903 the Ford Motor Company was incorporated; the Model A was launched the same year, followed by several others before the Model T, which was nicknamed the 'Tin Lizzy'.

Mass production led to a dramatic reduction in prices and therefore increased sales, which peaked at 1.8 million in 1923. However, times moved on and by 1926 sales were flagging; in spite of subtle improvements and the availability of other colours than black, the Model T was beginning to seem old-fashioned. A new model was required and in 1927 production of the Model T ceased after nearly twenty years, by which time over 15 million of these legendary cars had been sold.

Also this year...

Electric car lights are introduced by the Pockley Automobile Electric Lighting Syndicate of Birmingham; the first set includes headlights, side-lights and a tail lamp

Charles W. Furnas becomes the first passenger to fly in an aeroplane, and Thomas Selfridge becomes the first man to die in a plane crash; he was a passenger in a plane piloted by

Orville Wright. Later this year Thérèse Peltier becomes the first woman passenger to fly in an aeroplane

Suffragettes hire an airship for a raid on London, tossing out leaflets over the House of Commons demanding 'Votes for Women!'

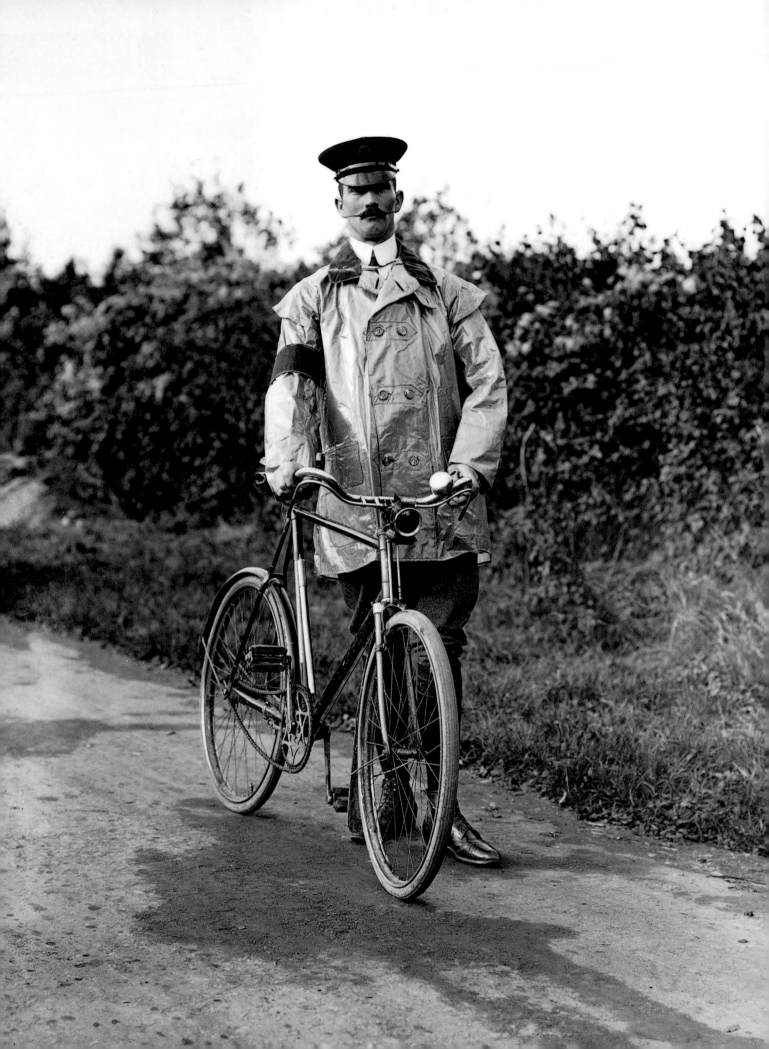

The fourth emergency service

An Automobile Association bicycle scout proudly displays the new uniform of oilskins, breeches, armband and peaked cap, which was introduced in 1909; the handlebar moustache was optional. Prior to the introduction of the uniform, scouts had simply worn their own cycling clothes with an armband and a prominently displayed AA badge.

The AA had been founded by a group of motoring enthusiasts on 29 June, 1905, at the Old Trocadero restaurant in London. Its aim was to protect the interests of motorists, and to counter the suspicion and prejudice that greeted the arrival of the motor car, which was considered a noisy and dangerous nuisance – 100 years later public opinion has come full circle!

Police speed traps were the motorists' greatest bug-bear, particularly after the Chief Constable of Surrey decided, in 1899, to end 'the nuisance and danger caused by reckless riders and drivers'. His officers would hide behind hedges and time passing cars with conventional stop watches to try to estimate their speed. Some motorists organized bicycle scouts who patrolled the London to Brighton road at weekends to find out where the police were operating and warn drivers of their presence. The AA continued this practice and patrolled other roads all over the country. Scouts like the one in the picture became a familiar sight, but the police began to prosecute them for obstruction of justice. However, the AA reasoned that they couldn't be prosecuted for obstruction through an act of omission, and decided that the answer was for scouts not to give their customary salute to AA members if there was a speed trap near by, and in this way the patrols triumphed over police harassment.

Today the AA has a more respectful relationship with the law but continues to campaign on behalf of motorists. It keeps an eye on any new rules and regulations which affect drivers, and brings its weight to bear on their behalf by raising objections or proposing modifications where necessary. But the AA also backs legislation where it makes sense; in 1966 it supported the introduction of the Breathalyzer but opposed the principle of random checks, an objection which succeeded in altering the legislation. The AA also campaigned for lead-free petrol and backed proposals to make the wearing of seatbelts compulsory.

Also this year...

Louis Blériot achieves the first cross-channel flight, in a 24hp monoplane

The world's first air show is staged at Rheims

Antarctic explorer Ernest Shackleton is knighted

The first closed-top double-decker bus goes into operation in Cheshire

The first commercial airline comes into being in Germany

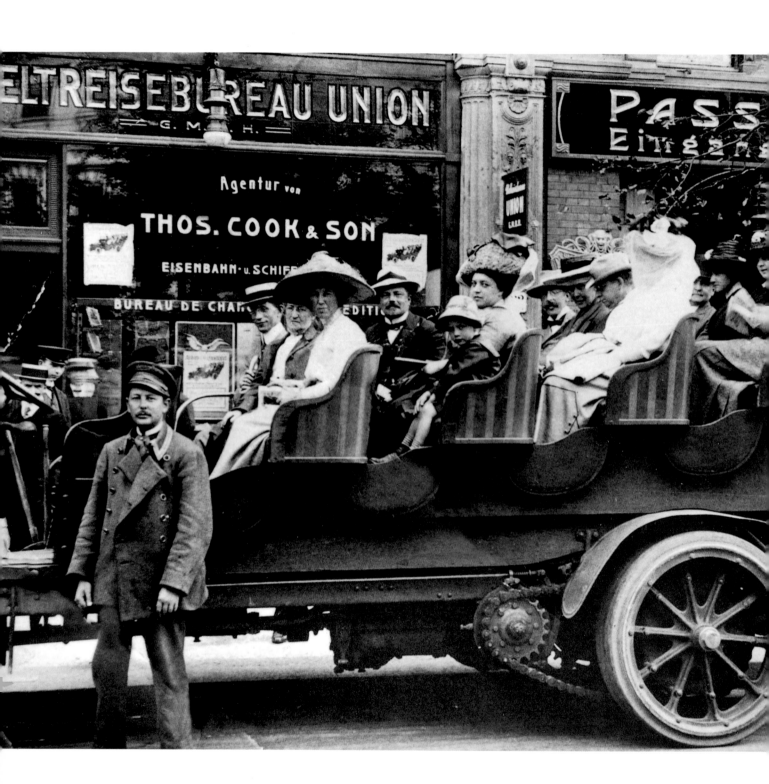

Don't just book it...

A charabanc loaded up and ready to depart from outside the Thomas Cook travel agency in Berlin. The word charabanc comes from the French *char à bancs*, meaning a carriage with benches; the first charabancs were horse-drawn and had the characteristic tiered seating which was carried through to the motor versions. Charabanc tours were organized by Cook's from the beginning of the century both at home and abroad.

Thomas Cook was the pioneer of the package tour, bringing foreign travel to the masses. But what is often seen today as purely a leisure activity arose out of his desire to improve the lives of Victorian workers through education. In 1841 Cook, a cabinet-maker and former Baptist preacher, hit upon the idea of 'employing the great powers of the railways and locomotion for the furtherance of this social reform'. At first he organized trips from his native Leicester for up to 500 people at a time to temperance meetings, then trips to the country and then to the Great Exhibition in London. During this time he also began to establish the principles of the package tour; he examined local accommodation and catering facilities, which he would later include in his tours, and on one occasion he wrote a guidebook.

An International Exhibition in Paris in 1855 gave him the impetus for his first foreign tour and before long he was escorting parties to Switzerland and Italy. Cook was already negotiating concessions with carriers, hoteliers and innkeepers, and in 1874 his company issued the first 'circular note' which enabled his tourists to obtain local currency in exchange for a paper note – he had invented the traveller's cheque, although it was not so-called until American Express launched their version nearly twenty years later. Cook's continued to expand rapidly and in the first quarter of the 20th century it still dominated the ever-growing market for world travel. John Mason Cook had taken over the company in 1879 and proved to be an even better businessman than his father, who had been driven mainly by altruism. In the early days the company had not been particularly profitable and had continued operating only because Cook Snr was motivated by the urge to make the world more accessible to people, describing himself as 'the willing and devoted servant of the travelling public'.

Also this year...

Frenchman Henri Fabre builds a seaplane which can take off and land on water

An air passenger is carried across the channel for the first time

The first eight-mile section of the Panama Canal is opened

Kissing is banned on French railways after claims that prolonged farewells delay trains

Charles Stewart Rolls, of Rolls-Royce, becomes the first British victim of an air crash

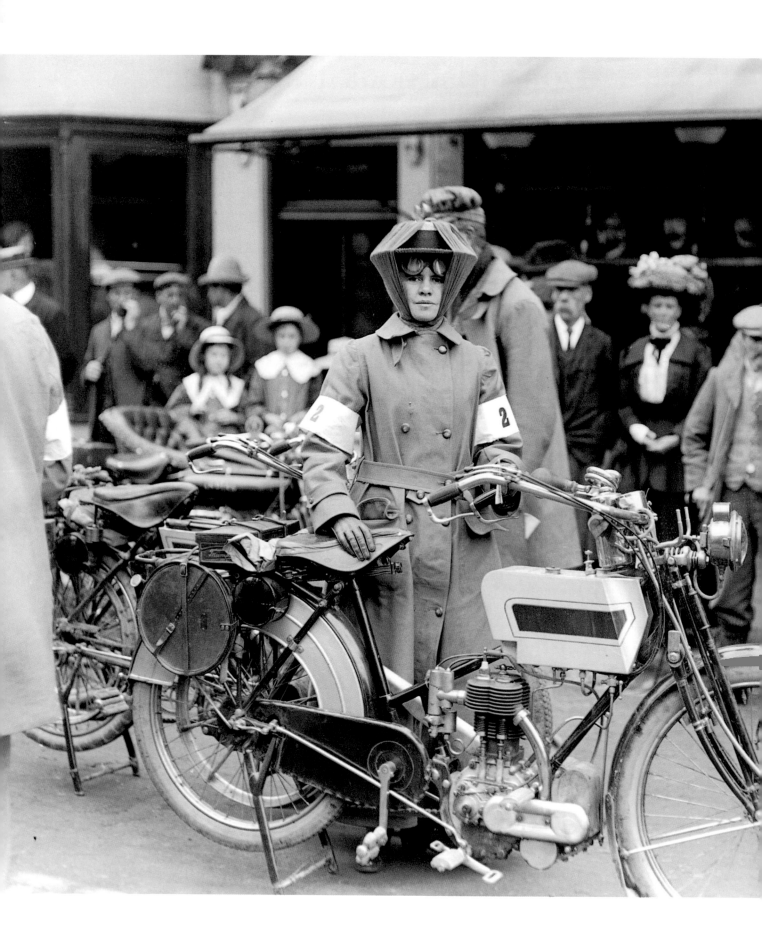

A day at the races

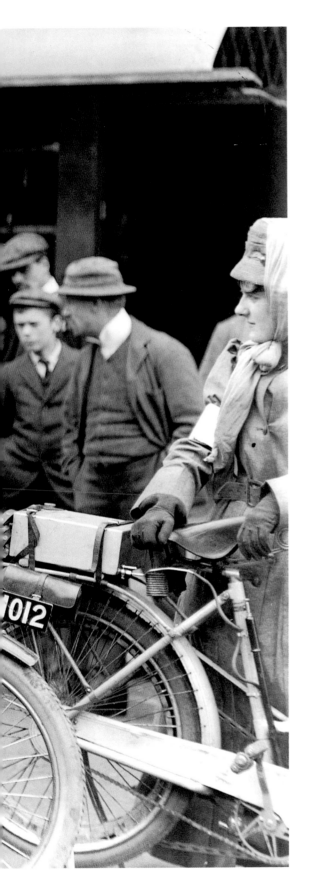

In the early days of motorcycling it was considered most unladylike for women to ride their own machines, but despite that there were soon enough women doing so for manufacturers to begin including ladies' models in their catalogues. However, despite breaking the rules of decorum by riding motor-bikes, these ladies did not break the dress code of the day, hence the need for a ladies' model which, as with pedal cycles, had a dropped frame instead of a cross-bar so that the bike could be ridden while a lady rider was wearing a skirt. Ladies still took great pride in their appearance, and the double-breasted coat and tied-down hat were the fashionable motoring clothes of the time, similar to the kind of attire necessary for travelling in the open cars of the day; Harrods even had a special catalogue of 'Charming Motor Millinery'.

The first motorbikes were little more than push-bikes with engines fitted. The German partnership Daimler and Maybach mounted an engine vertically in a wooden 'boneshaker' bicycle, with the saddle placed high up above the engine, but this proved not to be an ideal arrangement – Daimler's son Paul had to jump off the machine on a test run when the saddle caught fire! It was the Werner brothers of Paris who finally came up with the design which became a virtual prototype of all modern motorbikes, with the engine mounted where the bottom bracket of a pedal-bike would be. This had several advantages including providing a low centre of gravity, and other manufacturers soon followed suit.

Motorcycling attracted many lady riders, although from the beginning it was seen as a rebellious activity even for men. Among the most notable ladies were Muriel Hind, who wrote a column for the magazine *Motor Cycling*, encouraging other women to take part in the new pastime, and Rosa Hammett who claimed that a 12-hour ride was well within a woman's capabilities and thought nothing of going off for a 100-mile ride. Hind and Hammett both rode in motorbike competitions, which is what the two ladies in the picture are about to do, hence their numbered armbands.

Also this year...

Norwegian Roald Amundsen reaches the South Pole

The first Monte Carlo Rally takes place

The UK's first air mail service begins on 9 September and ends on 26 September, carrying mail from Hendon to Windsor

The Automobile Association and the Motor Union amalgamate

Rolls-Royce commission the 'Spirit of Ecstasy' statuette to discourage owners from fitting their own mascots

The Titanic is launched

The first electric trolley buses go into service in Leeds and Bradford

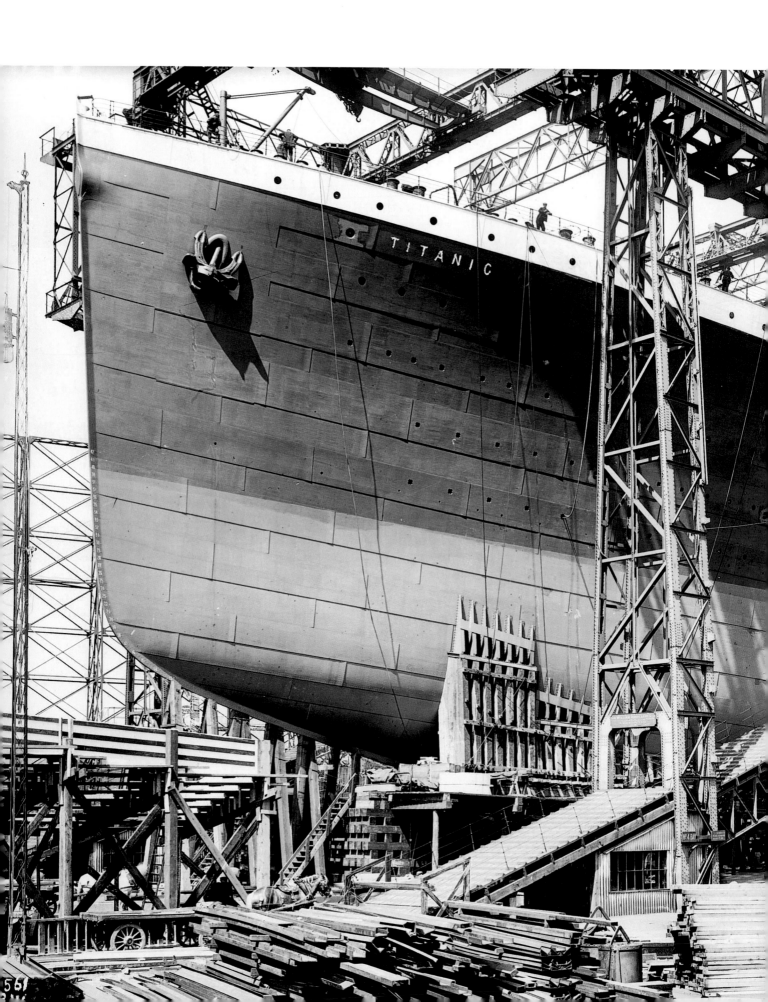

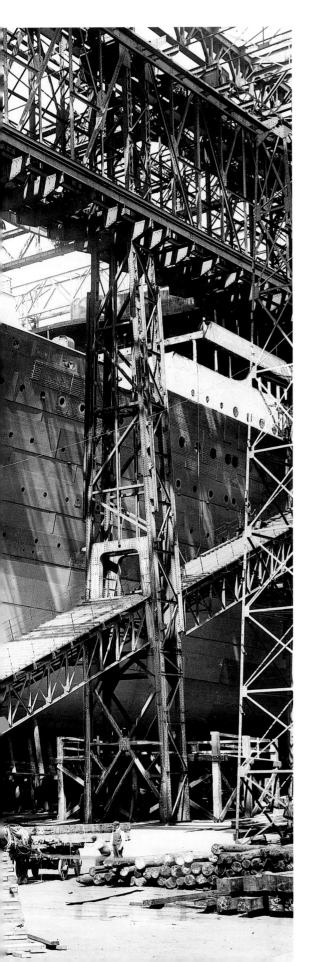

Women and children first

In 1998 one version of the *Titanic* story reached millions of people worldwide through James Cameron's Oscar-winning film. Of 121 'Titanic graves' lying in the Fairview cemetery in Halifax, Nova Scotia, most of them rarely visited, there is one which in 1998 was heaped with tributes, lighted candles, keys, sweets and trinkets – the grave of James Dawson, who was played by Leonardo DiCaprio in Cameron's film. But this devotion shows how the film subtly changed the survivors and the dead from victims of a disaster into characters in a romance. The film may have kept alive the memory of the century's worst transport accident but it was presented as entertainment, and has been accused of distorting the truth.

Distorting the truth is nothing new, however; just one month after the disaster George Bernard Shaw wrote in a national newspaper, 'Why is it that the effects of a sensational catastrophe on a modern nation is to cast it into transports, not of weeping... not of sympathy with the bereaved... but of... an explosion of romantic lying?' Shaw was questioning newspaper reports of the heroic and selfless behaviour of all involved when it was clear that several millionaires, including the managing director of the White Star Line, had got away in the first lifeboat and that some occupants of the lifeboats had actually pushed swimmers back into the icy seas.

It is well known that on the night of 14 April, the *Titanic* hit an iceberg and sank. The world's largest luxury liner was built to flotation safety standards higher than those required then or now but there was only space in the lifeboats for 1,178 of the 2,206 men, women and children on board. Accepted thinking was that the iceberg had torn a hole below the waterline, but in 1986 the discoverer of the wreck said that a split seam, not a hole, had caused the ship to sink. He claimed that the hull had buckled on impact and that the rivets had popped 'quietly but lethally' out of place. According to the Board of Trade inquiry, 1,503 people died and just 703 were saved.

Also this year...

Scott reaches the South Pole to find that he has been beaten by Amundsen; he and his men die on the trek home

A transport strike brings Britain to a standstill

The first international airship service is established when Zeppelin's Delag *expands domestic operations and opens routes to*

Copenhagen and Malmö

The first fatal accident on London's underground kills 22

Captain Albert Berry of the US Army performs the first recorded parachute jump from an aeroplane

The Royal Flying Corps is founded, becoming the first step towards a British air force independent of the army or navy

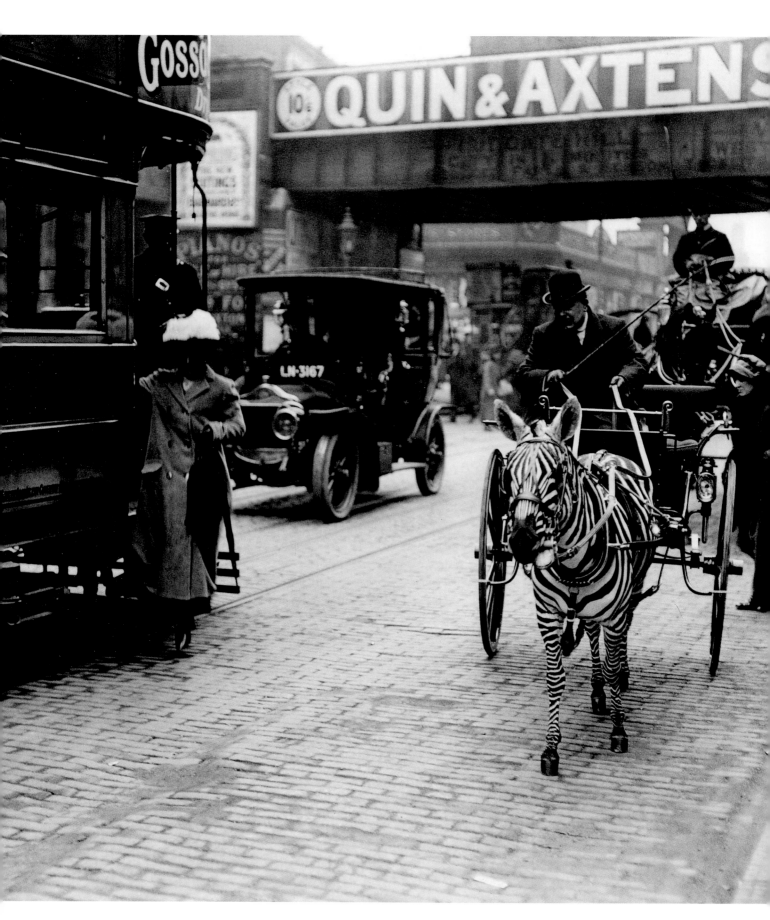

Zebra crossing

A zebra-and-trap shares the road with a horse-drawn carriage, a car and a tram, while the railway bridge serves as a reminder of the dominant form of transport. While zebras were not a common sight on the streets of Brixton, horse-drawn transport in general still made up a large percentage of the traffic in towns. In 1913 there were over 600,000 horses being used for transport in London alone, while the traffic census for that year records a mere 106,000 privately owned vehicles in the whole of Britain.

The evolution of transport affected the way Britain developed and had a fundamental effect on people's lifestyles. At a time when all transport was by horse or horse-drawn vehicle, trips to a market-town were weekly occurrences and a trip to the capital meant going there to live or to stay for an extended visit. With the development of the railways London and Edinburgh became accessible to overnight visitors from most parts of the country, and by the 1980s, some 70 years after this picture, people were commuting to the capital from as far afield as Bristol, Birmingham, Norwich, Leicester and Doncaster.

The railways also led to the standardizing of time in Britain. The longest east-west journey regularly undertaken by horse-drawn carriages was between London and Plymouth, a 220-mile journey which the mail coaches completed in 22 hours. Travellers arriving in Plymouth would find that the time was 20 minutes later than in London because of its distance east, a change that was easily accommodated. But for the railway operators the time difference became very significant because of the need to synchronize train times. The main east-west lines used Greenwich Time from their opening in 1838–41, and gradually the other companies followed suit. City Corporations also began to set their clocks to Greenwich Time, or Railway Time as it came to be known, and soon the country was unified as one time zone.

While the railways led to changes in the political and social structure of the country, the replacement of horse-drawn traffic by electric trams, motor-buses, motor-cabs and cars made for changes at a more personal level. The domination of the internal combustion engine saw the disappearance of horses from public transport but at the same time it brought travel to the masses. Transport became more democratic, a right of the many rather than a privilege of the few.

Also this year...

French aviator Pégoud says that parachutes are as safe as cars

In Paris, Louis Bleriot performs the first loop-the-loop

A 10mph speed limit is set at Hyde Park Corner, the world's busiest road junction

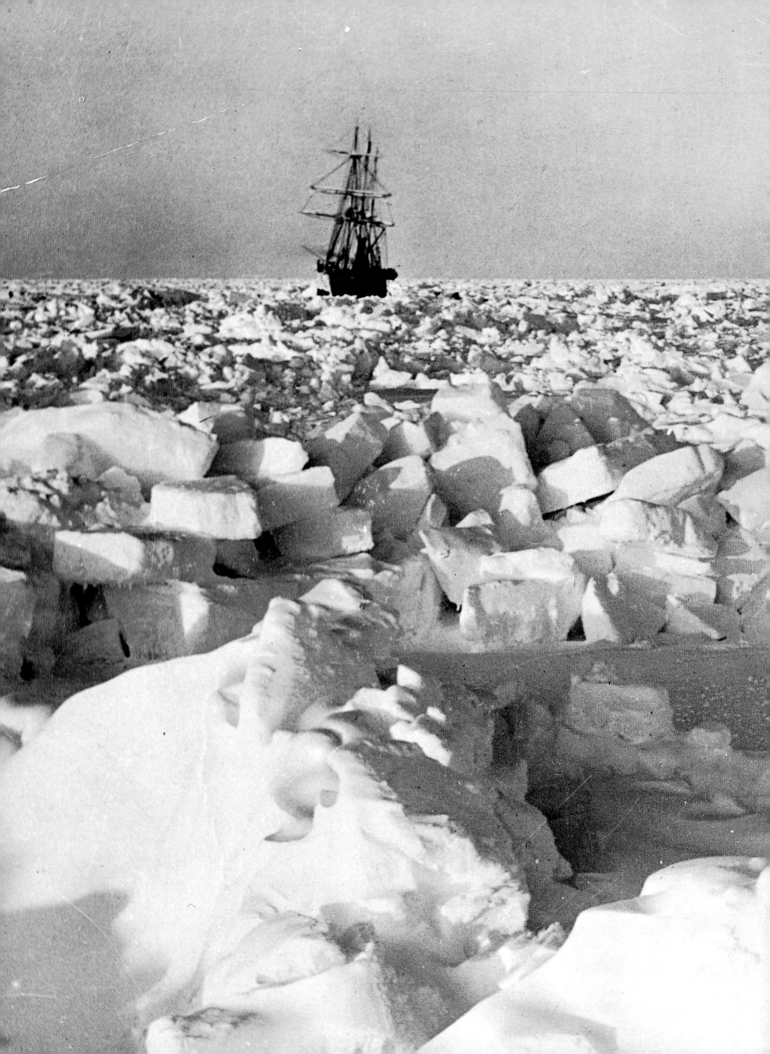

The ice man cometh

At 6p.m. the pressure develops an irresistible energy. The ship groans and quivers, windows splinter, whilst the deck timbers gape and twist.
(From the diary of Frank Hurley, expedition photographer.)

The Imperial Trans-Arctic Expedition left Plymouth on 8 August, 1914 with the aim of fulfilling Ernest Shackleton's goal of being the first to cross the Antarctic continent on foot. The expedition ship was specially designed to withstand ice and was renamed *Endurance* by Shackleton after his family motto *Fortitudine vincimus* – by endurance we conquer.

Having battled through 1,000 miles of pack ice for 6 weeks, the *Endurance* was 100 miles, or a day's sail, away from her destination when the ice closed in around her. In the words of the ship's storekeeper, she was 'frozen like an almond in a piece of toffee', and for 10 months the *Endurance* was dragged more than a thousand miles with the drifting ice pack. Shackleton knew that one of two things would eventually happen – in spring the ice would thaw and free the ship, or the pressure of the constantly shifting ice would crush her like an eggshell. After the night described above by Frank Hurley, Shackleton gave the order to abandon ship. His men set up camp on the ice and could only watch as their ship was broken to pieces. Six months later, the ice began to break up and they launched the three open lifeboats that they had salvaged from the ship: after enduring seven nights and days in the freezing waters of the Antarctic they made landfall on the uninhabited Elephant Island.

The only way for Shackleton to save his crew was to take the largest lifeboat with a small crew and sail 800 miles across the South Atlantic to the whaling stations of South Georgia. It is a miracle that they ever found that speck of land in thousands of miles of ocean. Five months later the crew who had remained on Elephant Island feared the worst and were preparing their own rescue attempt when a ship was sighted – it was Shackleton's fourth attempt to rescue his men, three previous efforts having been thwarted by pack ice. Shackleton's navigator wrote that 'by self sacrifice and throwing his own life into the balance he saved every one of his men' – within an hour, the entire company were safely aboard the rescue ship, Frank Hurley bringing with him the canisters of film which contained this photograph.

Also this year...

The first full meal to be served in the air is eaten aboard the Ilya Mourometz. *Two months later the First World War begins*

The British India Steamship Company amalgamates with the

Peninsular and Oriental Steamship Company (P&O)

Norwegian explorer Thor Heyerdahl is born

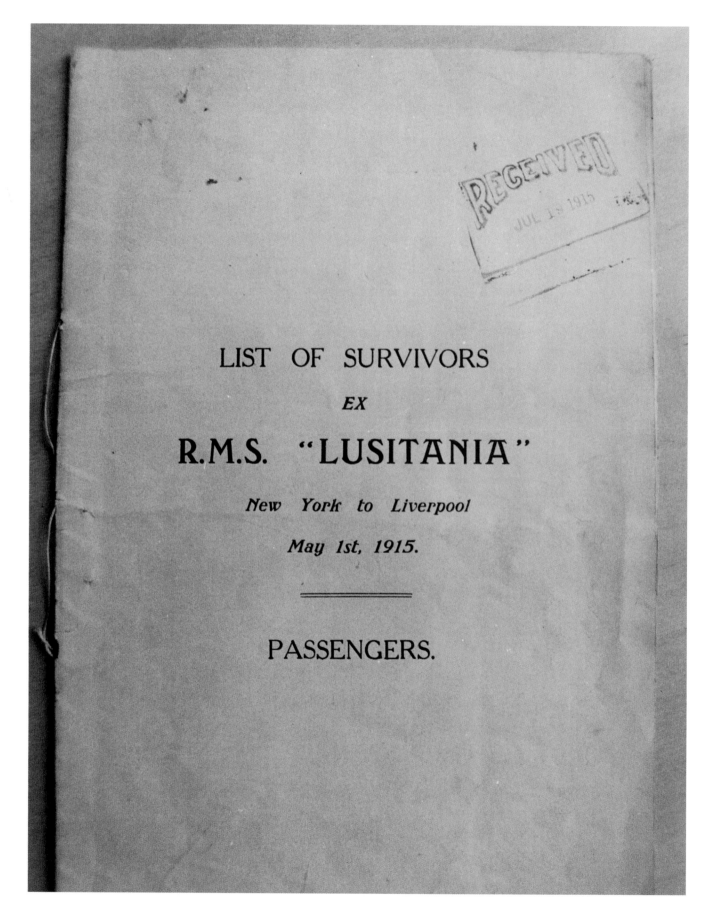

LIST OF SURVIVORS

EX

R.M.S. "LUSITANIA"

New York to Liverpool

May 1st, 1915.

PASSENGERS.

Piracy on the high seas

The *Lusitania* and her sister ship the *Mauretania* were considered the two finest ocean liners afloat, the pride of the Cunard fleet. Launched in 1906, the *Lusitania* took the blue riband a year later for the fastest Atlantic crossing, sailing from Liverpool to New York at an average of 23.99 knots. She continued to make monthly return sailings even after the outbreak of war, and before her fatal journey the German authorities in New York published warnings that she would be attacked by U-boats and advised passengers not to sail. However, the warnings were not taken seriously and it even appears that the Admiralty failed to warn the ship's captain of U-boat activity in her area, presumably thinking that the Germans would not contravene the rules of the Hague Convention.

The *Lusitania* sailed from New York on 1 May, 1915 with orders to steer a zig-zag course, but these instructions were ignored and she was approaching the Old Head of Kinsale in southern Ireland on a steady course when two torpedoes from the U-20 hit her starboard side. One survivor, Ernest Cowper from Toronto, said that he was chatting to a friend just after two o'clock when he caught a glimpse of a submarine's conning tower and saw the tracks of a torpedo; there was a loud explosion as the torpedo hit the ship near the bows, and another one shortly afterwards as she was hit aft. She sank within 20 minutes, at such a steep angle that it was difficult to launch the lifeboats: 1,198 passengers and crew lost their lives.

The attack caused outrage in America, where former President Theodore Roosevelt called it 'piracy on a vaster scale than the worst pirates of history'; the Germans claimed that the *Lusitania* was an armed merchant cruiser carrying troops from Canada, and minted a special medal to celebrate the sinking. Some 128 American citizens lost their lives and it was said that the attack weakened the grounds for President Wilson's neutrality policy and helped to bring America into the war in 1917. Less than a week later King George V stripped his cousin the German Kaiser of the Order of the Garter.

Also this year...

The Auto-Ped, a precursor of the motor scooter, hits the streets of New York

Near Gretna Green, in Scotland, 227 people are killed and 245 injured in a train crash

The first aerial bombing raid on Britain takes place, carried out by three German Navy Zeppelins

British pilot Reginald Warneford receives the VC for single-handedly destroying a German Zeppelin

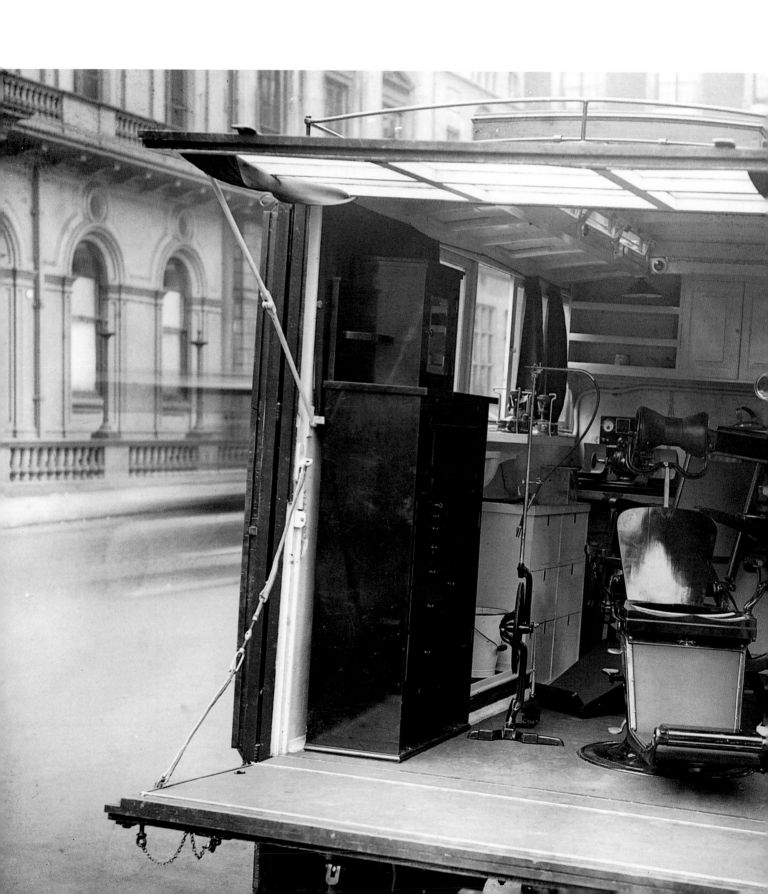

Open wide!

The interior of a dental caravan, fully kitted out as a mobile surgery. Caravans such as this enabled dentists to visit their patients at home and in rural areas, and were most often used for visits to schools. In 1914 the educational committee of Norfolk became the first to appoint a dental officer, who arranged for pupils to be seen by travelling dentists.

At the scheme's onset, each of the dentists had to set up a temporary surgery in the corner of one of the schoolrooms, but they soon found that in the smaller schools in more remote areas there was no space available. The solution to this problem was to use a horse-drawn caravan as a mobile surgery. There were several advantages to the caravan over the corner of a room: there was more privacy, virtually no delay due to packing and unpacking all the equipment, and much less disruption to the normal running of the school. By 1929 there were six horse-drawn caravans on the road. One of them was replaced by a trailer which could be towed behind the dentist's car and the experiment was so successful that by 1937 they had all been replaced by trailers.

Mobile surgeries are a far cry from the origins of dentistry, which in medieval times consisted of little more than cleaning and extracting teeth, and applying dressings or providing mouthwashes to relieve pain. Extractions were carried out by specialist tooth-drawers and by barbers, surgeons and blacksmiths. During the 18th century, as knowledge of dentistry increased, gold and lead fillings began to be used, although they were the preserve of the wealthy. By the middle of the 19th century dentistry was developing into a profession; scientific journals were published, professional societies formed and dental schools established to provide formal training. In 1878 a dental register was established, and 70 years later, in 1948, dental treatment was made available on the National Health.

Improved dental techniques, the wider availability of treatment and the reduction in rates of caries due to the fluoridation of water mean that the nation has healthier teeth than it did in 1916 but mobile surgeries still make the rounds of schools in rural areas to this day.

Also this year...

Windscreen wipers are introduced to some US cars

Tanks are used in war for the first time by Britain at the Battle of the Somme. For secrecy the tank corps was known as the Heavy Section Machine Gun Corps

The first air raid on London; German planes drop six bombs which land near Victoria Station

The government appeals against the use of cars and motorbikes for pleasure

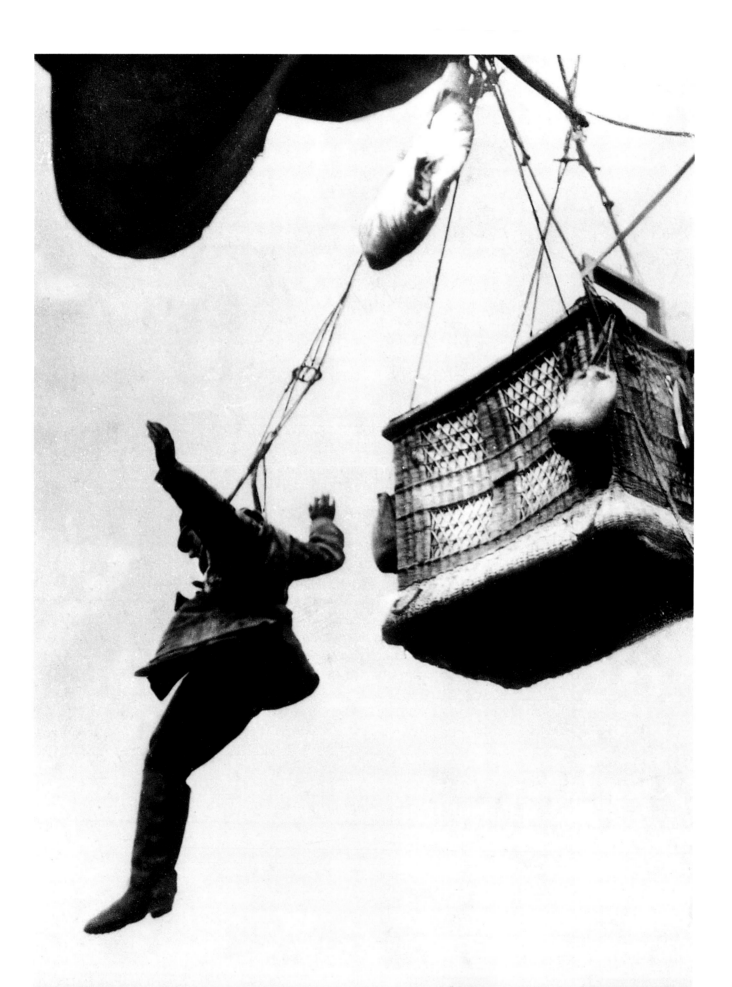

Full of hot air

Humankind made many legendary attempts at flight before eventually succeeding with the hot air balloon. Daedalus and his son Icarus reputedly built wings of feathers and wax to escape from Crete but Icarus flew too close to the sun which melted the wax and he was killed. And, closer to home, Bladud, King of Britain from 863 BC, is said to have crash-landed a magical flying stone on the site of St Paul's Cathedral in London! But the first recorded free flight in any type of aircraft was made in 1783 by two Frenchmen, who made a 5½-mile trip across Paris in a hot air balloon designed by the brothers Montgolfier. Just over a week later the first flight was made in a balloon inflated with 'inflammable air', more scientifically known as hydrogen. As with most new forms of transport, the military were quick to realize the potential of balloons, and only 11 years after its first flight the balloon made its war debut as a reconnaissance aircraft.

This photograph shows a balloon being used for the same purpose in the First World War, over a century later. A German soldier is jumping from an observation balloon after it has been destroyed by enemy fire. His means of escape is almost as old as his means of transport, although hardly recognizable by today's standards: he is wearing a primitive parachute which has yet to unfurl. History does not record whether or not the parachute worked.

The earliest surviving design for a parachute is by Leonardo da Vinci, who also designed an ornithopter, a helicopter and a powered aeroplane between 1483 and 1519. Da Vinci's parachute was due to be tested by a stunt man in the year 2000 but its rigid frame meant that it had to be taken aloft tethered beneath a hot air balloon – unfortunately strong winds blew it out of the drop zone before it had gained enough altitude to be released. In 1797 Andre-Jacques Garnerin tested a parachute by cutting himself loose from a hydrogen balloon over Paris. His parachute opened perfectly but swung so violently from side to side as it came down that its inventor was airsick; later parachutes had a hole at the centre to let the air escape and prevent the swinging. The first parachute to use a rip-cord was not patented until 1920; a few years earlier and it might have given this German soldier a better chance.

Also this year...

Women are permitted to become taxi drivers

The first night-time air raids occur

The Pacific Aero Products Co. changes its name to Boeing Airplane Co.

London's bus drivers go on strike

Winston Churchill returns to the government as chairman of the Air Board

The first landing of an aeroplane on a moving ship takes place

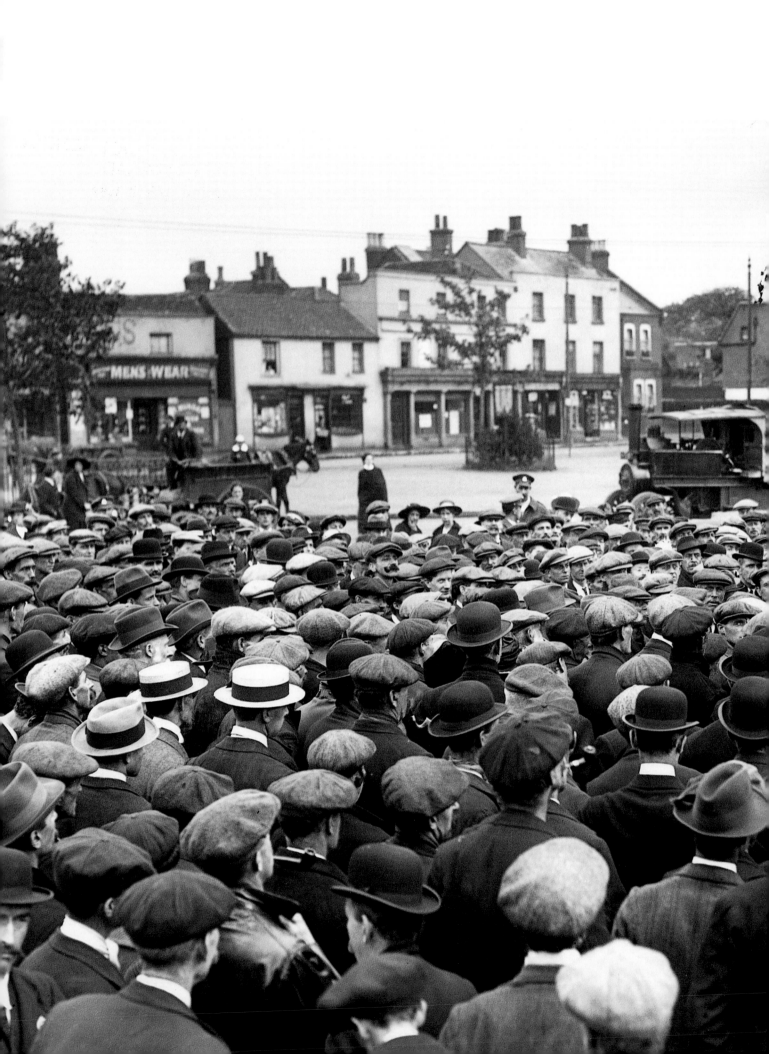

Off the rails

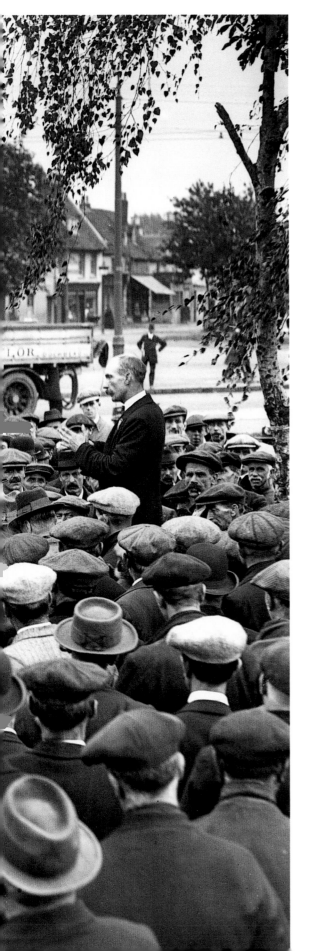

Transport workers hold a strike meeting at Mitcham Green in September 1918, but although the strike was for equal pay for women, there are very few women to be seen in this photograph.

Contrary to popular opinion, women have actually been employed in large numbers on the railways since they first began, and in 1918 they followed their fellow-workers on the buses and trams in striking for equal pay. At the beginning of the First World War there were over 13,000 women on the railways, compared with 9,000 in 1984, but their contribution has been largely ignored by railway historians, probably because they were segregated into jobs which were defined as 'women's work', and often exploited as a source of cheap labour. The 1918 strike was at least successful in persuading the government to set up a commission into equal pay for women.

During the First World War, so many railwaymen enlisted that the barrier against women performing 'men's work' had to be removed, and within 18 months 34,000 women were employed in many grades of work. The National Union of Railwaymen negotiated the terms and conditions of women's employment before admitting women members – to safeguard men's jobs, enlisted railwaymen were guaranteed reinstatement and women were paid no less than the minimum male rate. As the war dragged on and the manpower crisis grew, women trained as signalwomen, shunters and guards despite fierce opposition from the men, and by September 1918 52,000 women had replaced men in railway-related jobs. But the wartime cost-of-living bonus was paid only to men, which created an inequality about which women complained throughout the war, culminating in the 1918 strike. This action partially succeeded but did not prevent all those women who had substituted for men being dismissed after the war. Heavy casualties had left 20,000 vacancies but women were not allowed to fill the jobs despite having carried them out satisfactorily for nearly five years.

It is interesting to note that in this photograph every last man in the crowd except for the speaker is wearing a hat, ranging from bowler hats and trilbys to flat caps and boaters, and that, despite the rise of the internal combustion engine, the only vehicles visible are a horse-drawn cart and a steam lorry.

Also this year...

The Royal Flying Corps and the Royal Naval Air Service merge to form the Royal Air Force

George V grants the prefix 'Royal' to the UK's Aeronutical Society

Manfred von Richthofen, nicknamed the Red Baron after his red Fokker triplane, is shot down and killed during the second Battle of the Somme

Nose-diving to glory

Englishmen Alcock and Brown are famous throughout the world for making the first non-stop crossing of the Atlantic by air in 1919, but what is less well-known is that their journey ended with an ignominious crash-landing in an Irish peat bog. Both men escaped unhurt when their Vickers-Vimy biplane ended up nose-down in the dirt, but the plane almost overturned in the rough landing, which could have had disastrous consequences. Alcock and Brown were knighted for their achievement, but sadly Sir John Alcock died in a flying accident in France later the same year.

John Alcock was born in Manchester and served as a captain in the Royal Naval Air Service during the war, after which he became a test pilot for Vickers Aircraft; Glasgow-born Arthur Whitten Brown was his navigator on their epic journey. Their quest was to win a £10,000 prize offered by the *Daily Mail* for the first non-stop crossing of the Atlantic, and on 14 June, 1919 they took off from St John's, Newfoundland. They flew the 1,900 miles to Clifden in County Galway in 16 hours, 27 minutes, in what John Alcock described as a 'terrible journey' after flying through fog and sleet storms in an open cockpit. Their flimsy-looking biplane was actually classified as a heavy bomber; it was powered by two 350hp Rolls-Royce Eagle engines and was fitted with long-range fuel tanks for the transatlantic flight. The supplies they carried were more suitable for a country picnic than a pioneering flight, as all they had to sustain them was coffee and beer, sandwiches and chocolate.

Less than a month later the British airship R34 made two non-stop Atlantic crossings, carrying the first transatlantic air stowaway – rigger William Ballantyne hid on board after he was dropped from the crew at the last minute. The first crossing, a five-day journey from Scotland to New York, took slightly longer than the *Mauretania* did to make the same crossing, and on arrival in New York one crew member had to parachute to the ground to help anchor the airship.

Also this year...

The first daily international mail and passenger flights – between Paris and London – are introduced

The first public passenger service, first civil airline, and first intercontinental services also start operating in this busy year for air travel

Over 200 sailors on leave drown when the yacht Stornoway *is wrecked off Scotland*

Petrol now costs 3s.6d per gallon

The Admiralty announces that helium is a non-flammable alternative to hydrogen in airships

British airmen Hawker and Grieve are rescued from the sea 850 miles off Ireland after failing to fly the Atlantic non-stop

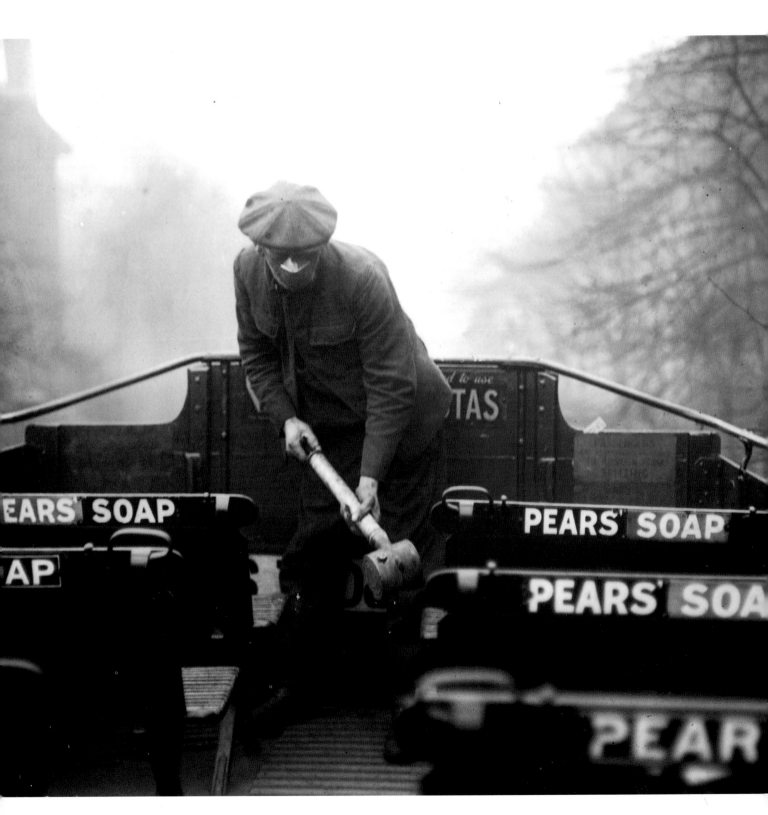

Anti-flu spray

A transport worker disinfects the top deck of a bus with an anti-flu spray during an outbreak of Spanish flu. At the end of the First World War, a flu epidemic reached Britain which had already caused millions of deaths worldwide. India and China had been the worst hit but the virus quickly spread through Europe and the United States amongst a population already weakened by four years of wartime hardship. At the end of 1918 2,225 deaths were reported during one week in London, while the US Federal Bureau of Health reported that deaths from flu exceeded American war dead of 53,000. By the beginning of 1919, deaths in England and Wales actually exceeded births for the first time on record due to the flu virus. The post-war outbreak of flu was the largest single epidemic in human history, claiming 21 million lives – more than twice the 10 million killed in 'the war to end all wars'. It is small wonder that the authorities took to the seemingly desperate measure of spraying the seats on public transport when flu broke out again in 1920.

Open-top double-deckers were still in service, and the advertisers seem even more desperate for space than they are today – it is ironic that seats bearing advertisements for Pears' Soap should need to be disinfected. Pears were something of a pioneering force when it came to advertising, and Francis Pears' son-in-law, Thomas J. Barratt, became an international figure when advertising was still a new profession. Barratt pursued celebrity endorsement and he managed to persuade Lily Langtry, actress and friend of Edward VII, to allow Pears to use her picture with the testimonial 'For years I have used your soap, and no other.' *Punch* lampooned this advert with a cartoon showing a filthy tramp writing out his own endorsement: 'Two years ago I used your soap, since when I have used no other.' Barratt had the last laugh though, because when the appeal of Lily Langtry wore off, he bought the *Punch* cartoon and used that as his advert.

Also this year...

The first retractable undercarriage is used on an aircraft

More than 1¼ million motorists sign a petition calling for a law to control the price of petrol

Compulsory signals are introduced for car drivers; a horizontal arm indicates a turn or slowing down, and a raised hand indicates 'stopping'

The London police force is told that, as a means of transport, they will get cars instead of horses

A new airmail service starts to Amsterdam, costing 3d per ounce of mail

The Ministry of Transport announces a tax of 20 shillings per horsepower on private cars

A night bus service starts in London

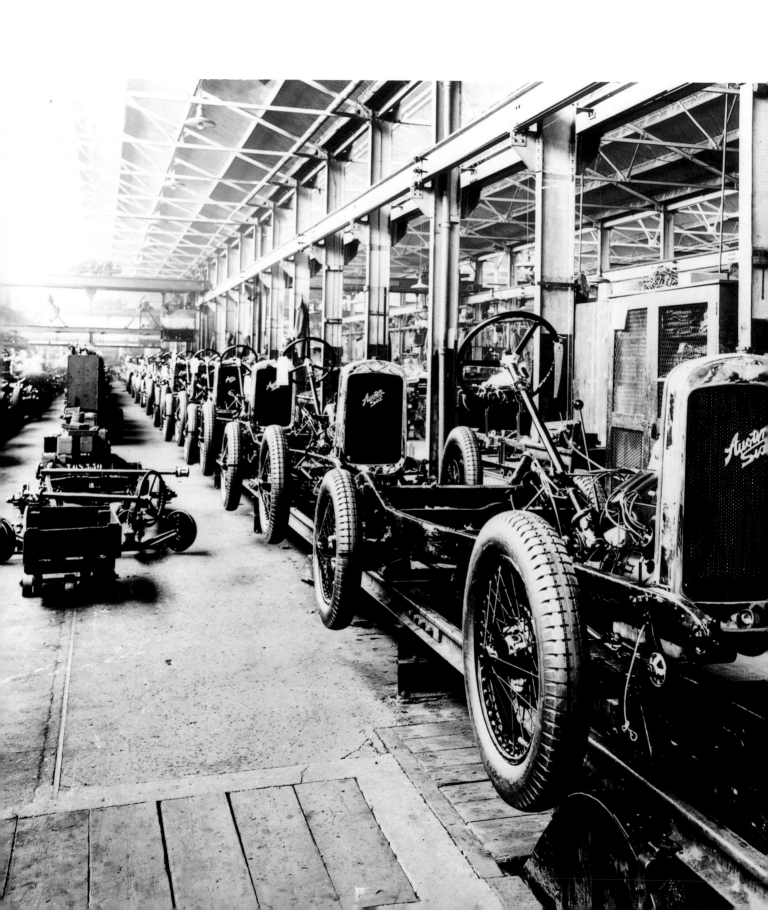

At sixes and sevens

Austin Sixes on the assembly line at Longbridge, Birmingham. Herbert Austin was one of the first British engineers to envisage the possibilities of the petrol-driven car, and built his first three-wheeler in 1895 when the industry was still in its infancy. He was also the first British manufacturer to exploit the potential of mass-production.

Austin was born in Buckinghamshire and educated in England but at the age of 18 he went to Australia, where he served his apprenticeship at Langlands Foundry in Melbourne. Whilst in Australia he met Frederick Wolseley and became manager of the Wolseley Sheep Shearing Company. He returned to England in 1893 to work for Wolseley in Birmingham, where he built his first car for the Wolseley Company. He went on to build several other cars for Wolseley before setting up his own company in 1905, on a 2½-acre site in Longbridge. The following year, with a workforce of 270, he produced 120 cars, and from there the Austin Motor Company Ltd developed rapidly. The Austin Six was one of many great successes for Austin, who as early as 1914 was producing cars with electrically operated starters and electric lights.

The first manufacturer to use mass-production in Britain was the Ford company, who started by assembling kits imported from the US but soon began manufacturing vehicles specially designed for the British market. Austin was the first British manufacturer to realize the advantages of Ford's methods. He set up production lines throughout the 1920s and was soon followed by other British companies. Mass-production brought cars within reach of a far greater number of people, and during the 1930s car manufacture became the main source of growth in the economy. Austin's company flourished and by 1930 the 2½-acre site had grown to 200 acres and the company was producing 76,000 cars with a workforce of 20,000. Austin's most popular pre-Second World War car was the famous Austin Seven, known as the 'Baby', which was introduced in 1922.

Wolseley continued to build cars after Austin had left but went bankrupt and was bought by Sir William Morris in 1927. Wolseley and Austin were effectively reunited in 1952 when Austin and Morris merged to form the British Motor Corporation, the biggest car company in Britain.

Also this year...

The world's first motorway opens, the six-mile Avus Autobahn in Berlin

Police patrols use motorbikes for the first time

Record numbers of people travel on the 50th anniversary of the August bank holiday; 'town full' notices are put up in Blackpool

US chemists discover that adding lead to petrol reduces knocking

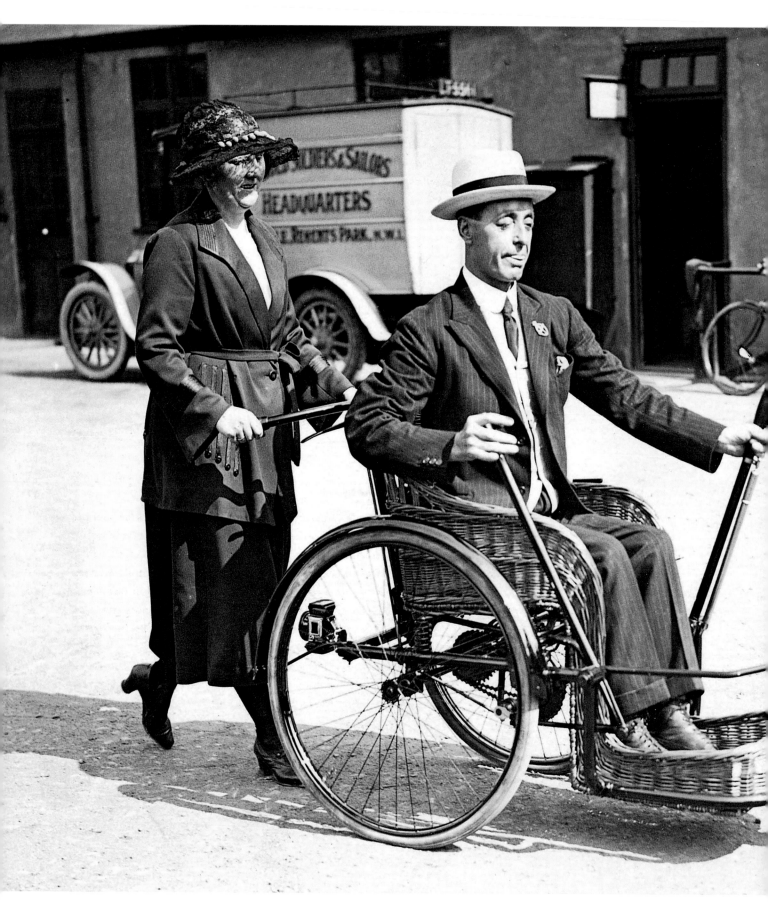

Esego

A disabled man at the controls of his *Esego* front steering wheelchair. This wheelchair was state of the art in 1922 and is described in the manufacturer's catalogue as an 'Invalid's Hand Tricycle, two speeds with Wicker Bath Chair Body'. It was propelled by backward and forward movements of the two levers in turn, but they could also be adapted to move together in parallel, giving a movement more akin to rowing. Steering was controlled by a slight twist of the right-hand lever. The chair also had a free-wheel mechanism so that it could coast downhill or be pushed by a friend or assistant without the levers continuously moving.

The catalogue for 1921–24 revels in the technical details of the tricycle: 'Ball-bearings are employed throughout, with best quality Hans-Renold ½ in. roller chain, securing absolutely smooth running. Very powerful double brakes are fitted, acting simultaneously on both side wheels, capable of applying any desired pressure, from a gentle retarding action to a rapid stop when descending steep gradients.' The model in the photograph was recommended for anyone who was able to lift their feet a few inches to get onto the footboard but for those who could not lift their feet there was a rear-steering *Esego* in which entry from the front was unobstructed.

The *Esego* was made by Carters (J. & A.) Ltd, who had been making wheelchairs since 1845. The company motto was 'The Alleviation of Human Pain', and in their catalogue Carters describe themselves as 'Surgical Engineers and Comfort Specialists, Member of the Distinguished Order of the Grand International Society of the Red Cross... the largest manufacturers in the world of invalid furniture and appliances, ambulances, etc'. Their telephone number was 1040 and the telegraphic address was "Bathchair. Wesdo. London." Four-figure telephone numbers, telegraphic addresses and wicker chairs may seem extremely dated but at the beginning of the 21st century the latest racing wheelchairs look more like this tricycle than the bulky four-wheeled chairs which are in general use. And the telegraphic address with its plethora of full stops looks very much like an e-mail address. Carters were also ahead of their time in using what is now a standard marketing ploy by corrupting the spelling of easy-go for the name of their chair.

Also this year...

Ford buys the Lincoln Motor Co.

The Civil Aviation Advisory Board is established

Queen Mary opens Waterloo Station

20 people die and 32 are injured *when a train carrying pilgrims to Lourdes crashes*

British polar explorer Sir Ernest Shackleton dies

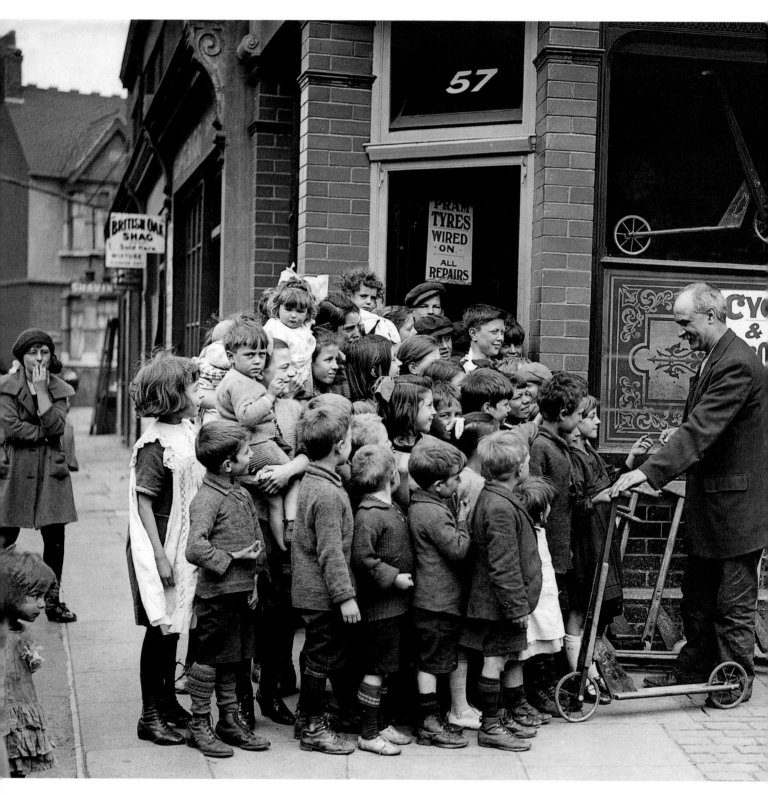

Plumb centre

Children queue on a street corner to hire scooters from Mr Plumb for a penny an hour. The scooter was one of the most successful and biggest selling toys from 1914 to 1920, and it was still very popular in 1923 judging by the enthusiastic crowd outside Mr Plumb's shop. It was designed in Britain and first patented in 1912 by C.E. Richardson and Co. of Sheffield, who called their version the 'Ska-cycle'. Other companies patented variations of the scooter from 1915 onwards under various names including skate cycle, ped-ska and ski cycle, but the new toy soon came to be generally known as a scooter, which is derived from an early 19th-century word for a small sculling boat which 'scooted' across the water.

The defining feature of a scooter was that it had a board between two wheels and an upright steering column, and it was driven by keeping one foot on the board and scooting along with the other foot. In this form it was one of the simplest machines imaginable and many children made their own scooters with pieces of wood and old brakes. One very popular model was a pedal-driven machine called the 'Auto-Scooter', which was advertised as not wearing out the soles of children's boots. During the 1920s the scooter gradually lost popularity to the new fashion of the 'juvenile cycle'; a 1944 catalogue of toys comments that 'it is more than probable that by this time the old type of scooter would have become almost a museum piece but for the present war which, by stopping the production of juvenile cycles, has led to a revival of the old type of foot-propelled scooter.'

After the Second World War, scooter frames progressed from wood to tubular metal, and at the end of the century they were even being built with tiny motors attached as a form of urban transport.

Also this year...

The first in-flight refuelling takes place, using two biplanes

Two Americans cross the US in a monoplane, flying 2,700 miles in 27 hours

The first 24-hour Le Mans Grand Prix is won by Frenchmen Lagache and Leonard

On 6 August American Henry

Sullivan swims the English Channel in 28 hours; six days later Argentinian Enrique Tirbocchi swims it in a record 16 hours, 33 minutes

The first transatlantic wireless broadcast to the US is made

US Astronaut Alan Shepard, the first American in space, is born

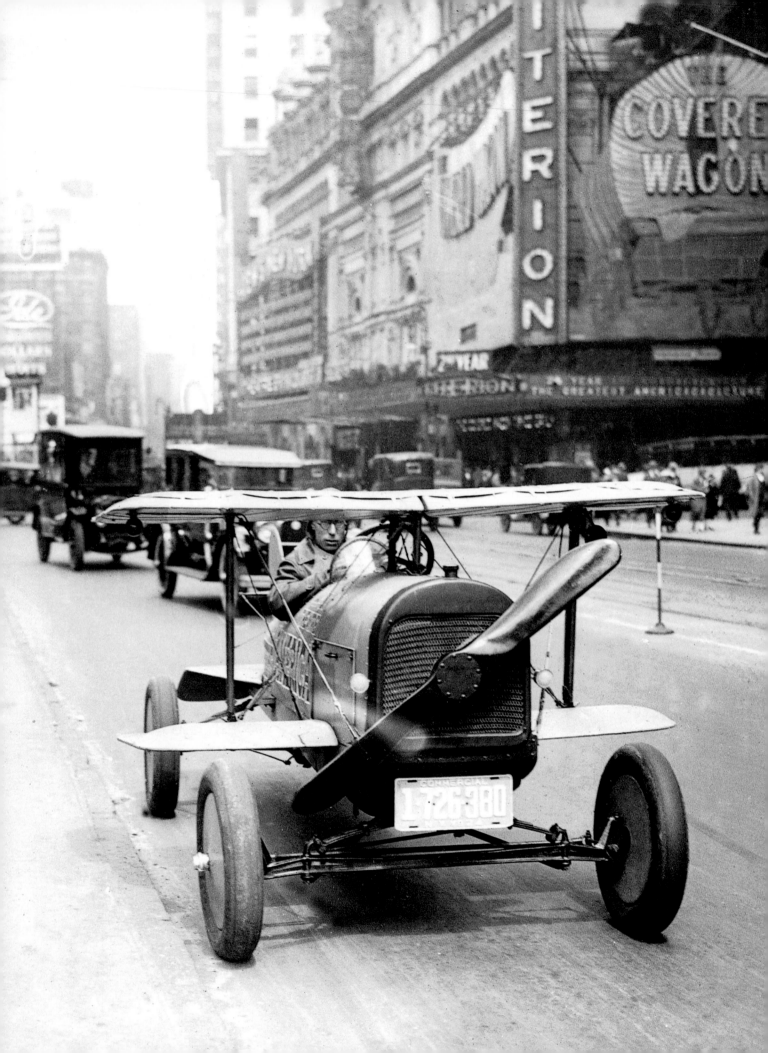

Auto pilot

A novelty car with wings and a propeller attached cruises round the American streets but it is doubtful that the idea will ever take off. Aeroplane design was moving on by 1924 but this car emulates the commonest planes of the day. Aircraft were already being built to a more recognizably modern design, with streamlined fuselages and cantilevered wings that were built out from the body of the plane with no need for extra wires or struts for support.

Aircraft propellers are derived from ships' propellers, or screws, which can be traced back to Archimedes; the propeller is an adaptation of the Archimedes Screw, an ancient device which raises water by turning a large-threaded screw inside an enclosed cylinder. Early steamships were propelled by paddle wheels mounted either at the stern or one at each side of the ship. There were many disadvantages to paddles, not least being the fact that when a ship rolled, one paddle would be lifted out of the water while the other was submerged, putting an uneven strain on the engine; the answer was to find a means of propulsion which stayed underwater. Several engineers are credited with the invention of the screw propeller, all of them between 1833 and 1836, but it was Englishman Francis Petit Smith who was awarded the patent. Marine engineers realized that the Archimedes principle could also be used to push water backwards, giving momentum to a boat or ship. They soon discovered that the length of the screw was irrelevant and then that only the tips of the thread were required, which is why propellers do not look much like the screws after which they are named.

The screw propeller is a remarkably efficient means of propulsion and was used by the Wright brothers in the very first aeroplane to make a powered flight. The Wright brothers borrowed another idea from ships, in that their propellers faced backwards and pushed the plane along; later aircraft used propellers mounted facing forwards which effectively pull the plane through the air.

Sadly for the driver of the car in the picture, however efficient his propeller is it is unlikely that he will take off with such short wings. He'll just have to wait for someone to invent the motorway flyover.

Also this year...

Imperial Airways, Britain's first national airline, is established with a fleet of 13 aircraft flying from Croydon

The secretary of the AA says that a rise in petrol prices to about 2s a gallon will cause an end to the motoring boom

Public vehicles are allowed into Hyde Park for the first time since 1636

The Harwich-Zeebrugge boat train goes into service

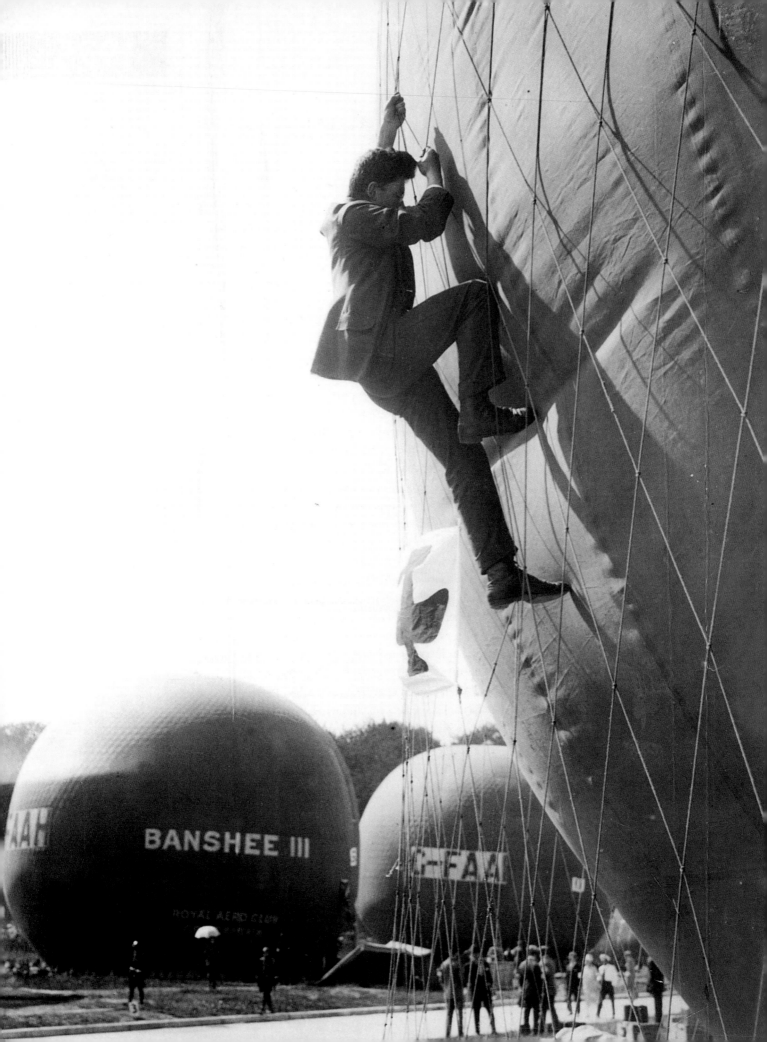

Gordon Bennett!

A competitor climbs up the side of his balloon to repair a damaged cord before the start of the 1925 Gordon Bennett balloon race. At the beginning of the century ballooning for pleasure had largely been a matter of individuals setting their own distance or endurance goals, but many balloonists wanted a more exciting and immediate challenge. Gordon Bennett provided it by setting up the first race under his name in 1906, providing a trophy and an annual cash prize. In fact it could be said that he invented the sport of balloon racing, and the International Gordon Bennett Balloon Race continues today, having been revived as an annual event in the US in 1979.

Bennett's father, James Gordon Bennett Senior, founded the *New York Herald* in 1835, which he edited until 1867, and where he pioneered many of the methods of modern journalism, including the use of foreign correspondents. His son, James Gordon Bennett Junior, was known to all simply as Gordon Bennett. He succeeded his father as editor of the *Herald* and he too proved to be a good journalist; it was Bennett who sent Henry Stanley to Africa to find Dr Livingstone. In the myths which subsequently built up around him, it was also said that he would embellish stories if necessary to make them more interesting, which is one of the supposed origins of the phrase 'Gordon Bennett' as an expression of disbelief; people would shake their heads at an unlikely sounding story and invoke his name as the probable author.

Not content with journalism, Bennett had a taste for the good life in London and Paris and spent most of the fortune which he and his father had built up in playing the playboy and promoting polar exploration, yachting and air and road races. Bennett's name is associated with several sports in Europe: he sponsored the Bennett Trophy for motor racing from 1900 to 1905, a trials course in the Isle of Man is named after him, the Gordon Bennett balloon races began in 1906, and he also gave a cup for powered air racing.

Another theory as to the use of his name as a catchphrase is that sometimes his behaviour was eccentric and boorish in the extreme. He is listed in the *Guinness Book of Records* under 'greatest engagement faux pas' for breaking off his engagement after arriving late and drunk at the family mansion of his fiancée and urinating in the fireplace in front of his prospective parents-in-law.

Also this year...

America's first freeway opens, the Bronx River Parkway in New York

The Ministry of Transport decides to paint white lines on Britain's roads in an attempt to reduce accidents

A new law introduces jail sentences for drink driving

Walter Chrysler founds the Chrysler Motor Company

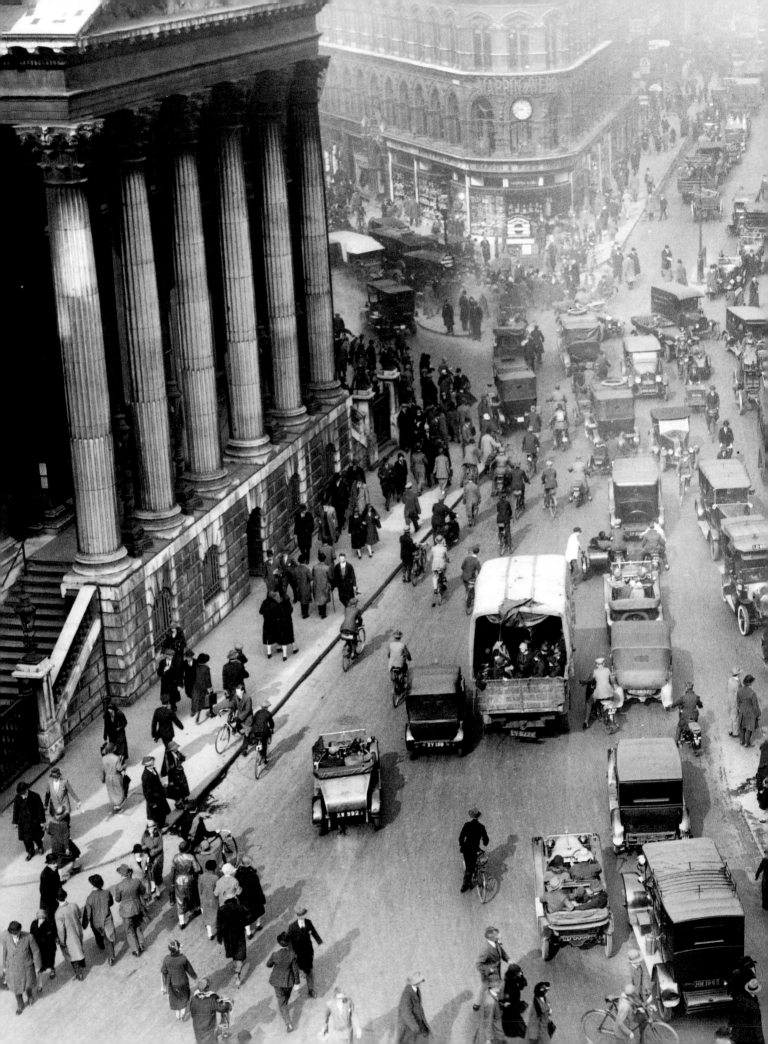

Sheer weight of traffic

Some things never change. This scene, apart from the type of vehicles involved, is familiar to all city drivers – the traffic jam. 'Jam' entered the language from America but the British had been experiencing traffic 'blocks' since long before the car was invented, particularly in London where even hundreds of years ago it could take an hour to cross London Bridge. To help alleviate the problem, a rule of the road was established whereby carts would keep to the left, a rule which isolates Britain from the rest of Europe to this day. In this traffic jam close to Mansion House in the City of London, traffic keeps to the left but there are no white lines, despite a Government decision the previous year to introduce them. A Ministry of Transport memo later in 1926 observed that white lines helped 'not only to reduce the number of accidents, but also to assist materially in the control of traffic by the Police.' Not much evidence of control here!

During the 1920s most private cars and motorbikes were used for pleasure, and the majority of people travelling to work did so on foot, by pushbike or by public transport. This is borne out by the crowded pavements, numerous pedal cycles and the open-topped bus and charabanc, both of which are filled with passengers.

Traffic in modern London moves at an average of 10 miles an hour, and a typical vehicle can expect to be stationary for a third of the time, figures which have not changed significantly since the age of the horse and cart. For a brief time when cars were introduced there was relative freedom for drivers, but car ownership rose from 8,000 in 1903 to 1 million in 1930, so by the time of this photograph that mythical Golden Age of stress-free city motoring was already over. By the end of the 20th century there were over 20 million private cars on the road.

Also this year...

Early in the year Alan Cobham flies a 16,000-mile return trip to Cape Town and in October lands his seaplane on the Thames after a 27,000-mile round-trip to Australia

German airline Lufthansa is founded

A French airliner bursts into flames over Kent, killing seven passengers

A one-way traffic system comes into operation at Hyde Park Corner and a circular traffic system at Piccadilly Circus

The Northern Line extension from Clapham to Morden opens; the 17-mile tube from Morden to East Finchley via Bank becomes the world's longest tunnel

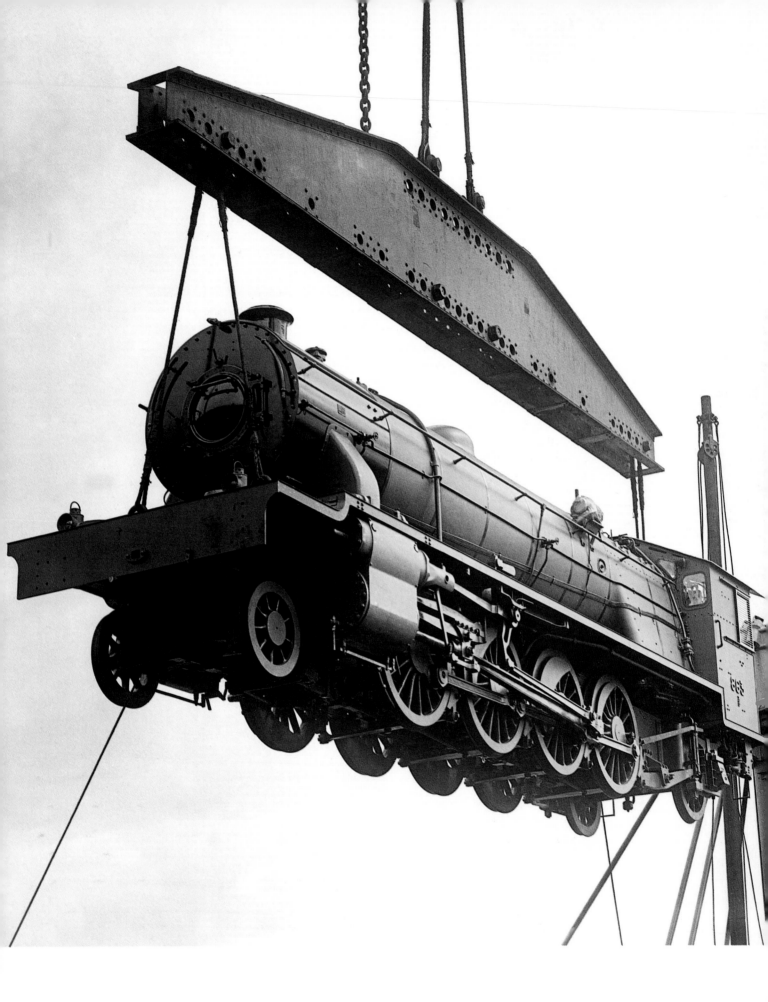

Empire building

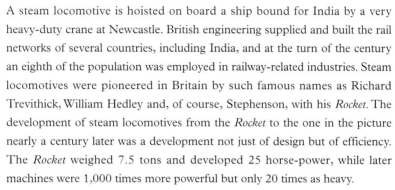

A steam locomotive is hoisted on board a ship bound for India by a very heavy-duty crane at Newcastle. British engineering supplied and built the rail networks of several countries, including India, and at the turn of the century an eighth of the population was employed in railway-related industries. Steam locomotives were pioneered in Britain by such famous names as Richard Trevithick, William Hedley and, of course, Stephenson, with his *Rocket*. The development of steam locomotives from the *Rocket* to the one in the picture nearly a century later was a development not just of design but of efficiency. The *Rocket* weighed 7.5 tons and developed 25 horse-power, while later machines were 1,000 times more powerful but only 20 times as heavy.

The word locomotive means 'to move from place to place' and distinguished the vehicles which pulled trains from stationary steam engines. Richard Trevithick demonstrated the world's first steam locomotive when he hauled 10 tons of iron and 70 men a distance of 9.5 miles on the Penydarren ironworks railway in South Wales at a stately 5mph. It was William Hedley who demonstrated that the grip between the smooth rails and smooth iron wheels would be sufficient to allow a locomotive to pull loaded wagons up a gradient, and Stephenson's *Rocket* which opened the way for passenger travel.

Stephenson's *Rocket* was described as 0-2-2, while the locomotive in the photograph is 2-8-2. There is a meaning to these numbers, which describe the locomotives by a system of wheel notation devised by the engineer F.M. Whyte of the New York Central Railroad. He proposed enumerating the leading wheels, coupled driving wheels, and trailing wheels under the engine from front to back. The locomotive in the picture has a pair of small leading wheels, eight larger coupled wheels driven by pistons linked to the engine, and a pair of smaller trailing wheels: 2-8-2.

Also this year...

Captain Charles Lindbergh achieves the first solo transatlantic flight, non-stop from New York to Paris, in his plane the Spirit of St Louis

In February Malcolm Campbell breaks the world land speed record for the third time, setting a new record of 174.22mph in his car Bluebird; *in March Henry Seagrave increases the record to 203.84mph*

The first scheduled London-Delhi flight arrives in India after a 63-hour flight

Morris Motors buys Wolseley Motors for £730,000

Petrol prices drop to 1s.4½d a gallon; in August they are cut again to 1s.1d, the lowest price since 1902

New regulations limit the length of cars in Britain to 27 feet, 6 inches

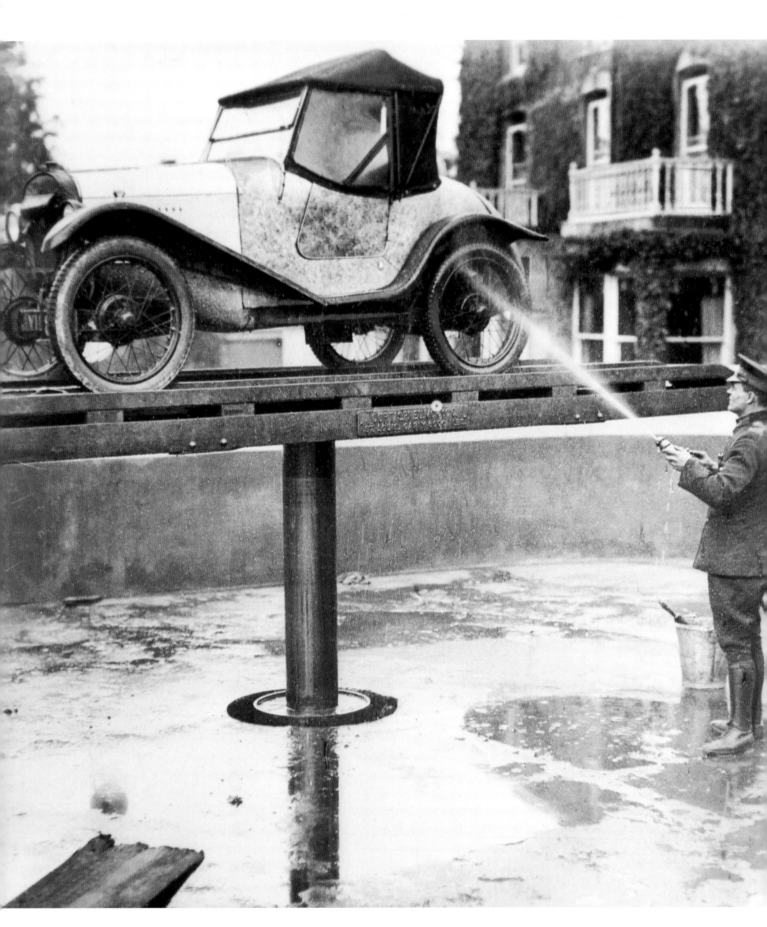

Rising damp

A car being cleaned on a new hydraulic hoist at Gatton Point service station on the Brighton Road. Modern motorists take garages and service stations for granted but, like the car, they have only evolved since the turn of the century. Early motorists had to plan their journeys very carefully: they had to buy their fuel at an ironmongers or an oil shop, remember to carry extra with them, and be capable of repairing the car should it break down. If the car couldn't be repaired at the roadside then the motorist had to suffer the indignity of being towed by horse to the nearest place with the necessary equipment to help, which was often a cycle shop.

Other businesses offering help were listed in the first AA Handbook of 1908 and included ironmongers, coachbuilders, gunsmiths, electricians, iron founders and engineering firms. A name was needed to describe this new trade and the services it offered, and the first use of the word garage is claimed by Frank Morris of King's Lynn. *Garage* was a French word for the wide part of a canal in which barges could pass each other; it was later used by the French railways to describe train sheds, then as a French motoring term and from there it passed into English. During the 1920s garages and filling stations appeared all over the country, built by the AA, the oil companies and enterprising businessmen. So many were built that by the end of the 1920s legislation had to be passed giving local authorities the power to license them and dictate their design.

Early garages combined several functions as sales points, repair shops and filling stations. With the onset of mass car production after the First World War, many garages agreed to sell only one make of car and became exclusive dealers, while others concentrated on repairs or servicing, and yet others operated purely as filling stations. The commonest repairs were to punctures caused by rough roads and nails from horseshoes, and the most frequent requirement for servicing was greasing the car. The smaller garages did this using an inspection pit but one of the great innovations of the late 1920s was the hydraulic car hoist. Gatton Point service station was one of the first to make use of this newly available device which, with a high-pressure hose, made the job of cleaning and greasing the car much less onerous.

Also this year...

The Flying Scotsman makes the first non-stop journey from London to Edinburgh

Amelia Earhart becomes the first woman to fly the Atlantic

Piccadilly Circus tube station opens

The Prince of Wales opens Britain's longest road bridge, the Royal Tweed Bridge

Figures show that an average of 14 people a day died in road accidents in Britain

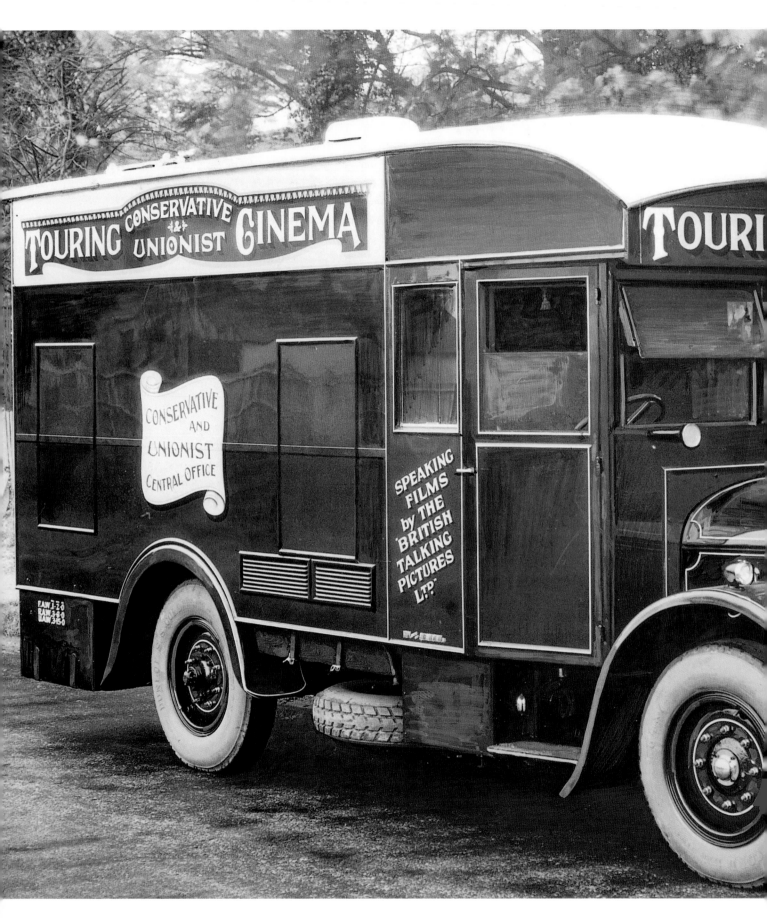

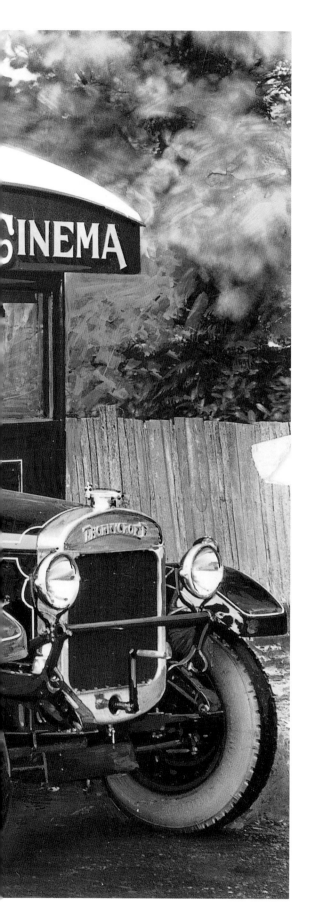

Reels on wheels

The Conservative and Unionist Touring Cinema travelled around the country showing free films to the people but there was a catch: it was part of the Conservative party propaganda machine. Daylight cinema vans such as this one were first used for publicity by the Conservatives in 1926. In a sense they were a precursor of the modern Battle Bus, and the films can be seen as an early form of party political broadcast; they were pitched at various levels ranging from a cartoon pastiche of Labour policies to rousing speeches by Tory politicians.

The most visible signs of the progress of the 'new conservatism' of Stanley Baldwin were to be seen in the party's publicity and propaganda, which was way ahead of the efforts of the other parties. Publicity in the 1920s involved techniques not available before the war, and Baldwin made the most of them. The party's Principal Agent was sacked because he was 'ignorant of the possibilities of new forms of propaganda' and replaced with someone more au fait with the new media, which included radio and film.

The Conservative party was very quick to adopt the use of film, which reached a wider audience than public meetings and had a more immediate impact than the written word. Commercial cinema was not open to direct propaganda, so the party decided to use its own mobile cinemas. This was a very expensive exercise but it paid dividends; by travelling around the country the films could be shown to an extremely wide audience, and the Touring Cinema would often play to 2,000 people a day in towns. Once parked, the rear panel of the van opened out to reveal a screen set back within the body of the truck where it was protected from direct sunlight. The Conservatives had one van in 1926 and it was such a success that there were 10 in operation by 1928 and 22 by the time of the 1931 election, at a cost of over £13,000 each. In their understanding of the power of the media and the adoption of radio and film, the Conservatives were the least conservative of all the parties.

Also this year...

The RAF makes the first non-stop flight from Britain to India

The airship Graf Zeppelin *flies round the world in 21 days*

The Flying Squad is issued with high performance cars linked by radio to Scotland Yard

Traffic lights are standardized in Britain; a trial in Oxford Street allows traffic to keep up an average speed of 10mph

Britain's new airship, the R101, makes her maiden voyage; passengers are amazed that they can hear the sound of car horns and trains from the ground below

The first in-flight movie is shown, on a Universal Air Lines flight from St Paul to Chicago

It is announced in London that all buses will be red, after trials with yellow-and-red buses prove unpopular

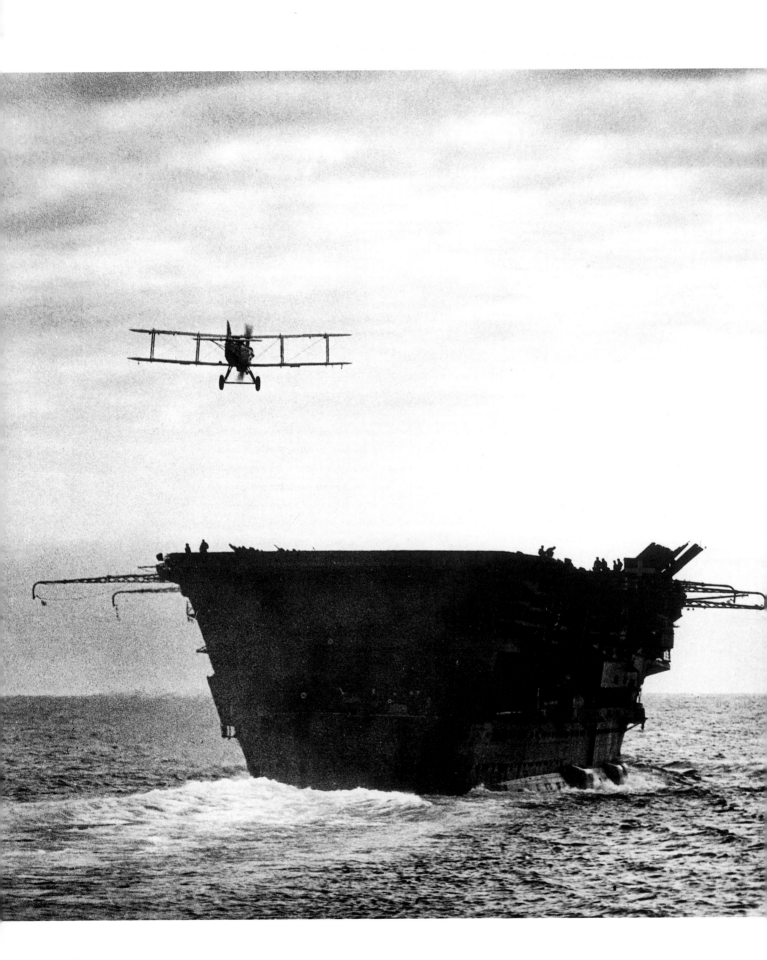

Light she was and like a fairy...

A Fairey III biplane lands on HMS *Furious*, one of the first true aircraft carriers. There had been various early versions of aircraft carriers, including one during the American Civil War – in 1861 a specially adapted barge was used for launching and towing hot air balloons. This photograph shows the *Furious* after she had been rebuilt as a 'flush-deck' aircraft carrier following a period of service as a conventional warship with a short flight deck built over the forecastle.

Throughout the First World War, planes were often flown from specially adapted ships but rarely landed on them. HMS *Furious* made history in 1917 when Squadron Commander E.H. Dunning 'side-slipped' his Sopwith Pup onto the short flight deck while the ship was steaming at 26 knots, thus making the first landing of an aeroplane on a moving ship. The landing was carried out with the assistance of the ship's crew, who grabbed the tail of Dunning's plane to help slow it down. Sadly, Dunning was killed five days later attempting to repeat the landing, when his aircraft stalled and he was blown over the side, but his pioneering spirit proved that it was possible to land on a moving ship, and the Royal Navy went on to perfect the concept.

The value of aircraft carriers was plain to see but regular take-offs and landings did not become a success until ships were built with an unobstructed deck over their entire length. Two types of ship emerged: 'flush-deck' and 'island' carriers. The latter had the superstructure offset to one side while the former, like HMS *Furious*, had no superstructure at all. This was achieved by having a bridge which was hydraulically raised and lowered, with a funnel discharging boiler smoke and gases over the stern. Having played such a pioneering role in the use of aircraft at sea, HMS *Furious* was rebuilt as a flush-deck carrier and re-entered service in 1925 in the form seen in this photograph.

Also this year...

Amy Johnson becomes the first woman to make a solo flight from Britain to Australia, taking 19 days to complete the trip

Mahatma Gandhi completes a 300-mile protest walk against the Salt Law in India and is later arrested

The Highway Code is issued

R101 airship crashes in France en route to India, killing over 40 people

Frank Whittle patents the jet engine but it does not fly until 1941

The Road Traffic Act abolishes the 20mph limit and makes third party insurance compulsory

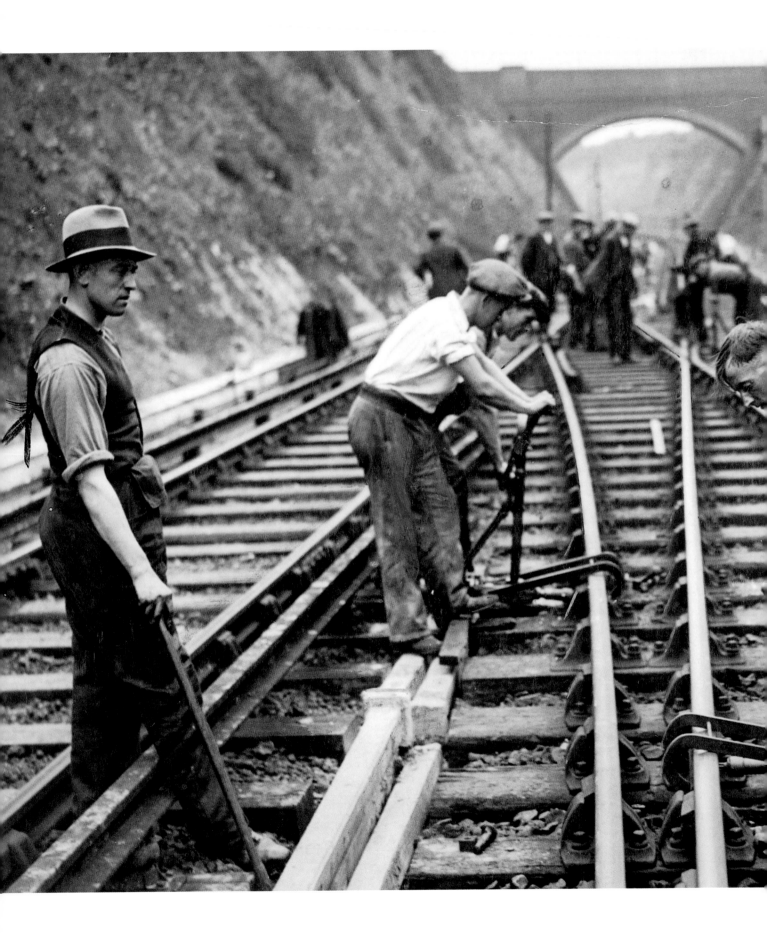

Brighton Line electrification

Railway workers laying the conductor rails for the electrification of the London to Brighton line. Brighton's popularity had peaked in 1836, when there had been 16 daily coach services from London, taking an average of 5½ hours to complete the journey. By the time the London & Brighton Railway opened in 1841 the town was becoming less fashionable but within 10 years the railway had reversed the trend. Not only did the railway revive the town's fortunes by bringing crowds of visitors from London in less than half the time but many more people began to live in Brighton and travel to London to work.

There had been small-scale local electric railways in Britain from as early as 1883 but it wasn't until 1903 that the first steam railway was converted to run on electricity. The London Brighton & South Coast Railway began electrifying its suburban lines in 1909 with the ultimate intention of electrifying the main line to Brighton but the First World War got in the way. The 'Brighton' was amalgamated into the Southern Railway at its formation in 1923, the smallest of the 'Big Four' new railway companies but the first to embrace electrification. General Manager Sir Herbert Walker saw the advantages of electricity when the other railways put their faith in steam, and he implemented a 'rolling programme' of electrification under which teams of labourers were continuously employed from 1923 until 1939. By 1931, 293 route miles had been electrified, covering the whole of the suburban system and part of the London to Brighton line.

The line to Brighton was operating electric trains by 1933, providing a much better passenger service, and in the meantime the trains themselves were being improved. Buffet cars and luxury Pullman cars were available on most electric routes, and the *Brighton Belle* was unique in being an all-Pullman electric train. Even today the London to Brighton line carries an enormous number of commuters, holidaymakers and day trippers to the town which is known as 'London by the sea'.

Also this year…

Malcolm Campbell reclaims the world land speed record, at 245mph

Traffic 'rationalization' on Oxford Street bans horses and slow vehicles, prohibits turning round or waiting, and introduces automatic signals; it is reported that traffic lights speed up rush hour traffic by 90%

The Road Traffic Act comes into force, introducing traffic police and compulsory third-party insurance

Imperial Airways starts a new route connecting London with central Africa

Rolls-Royce buys Bentley

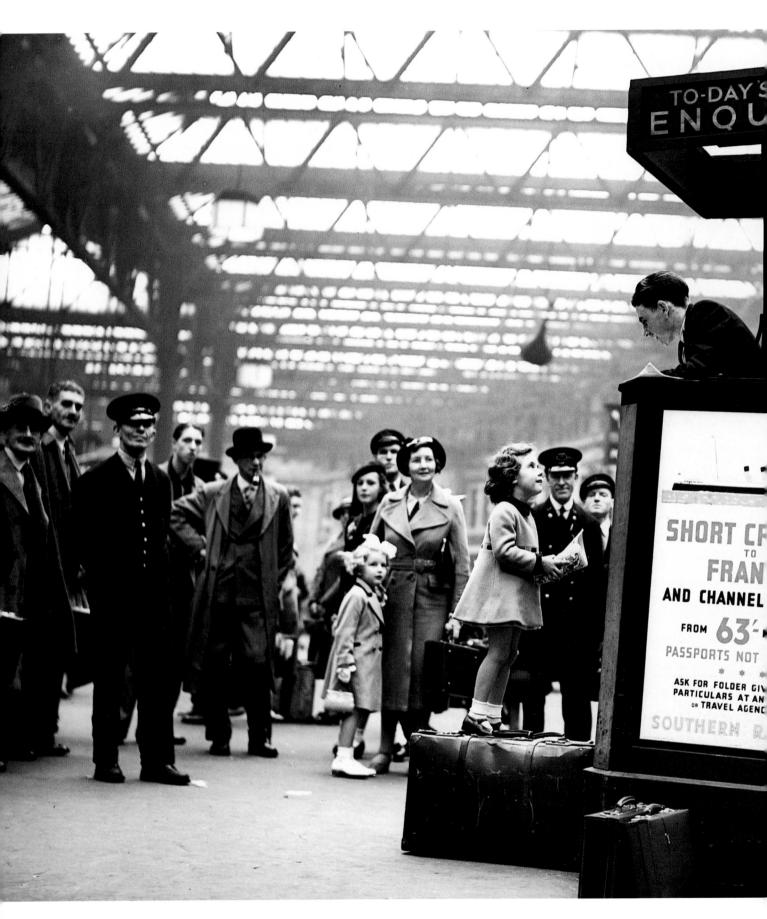

The railway children

Holiday scenes at the Southern Railway's enquiries stand at Waterloo Station, London. But holidays, even short cruises to France, were not for everyone. Towards the end of the 19th century the wealthy had begun to see foreign travel as a pleasurable activity in itself, rather than being a means of learning or self-improvement. Rail travel boomed, particularly after Queen Victoria had made it respectable by her willingness, after an initial hesitancy, to travel by train. Glamorous trains such as the *Blue Train* and the *Golden Arrow* became *de rigueur* for the moneyed classes with plenty of leisure time, promising to allow passengers to 'sleep your way from the city's fog to the Riviera sunshine'.

After the war people began to travel around Europe far more, train ferries were introduced, and the percentage of first class travellers was dropping. However, despite the increase in the numbers travelling, one 1930s holiday-maker wrote: 'If you were very rich you could go to Bournemouth. We never thought of going to places like Spain or Portugal. The only time we heard about such places was when there was a war on.' It wasn't until 1938 that the Holidays With Pay Act was passed, which would have allowed the masses to begin travelling abroad were it not for war breaking out the following year.

At its formation in 1923, the Southern Railway had inherited the all-Pullman luxury *Golden Arrow*, a continental boat train with its own fast steamer connection. The Southern also developed the other shipping services which it had inherited, and, after replacing ships lost on war duty, by 1931 the railway owned and operated 44 cross-channel ferries and 12 to the Isle of Wight. After parliament rejected a Channel Tunnel proposal in 1930, the Southern Railway built special train ferry ships in association with the Nord Railway in France. These ships carried freight as well as the new Night Ferry service, which together with the *Golden Arrow* succeeded for a while in staving off competition from the new airlines.

Also this year...

The Sydney Harbour Bridge opens

Amelia Earhart becomes the first woman to fly solo across the Atlantic

The Automobile Club of America is to be dissolved, a victim of the Depression

The House of Lords approves the Motor Traffic Bill, which makes drivers who kill guilty of manslaughter

Imperial Airways begins a regular service between London and Cape Town

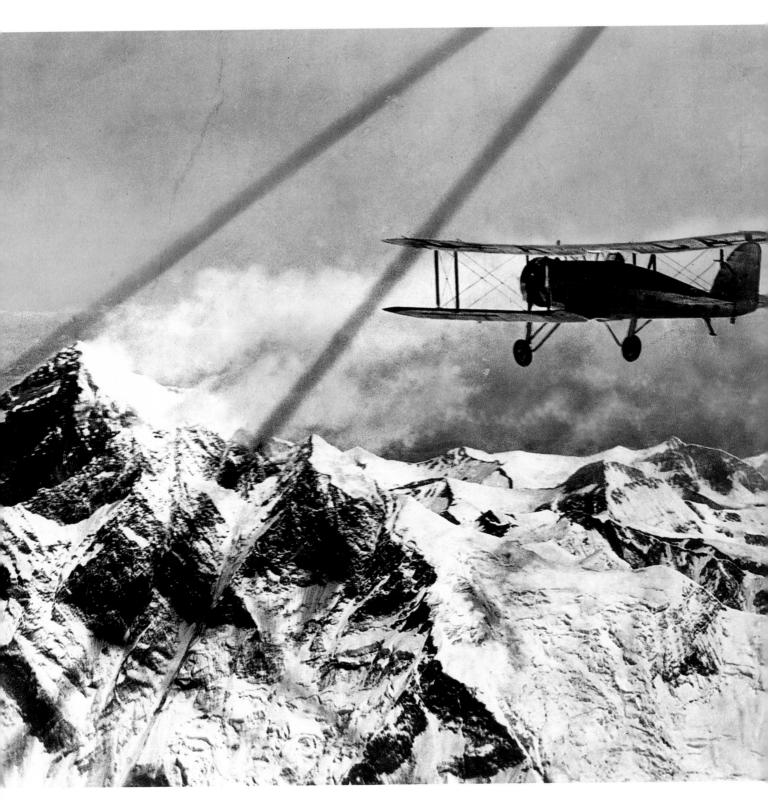

Feeling on top of the world

It was to be another 20 years before Edmund Hillary and Tenzing Norgay would stand on the summit of Everest, but in 1933 four Britons in two Westland biplanes made the first ever flight over the mountain as part of the Houston Mount Everest Expedition. This view is looking down from 34,000 feet at the south face and summit of Everest, and was taken by Colonel Stewart Blacker from the enclosed rear cabin of one of the planes; both pilots sat in open cockpits. The lines across the photograph are the wire stays of the plane in which Blacker was flying.

Mount Everest was named after Sir George Everest, a surveyor-general of India, and is known in Nepali as Sagarmatha; in 1952 China claimed Everest and banned other names in favour of the Chinese Qomolangma Feng, meaning Goddess Mother of the World. The 29,000-foot mountain was finally conquered by human climbers at 11.30a.m. on 29 May, 1953, the day before the coronation of Elizabeth II. Hillary described the top of the world as 'a symmetrical, beautiful snow-cone summit', which can be appreciated in this photograph but is very different from the harsh rocky ridge seen from below. Hillary and Norgay spent 15 minutes at the summit, eating the obligatory mint cake, before leaving the flags of the United Kingdom, the United Nations and Nepal, as well as a Buddhist offering from Tenzing. Edmund Hillary and expedition leader John Hunt were knighted less than a week later for their achievement.

Also this year...

The Boeing 247 becomes the first modern-style airliner

Traffic lights are now being installed in London at the rate of one set a day

Sir Malcolm Cambell sets yet another land speed record, this time reaching 272mph

Richmond, Chiswick and Hampton Court bridges all open in July

Air France is created

Sir Frederick Henry Royce, co-founder of Rolls-Royce, dies

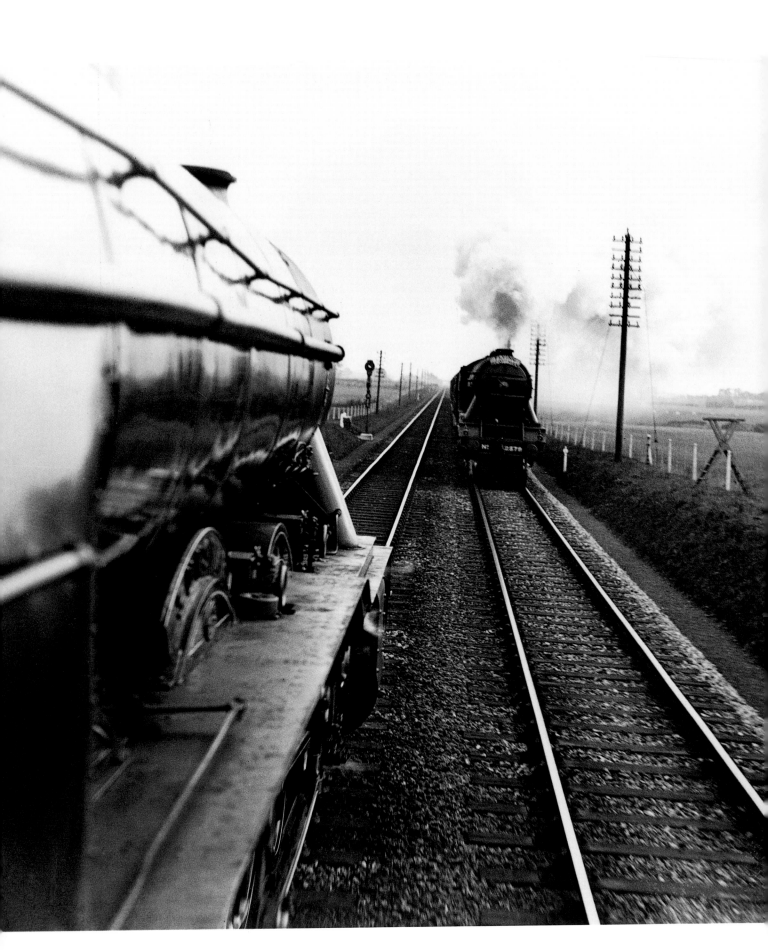

Flying Scotsman

Two Flying Scotsmans approach each other at high speed; this photograph is taken from the footplate of the southbound train out of Edinburgh as it is about to meet the train heading north from King's Cross. Unlike the legendary *Mallard*, which was the name of an individual train, the Flying Scotsman was a generic name given to a service operated by the Great Northern Railway between London and Edinburgh. *Flying Scotsman* was also the name given to a locomotive designed by Sir Nigel Gresley and built in 1923 for the route. Gresley's *Flying Scotsman* made the first non-stop journey from London to Edinburgh in 1928 and, on 30 November, 1934, reached 100mph and set a new record average speed of 97.5mph between London and Leeds.

From the beginning of the railways speed had always been the big advantage of the train over other forms of travel. The quest for speed was halted by the First World War but the 1920s saw a renewed momentum; in 1923 the Cheltenham to Paddington express became the fastest train in Britain and was dubbed the 'Cheltenham Flyer'. The 1930s were known as the 'streamline' era, which many railways exploited for publicity with speed records frequently being set and broken. The *Flying Scotsman*'s record came in 1934, and in 1935 the London & North Eastern introduced a train known as the *Silver Jubilee* which was due to run at 70mph but on its press run managed a record 112mph. Not to be outdone, the London Midland & Scottish set a new record of 113mph in 1937 with the first of the Princess Coronation class, and then in 1938 the LNER took the record back when *Mallard* reached 126mph, which is still a world record for a steam train.

Also this year...

Yuri Gagarin is born. He was to become the first man to travel in space

Yorkshireman Percy Shaw patents the Catseye road stud

Pedestrian crossings are introduced in London

Road signs are standardized

Cunard-White Star launches the Queen Mary

Austin launches a two-seater version of the Austin Seven

The Queen Mary *is launched on Clydebank*

Return rail fares are cut by 1d a mile

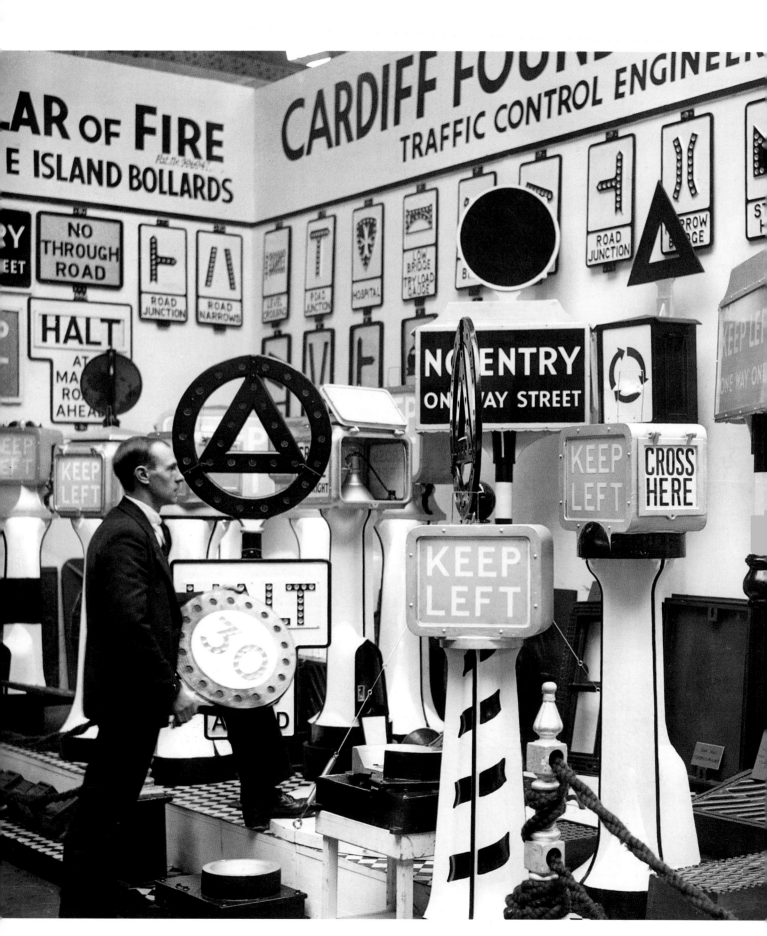

A sign of the times

Street and traffic signs today are taken for granted but in the 1930s they were a new phenomenon and created enough interest to warrant their own exhibition. This is not a museum but the opening day of the Public Works, Roads and Transport Exhibition at the Agricultural Hall in Islington in 1935. The Road Traffic Act, which came into force in January 1931, heralded sweeping changes in the nature of motoring. The 20mph speed limit was abolished and the Act also introduced specialized traffic police and made third-party insurance compulsory. White lines had been introduced in 1925 but were not yet common, traffic lights were in their infancy and the first pedestrian crossings appeared in 1934.

Road signs were only introduced as a general rule during the 1930s, and were standardized in 1934; before then drivers had to rely on the signs provided by the AA. In 1906 the AA began to erect distinctive yellow and black village nameplates – these showed the AA badge with the name of the village across the middle, the distance from London, and the distance from the next villages in each direction. More than 35,000 of these signs were put up but most of them were removed during the Second World War to confuse the enemy in the event of an invasion. In the same year the AA also carried out a series of road surveys and began to put up Danger and Warning signs, marking sharp corners, level crossings, narrow bridges, steep hills and school exits. In the early 1930s signposting became the responsibility of local authorities and the AA stepped aside, although they still provide information signs to this day.

The photograph of the exhibition shows some of the new standardized signs, which look very quaint to modern eyes, with their rectangular borders and explanations written below the various symbols. Many of the actual symbols are still in use today, although the signs have been modernized with specific shapes and colours to help instant recognition. Warning signs are now mostly triangular with a red border, while signs giving orders are mostly circular, with red borders for the prohibitive signs and blue backgrounds for instructions. Modern signs are depicted in the Highway Code, and learning their meaning is an essential part of the driving test, which became compulsory in 1935.

Also this year...

World's first parking meter comes into service in Oklahoma City

A 30mph speed limit comes into force in built-up areas

Driving tests become compulsory in Britain

Sir Malcolm Campbell becomes the first motorist to exceed 300mph, at Bonneville Salt Flats, Utah

The Moscow underground railway opens

French car manufacturer Andre Citroën dies

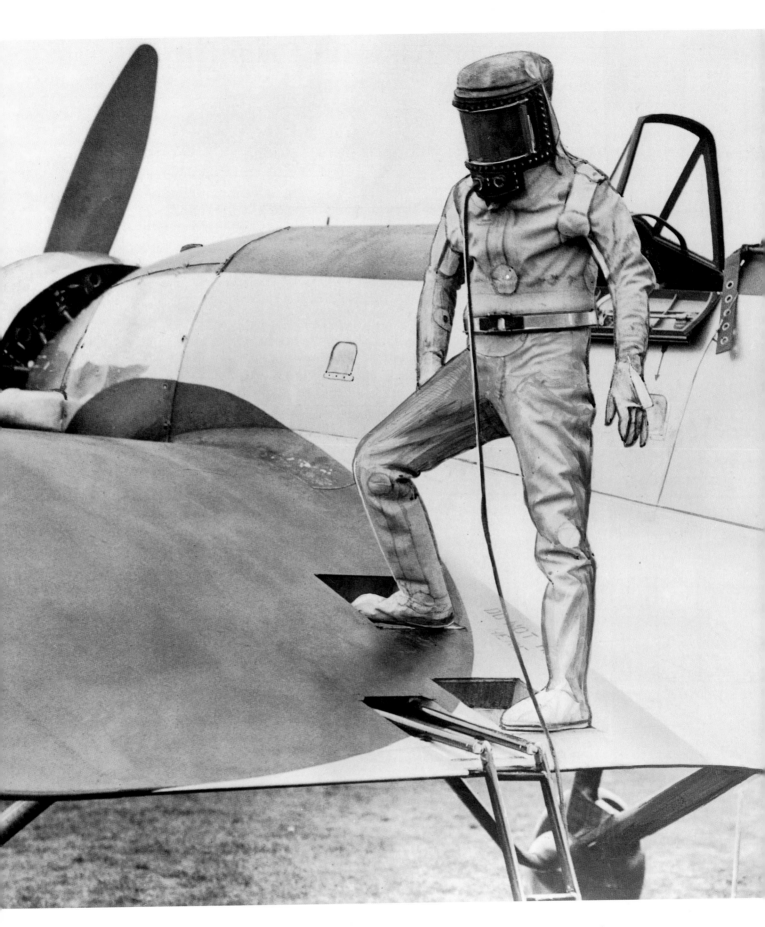

High as a kite

Not Flash Gordon but Squadron Leader F.R.D. Swain, stepping up into the cockpit of his Bristol 138 low wing monoplane prior to his attempt at the world altitude record. Just as the quest for speed in motor racing eventually leads to improvements in road cars, so the pursuit of goals such as high altitude flying led to improvements in passenger travel. Pressure suits like the one worn here by Sqn Ldr Swain had been developed for high altitude flights by Wiley Post in America and led eventually to pressurized cabins in jet airliners.

Wiley Post was born in 1900 and in the early 1920s toured America as a mechanic, stunt parachutist and wing-walker; he learned to fly in 1924. His most famous achievements were two round-the-world flights in a Lockheed Vega called *Winnie Mae*; he also pioneered the development of the pressure suit during high altitude flights in the same plane. He was killed in an air crash in Alaska in 1935. It was Lockheed who made the pressurized cabin fully efficient, and in May 1937 a Lockheed XC-35 made the first flight using the new cabin. Since then Lockheed have gone on to build the world's most famous high altitude planes, including the first stealth bomber, the SR-71 *Blackbird* and the U-2 spy plane. The U-2 was nicknamed the *Dragon Lady* and was developed in great secrecy at Lockheed Martin's 'Skunk Works' to operate at 80,000 feet. The *Blackbird* could operate at 85,000 feet and was built almost entirely of titanium and stainless steel to cope with high temperatures generated at its top speed of Mach 3.35.

Just two years after men like Swain were going aloft in pressure suits, and only 18 months after Lockheed's pioneering flight, a prototype Boeing 307 became the first airliner to fly using a pressurized cabin. It eventually went into service in April 1940, when the pressurized cabin allowed it to fly above the worst of the weather, making passenger air travel a much more comfortable experience.

Also this year...

The first practical helicopter is demonstrated in Germany

Gatwick airport opens

Hitler launches his 'people's car', opening the first Volkswagen factory in Saxony; a prototype Volkswagen Beetle is built, designed by Ferdinand Porsche

The Spitfire goes on show for the first time, built by Vickers and powered by a Rolls-Royce engine

The Queen Mary *leaves Southampton on her maiden voyage*

A new Night Train ferry is established between Dover and Dunkirk. Passengers do not have to leave their sleeping cars

Louis Blériot dies

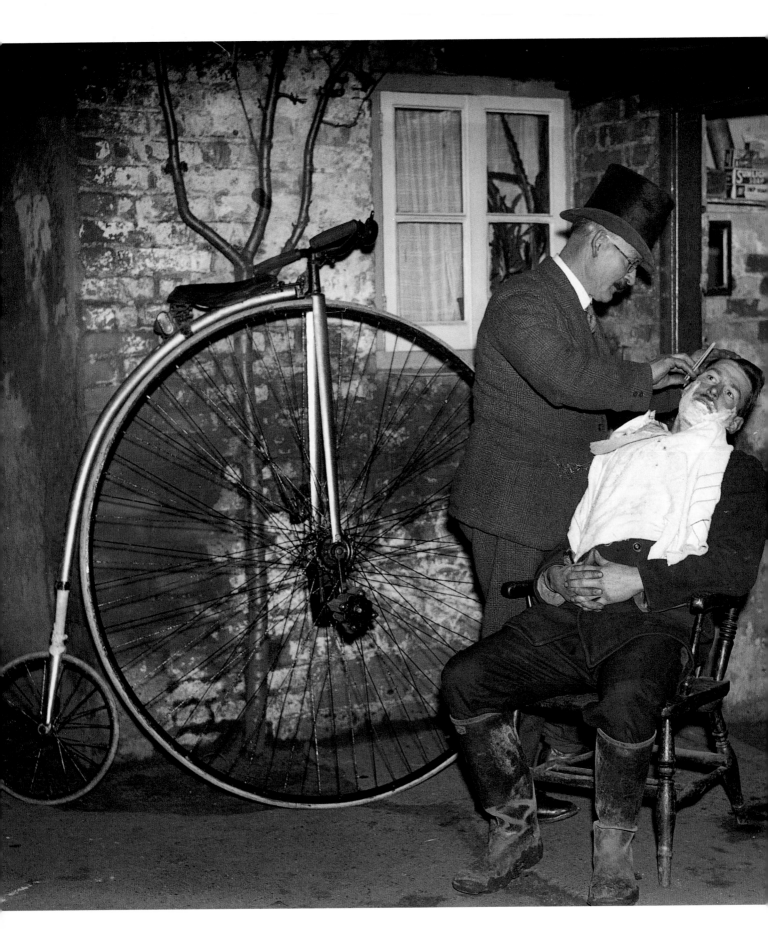

No ordinary barber

Mr Dietrich was something of an eccentric, travelling around on a bicycle which had already been obsolete for a good 40 years in order to shave people or cut their hair. A travelling barber was no doubt a good idea, allowing people to use his services in the comfort of their own home; or outside it in this case. But his choice of transport was not so modern – the Penny-Farthing, or 'Ordinary', having been invented a full 67 years earlier.

Bicycles evolved over a long period of time but it is perhaps surprising, given that the wheel has been in use for over seven thousand years, that they did not evolve sooner. It was not until 1818 that the precursor of the modern bike appeared. It was a two-wheeled wooden frame known variously as a 'Hobby-horse' or 'Draisienne' after its inventor, the Baron von Drais. The rider leaned forward across a padded support and propelled the machine forward by simply taking huge strides as the wheels turned. This was an important step forward because it proved that a human being mounted on two wheels could keep their balance so long as they were moving. Some 45 years later Pierre Michaux was repairing a Hobby-horse for a customer when he fitted cranks to the front wheel to see if it could be driven by pedals. Finding that it could, he set up a very successful business building machines which he called Velocipedes but which were soon nicknamed 'Boneshakers'.

The Penny-Farthing was invented in England by a Coventry sewing-machine manufacturer called James Starley. He had bought a Boneshaker and, realizing the potential of such transport, set up his own bicycle business. He produced an improved version of the Boneshaker and then, in 1870, he produced what he called the Ariel. Starley had realized that the distance travelled for each revolution of the pedals, which at that stage were fixed directly to the wheel hub, depended on the size of the front wheel: by making the front wheel bigger, his bike would go further for each turn of the pedals, making it possible to go much faster. In order to keep the bike short and to make it possible to mount, the back wheel had to remain small, and so the Penny-Farthing was born, and named after the coinage of the day: the large penny-piece at the front and the small farthing behind.

Also this year...

Sir Billy Butlin opens his first holiday camp, at Skegness

Horse-drawn traffic is banned from most of London's West End

Autopilot is developed in aircraft to the point where the first landing is *made using automatics only*

Frank Whittle demonstrates the first jet aircraft engine, at this stage still mounted on a test bench

The first London Motor Show opens at Earl's Court

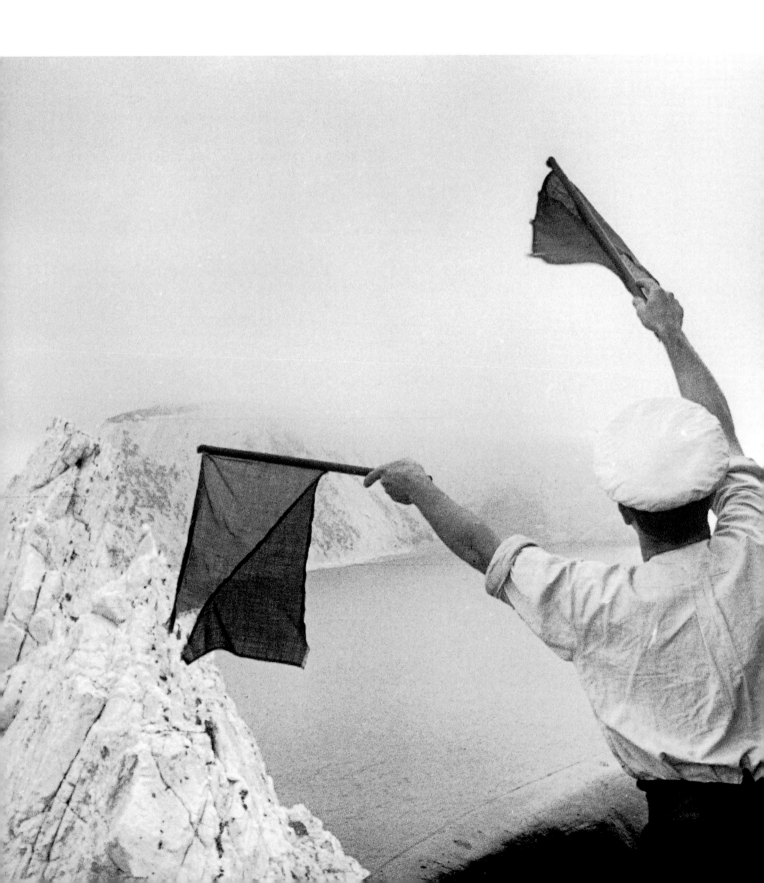

To the lighthouse

A lighthouse-keeper signals to the shore with semaphore flags from the Needles lighthouse off the coast of the Isle of Wight; 60 years later the last of Britain's 210 major lighthouses was automated and the profession of lighthouse keeper was obsolete. For centuries lighthouses have been used to protect maritime travellers and without doubt the most famous was the lighthouse on the island of Pharos at Alexandria, one of the Seven Wonders of the Ancient World. The word pharos has passed into many languages as a signifier for light, or lighthouse, crossing the usual linguistic boundaries for root words, and the study of lighthouses is known as pharology.

Britain's most famous lighthouse keeper is usually remembered for the daring rescue he carried out with his daughter, Grace Darling. The two of them rescued a group of travellers from the steamship *Forfarshire*, which foundered off the Farne Islands close to the Longstone Light where William Darling was lighthouse keeper. Nine passengers struggled onto a reef, from which they were saved by the Darlings who left the safety of the lighthouse to row out to them in an open boat.

The problem of building 'rock lighthouses' off the coast was largely overcome by one family, the Stevensons, although they are more often remembered for the writing of Robert Louis, author of *Kidnapped* and *Treasure Island*. The Stevenson family built almost every one of Scotland's lighthouses, made advances in both optics and construction, and achieved feats of engineering in conditions which would be forbidding even today. In four generations not one of them took out a patent on their inventions, believing they were for the good of the nation and unworthy of private gain or personal celebration. Robert Louis Stevenson wrote of his family's achievements for sea travellers that, 'I might write books till 1900 and not serve humanity so well.'

Also this year...

The Boeing 307 becomes the first airliner with a pressurized cabin, allowing it to fly above the worst of the weather

A jet engine is test-flown attached underneath a conventional plane, effectively the first ever flight by a jet-powered plane

Howard Hughes gets a ticker-tape welcome in New York after setting a new record of 3 days, 19 hours for flying round the world

The Holidays With Pay Act comes into force, allowing more people to travel at home and abroad

Mallard sets a new speed record for steam trains, achieving 126mph

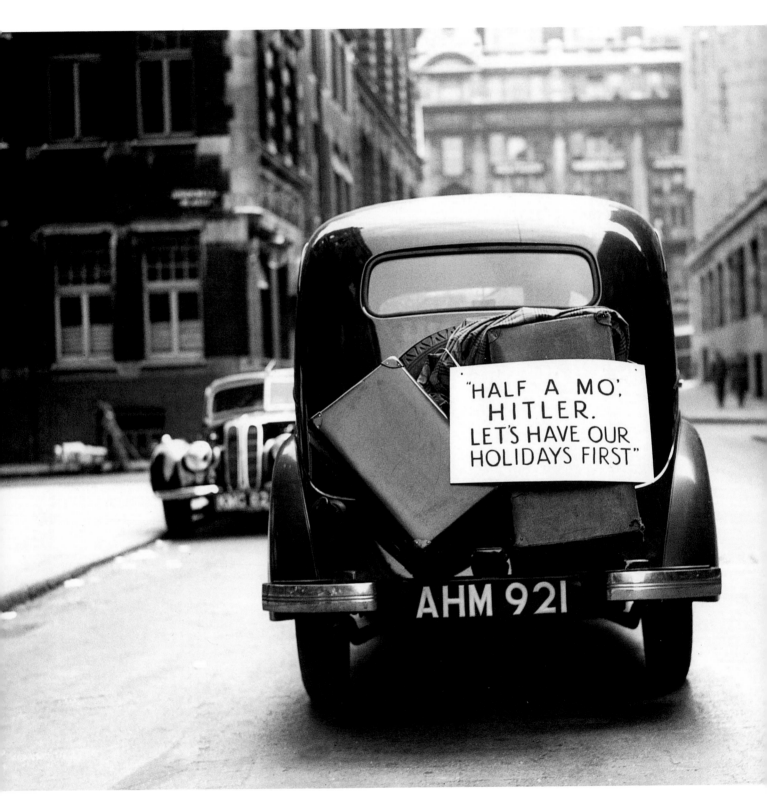

Half a mo' Hitler

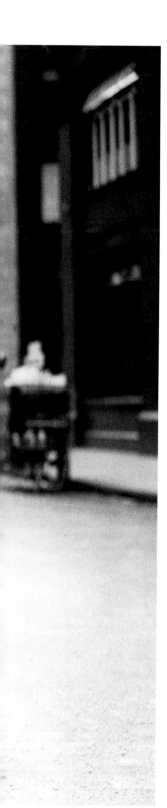

This photograph was taken on 28 August, 1939, as with a determined sense of priorities one family strapped their luggage to the boot of their car and set off on holiday. Four days later Germany invaded Poland, and war was declared just two days after that. Following the First World War cars had become available on the mass market and many people began to take motoring holidays abroad; in the late 1920s, 120,000 people went to Italy by car. However, with war so tangibly in the air, this family was unlikely to be travelling abroad. Many families at the time went to the coast or to the country; for a typical family holiday at the seaside, older children would stay in a hotel with their parents while the younger ones would stay in a boarding house with a nanny.

Holiday habits had changed considerably between the two world wars and by 1939 there were 200 holiday camps dotted around the country. It was on a boring, rain-soaked holiday in Skegness in 1932 that Billy Butlin decided to build a holiday camp offering both outdoor and indoor entertainment to the masses; it opened in 1936. Skegness was soon followed by camps at Clacton and Filey, all offering a chalet, four meals a day and entertainment included in the price of £3 per head – the famous redcoats acted as hosts, cheerleaders, guides and babysitters. Butlin's idea was a huge success, attracting millions of holidaymakers and creating a £55-million empire for its founder, who had worked his passage to England from South Africa after the First World War with only £5 capital. William Edmund Butlin was knighted in 1964 for his services to charity, and died in 1980.

One of Billy Butlin's famous slogans was 'Holiday with pay! Holiday with play! A week's holiday for a week's wage.' Paid holidays for workers were almost unheard of before the First World War, and although the idea gradually spread beyond the first enlightened employers it was not until 1938 that the Holidays With Pay Act was passed, although people could not take advantage of it until after the Second World War.

Also this year...

PanAm launches the first scheduled passenger flights across the Atlantic

A German U-boat sinks a civilian liner, the Athenia, *within hours of war being declared*

The Graf Spee *is scuttled by her own crew after being trapped on the*

River Plate by three British cruisers

Dutch aircraft designer Anthony Fokker dies

The first drive-on car ferry, the Princess Victoria, *goes into service between Stranraer and Larne*

Operation Pied Piper

These London parents and children seem surprisingly happy to be waving goodbye to one another as the children are evacuated from the city to a safer area in the country. Mass evacuations had taken place the previous year, when Operation Pied Piper had seen 1.5 million children evacuated from Britain's cities. There had been air raids over Britain during the First World War and the government feared that modern bombers were capable of devastation on a far greater scale, so plans were made to evacuate the most vulnerable people (children, the elderly and the disabled) from key target areas, principally the capital and Britain's industrial cities and ports.

The country was divided into three areas designated Evacuation, Neutral, and Reception and entire schools were evacuated en masse from Evacution to Reception areas; children and teachers would be moved to the same area where they would share the neighbourhood school with the local children. Parents were told when their child's school would be leaving but were not told the destination until after the children had arrived; pre-school children were evacuated with their mothers. A government leaflet instructed parents to pack 'a handbag or case containing the child's gas-mask, a change of under-clothing, night clothes, house shoes or plimsolls, spare stockings or socks, a toothbrush, a comb, towel, soap and face cloth; and, if possible, a warm coat or mackintosh. Each child should bring a packet of food for the day.' Some of them were away for five years.

After the mass evacuations of 1939 came the so-called 'phoney war' – Hitler had not expected Britain and France to enter the war so soon and was not ready to make a full-scale attack, so the expected air raids did not materialize; in fact, during the winter of 1939–40 more people died in black-out traffic accidents than in air raids. Homesickness, parents missing their children and the seeming lack of any danger meant that by Christmas nearly half of all the evacuees had returned home. But with the fall of France in 1940 Britain became the next target and the South Coast was hastily changed from a Reception to an Evacuation area: with the threat of invasion and the reality of the Blitz, a new wave of evacuations began and more families were split up.

Also this year...

The Queen Elizabeth *makes her maiden voyage in secret, painted grey as camouflage; the plan is that she will remain at anchor off Staten Island until the war is over*

Allied forces are evacuated from Dunkirk aboard a fleet of destroyers

and small ships

The US Army produces a four-wheel drive General Purpose vehicle which becomes known as the GP, or jeep

US car manufacturer Walter P. Chrysler dies

Chat-anooga choo-choo

History gives the impression that women were only allowed to work on the railways during the two world wars but nothing could be further from the truth. Large numbers of women have always been employed on the railways but only in jobs which were considered suitable as 'women's work'; during both world wars necessity meant that women were allowed to do 'men's work' on an equal footing, but on both occasions they were expelled from those jobs when peace came. It wasn't until the Sex Discrimination Act of 1975 that the theoretical inequalities were removed, although practically speaking there are barriers still in place today.

By the beginning of the Second World War there were already 26,000 women employed on the railways and, as in the First World War, enlistment and recruitment of men meant that women were allowed to carry out jobs previously barred to them, so that women became guards, signalwomen, welders, blacksmiths, sleeper-makers and signal repairers. There was considerable opposition from men, particularly when the railway companies suspended the minimum height requirement, altered the promotion structure in order to use women as passenger guards, and put men on the dirty old steam trains while women were assigned to the more prestigious electric trains. By 1944, the number of women working on the railways had risen more than fourfold since 1939, to 114,000, two thirds of whom were now working in male jobs barred to them in peacetime.

Railway jobs were far more dangerous during the war because the railways were targets for German bombs; nearly 400 staff were killed and 2,500 injured. In 1941 a steamer belonging to the Great Western Railway was bombed and sunk; stewardess Elizabeth Owen repeatedly dived into submerged cabins to rescue passengers and was awarded the George Medal and the Lloyd's War Medal for her bravery. Porter Violet Wisdom saw an air attack on a Southern Railways' train close to her own and ran to the wreckage to help deal with the catastrophe, and guard Isabella Gilder remembers the difficulties of shunting trains through bombed-out stations during the black-out: 'Not knowing where one was. Going out into strange yards and listening to trains moving about and not seeing them, not knowing where the points were... I had to get out of the van to change a rear lamp. There was hardly anything there but rubble.'

Also this year...

The Royal Navy sinks the Bismarck *after a three-day, 1750-mile pursuit*

Amy Johnson dies after baling out of a plane over the Thames estuary

Whittle's jet engine makes its first successful flight

Motor engineer Louis Chevrolet dies

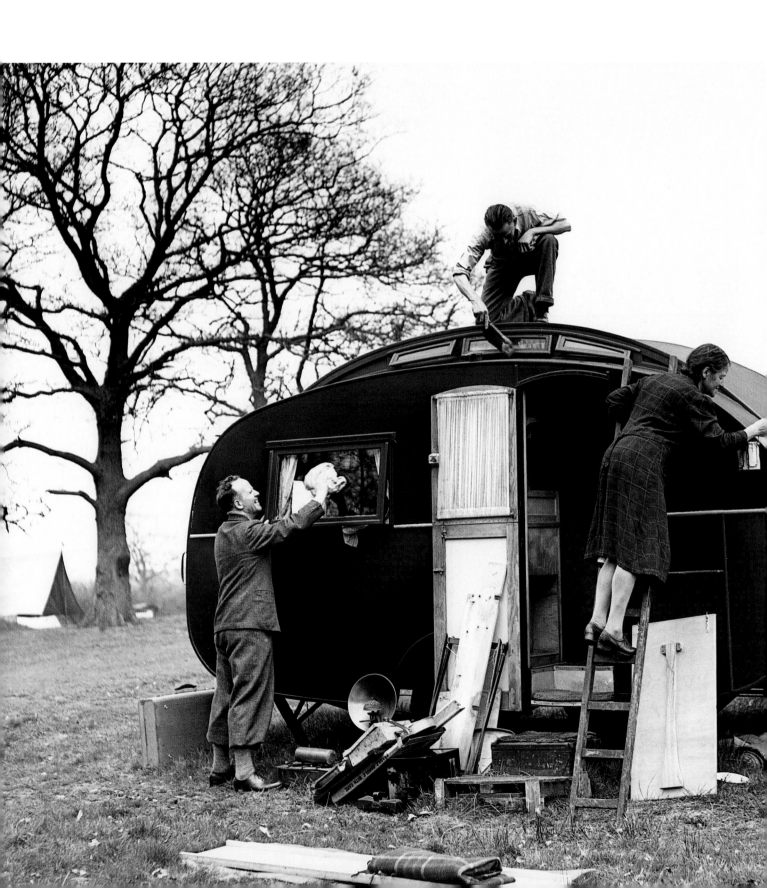

Land yacht wanderers

Holidays during the Second World War were an extreme rarity; in an effort to maximize war production, workers were no longer given holiday time, travelling restrictions were imposed, and there was severe petrol rationing from the end of 1942. Nonetheless, this family is giving its caravan a thorough spring clean and painting it in readiness for an Easter break in Cheshunt.

Contrary to popular belief, the caravan was not invented by gypsies, who used tents until the second half of the 19th century. The word was applied to various vehicles before the caravan as we know it came into being in about 1820 as a travelling showman's vehicle. By the end of the century the idea had spread to the leisured classes who took on the role of 'gentlemen gypsies' and toured the country in their caravans; one even wrote a memoir, *The Cruise of the Land Yacht Wanderer*. The Caravan Club was formed in 1907, devoted to horse-drawn caravans at a time when 'motor caravan' meant a self-contained vehicle – the first of these was shown in Paris and was known as a *maison automobile*, or house car. The first trailer caravan to be towed behind a car was custom-made in 1914 by Frederick Alcock, to be towed behind his Lanchester, and it wasn't until after the First World War that caravans became a common sight on the roads. Many people began to build their own caravans for holidays and tours, and several companies started building caravans commercially.

Early trailer caravans were square, box-like contraptions and some were even decked out as 'mobile cottages', complete with bow windows and wainscoted exteriors. But caravan design was revolutionized in 1930 when Bertram Hutchings released his new Winchester, rounded with the streamlined curves of what became known as the 'aero' look. Hutchings also brought back the lantern roof which had been a feature of the earliest horse-drawn caravans and which in this photograph is being so conscientiously cleaned by the gentleman on the roof. The caravan in the picture was a relatively new design for its time, showing the influence of Hutchings' innovations, although presumably the black paint was a wartime precaution.

Also this year...

The government proposes the introduction of fuel rationing but plans are postponed after widespread opposition; rationing eventually begins in December

Driving for pleasure is banned

Actress Carol Lombard and her mother are among the victims of a TWA crash

The Duke of Kent is killed when a flying-boat crashes during a visit to Iceland

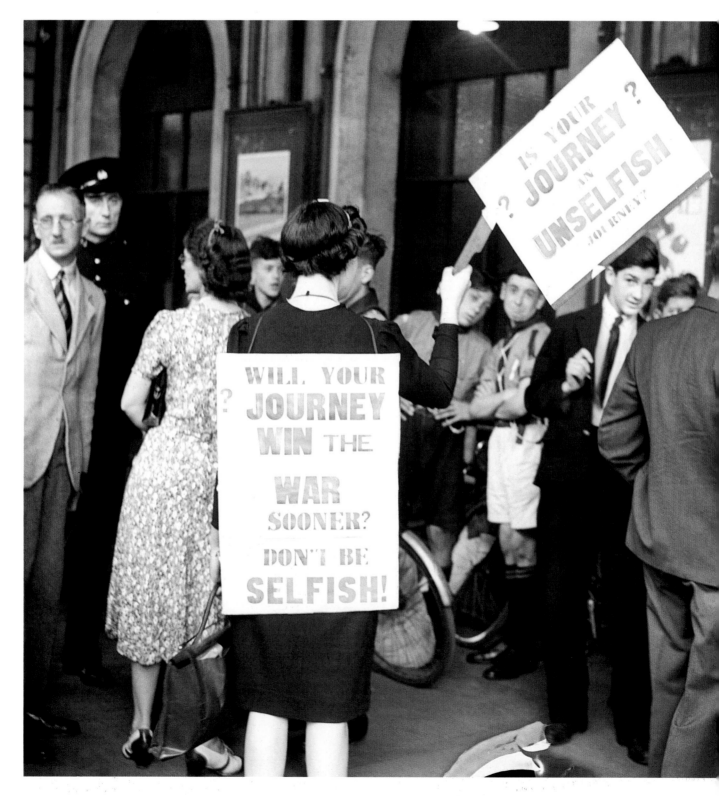

Is your journey really necessary?

By 1943 the privations of the war were really beginning to take effect. Petrol rationing was brought in at the end of 1942, driving for pleasure was banned, and for the railways the priority was the transport of troops and war materials. The power of the poster came into its own during the Second World War, with some including famous phrases such as 'Careless talk costs lives', and one depicting a British soldier standing at a railway ticket office asking, 'Is your journey really necessary?' In this photograph Mrs Hoyer, a war widow from Kensington in London, reinforces the message as she parades with her anti-travel posters, haranguing holidaymakers outside Paddington Station.

With most resources channelled into the war effort, the transport facilities that were left for civilians were often in a poor state of repair. Charles Harris remembers that 'most of the buses were so old that when they went up Chingford Mount they couldn't get all the way up with all the passengers on board; they'd stop half way up, then we'd all get off and walk to the top and then get back on.' People did travel, however, and particularly parents desperate to visit their evacuated children. Others would visit relatives in the country and holidays would often be organized for children by clubs or organizations such as the Scouts or Guides. But for most ordinary people holidays were simply a memory, or something to look forward to when peace returned.

In 1942 the government had introduced a 'Stay-at-Home Holiday Scheme'. Industrial workers engaged in war production were given a week's leave but were encouraged to spend it at home, with entertainment and events laid on locally; concerts, fetes, festivities and bands were organized by local councils and associations. Despite, or perhaps because of, the rationing and restrictions, there were frequent get-togethers. Barbara Courtney recalls that, 'We used to have parties at the weekend all the time – people brought whatever food they could get – drink, too, they got somehow... we were just glad still to be alive.'

Also this year...

Car mogul William Morris, now Lord Nuffield, creates the Nuffield Foundation, Britain's biggest charitable trust, with a gift of £10 million

The government says that signposts may be re-erected in rural areas after they were removed to confuse German troops in the event of an invasion

The London County Council unveils plans for a ring road around the city

Actor Leslie Howard is one of 13 passengers killed when the Luftwaffe shoots down a civilian airliner over the Bay of Biscay

High protection factor

A woman sits reading on the beach at Bournemouth in August 1944 surrounded by barbed wire, part of the coastal defences. Holidaying at all was rare by this stage of the war, and trips to the coast even rarer. If Britain was to be invaded it was clear that landings would be on the south or east coast, and from early in the war beaches stopped being places of recreation because they were planted with mines, barbed wire and other deterrents to any would-be invading forces. This meant that family trips to the seaside were definitely out; paddling, swimming and playing in the sand had suddenly become potentially fatal pastimes. Occasionally certain areas of the country, and most often the coastline, were closed to visitors altogether – in April 1944 all civilians except for those who lived there were banned from a coastal strip 10 miles wide which stretched all the way from the Wash to Land's End.

Apart from rare exceptions such as this lady at Bournemouth, trips to the beach were just one of the things that had to wait for peace before they could be enjoyed again. Others included bonfire night – fires were banned as part of the black-out and it was impossible to buy fireworks since all explosives were reserved for the war effort. In any case, firework displays would have been too reminiscent of the air raids for anyone to have enjoyed them. Christmas celebrations were also severely curtailed. People had to make do with home-made gifts and decorations, and ration-friendly recipes were issued by the government for things like Wartime Christmas Pudding and Emergency Cream; even food preparation was part of the war effort, and became known as the Kitchen Front.

After the war, when the barbed wire and the mines had been cleared, England's beaches and coastal resorts had their golden age. Paid holidays for workers were a reality, more people than ever had access to cars, and for a couple of decades seaside towns prospered before mass foreign travel took people to more exotic destinations. Even today, many of Britain's beaches carry reminders of the war, with crumbling pillboxes which fortunately never had to be used in action.

Also this year...

A new wave of evacuations begins as V-1s fall on London

Germany launches the first V2 rocket

The RAF sinks the Tirpitz

Troops drive London buses during a drivers' strike

Bandleader Glenn Miller's plane disappears without trace over the English Channel on a routine flight to France, where the band was due to play

The government bans all travel abroad

Head over heels and over there

GI brides board a liner in Southampton as they head off at the end of the war for a new life in the United States; in all some 75,000 women married American soldiers and left Britain as GI brides. These two ladies were among the first to leave and their departure was clearly newsworthy; a second photographer can be seen with his tripod in the background of this picture. In January 1946, GI brides were arriving en masse at transit camps before leaving for the States. Special trains were laid on and two 'bride's expresses' carried 344 women with their 116 children from Waterloo to Tidworth in Hampshire, where they stayed until they could sail for New York on the *Queen Mary* and the *Argentina*.

With so many men called up to fight, the uncertainty over which of them would return and a prevailing attitude of 'Eat, drink and be merry – for tomorrow we die', the arrival of 1½ million American troops in Britain in 1942 was a recipe for romance or moral laxity, depending on one's viewpoint. For many British women the American GIs, whose nickname came from the General Issue stamp on their uniforms, were irresistibly attractive with their strange accents and seemingly endless supplies of scarce luxuries such as nylon stockings, chocolate and cigarettes. This bred resentment among British men and drew indirect condemnation from the Archbishops of York and Canterbury, who did not refer to GIs specifically but blamed promiscuity and moral laxity for a rise in rates of venereal disease since the start of the war.

For most women, getting dressed up for a dance was rather a challenge. Clothes rationing, Board of Trade restrictions on styles and types of cloth, and the prohibition of embroidery on underwear and nightgowns meant that looking good required a lot of ingenuity, although one consequence of rationing was that skirts became shorter in an effort to save cloth. Cosmetics were also in short supply and women had to improvize, using starch as face powder, beetroot juice for lipstick and rouge, and having to paint gravy browning on their legs instead of stockings, with a seam drawn on in pencil. Washing it all off again wasn't easy either, with soap rationed to a bar a month. Small wonder that when the Americans arrived with supplies of nylon stockings, British girls fell head over heels.

Also this year...

A US Boeing B-29 bomber drops the first atomic bomb on Hiroshima

The first boat-train in five years leaves for the Continent

De Gaulle nationalizes Renault and Air France

Thousands of American troops sail home aboard the Queen Elizabeth

30 die in a train crash in Hertfordshire

Fit for a queen

After the war, two saloons which had been used during hostilities were added to the royal train run by the London, Midland & Scottish Railway. This photograph shows the private lounge used by Queen Elizabeth, now HM The Queen Mother. The King and Queen each had their own saloon, which consisted of a lounge, bedroom and bathroom.

Trains had been part of royal travelling arrangements since the time of Queen Victoria, and two new trains were built for George V. During both world wars the royal trains came to serve a more important purpose than simply supplying the required pomp and circumstance, as they provided a safe haven for the royals as they travelled around the country. George V in the First World War and George VI in the Second World War both made morale-boosting visits to various parts of the country during hostilities, and travelling by train afforded better security against air attack than most forms of transport. On long journeys the royal train was often parked in a quiet siding for overnight stops.

It is strange that these saloons should be supplied by the London, Midland & Scottish, whose reputation was for strict economy. Their notorious penny-pinching meant that stations were infrequently cleaned, seldom painted and became extremely run-down. Unlike the other big rail companies, the LMS had no reconstruction or modernization programme for its buildings or stations. The company was, however, very sensitive to the power of publicity, producing a series of posters by well-known artists and pioneering the use of publicity films which are now historic documentaries. It could be said that the provision of a royal train made extremely good publicity for a company which, despite the state of its stations, also commissioned the first diesel-electric locomotive in the post-war run-up to nationalization.

Also this year...

Piaggio markets the first commercially successful motor scooter, the Vespa, which is the Italian for 'wasp'

Test flights and building work begin at a new airport to the west of London, known as Heath Row

The new Labour government votes to nationalize the railways, ports and the road haulage industry

Rail fares rise; a return from London to Edinburgh now costs £6.18s.9d

Morris raises its prices: two-door saloons cost £270, four-door £290. Fords cost £275 for the Prefect, £229 for the Anglia

British European Airways is created

The government announces it is to set up a tourist board

Snow had fallen, snow on snow, snow on snow

Point duty is a lonely job when there's no traffic about. This policeman is directing what little traffic has ventured out after a night of snow during one of the worst winters ever recorded. The transport infrastructure was completely disrupted by the severe weather and at the same time Britain was struggling to cope with crippling fuel shortages. Over four million workers were made idle by power cuts, and the coal shortages were exacerbated by the fact that coal trains were unable to battle their way through snowdrifts which reached 20 feet deep in places, leaving thousands of homes without heat or light. In Yorkshire the RAF dropped food over villages which were cut off by the snow, and one hamlet in Devon sent a telegram in mid-February saying 'No bread since Jan 27. Starving.' By March, 300 roads were blocked and 15 towns cut off.

Hundreds of rail passengers were stranded in drifts, fishing fleets were kept in port, and blizzards stopped all shipping in the English Channel, creating a new threat to food supplies so soon after the hazards of war. Sixty main line trains a day were being cancelled due to the combined effects of the weather and the need to make way for urgently needed coal trains. The Great North Road was blocked for 22 miles by 10-foot snowdrifts, and air travel was also hit, with only 3 aircraft instead of the usual 42 landing at London's three main airports on one particularly bad day. Doctors in the Fells made their rounds on horseback, troops in Dorset tried to clear snowdrifts with flame-throwers, and in Yorkshire prisoners were enlisted to help clear the snow.

The worst of the weather lasted for over two months, with the temperature dropping to as low as -16° Fahrenheit at the end of January, heavy snow and continuing sub-zero temperatures during February leading to the threat of fuel rationing for those who had any fuel at all, followed in March by a thaw which brought massive flooding. Flood damage was calculated in terms of food rations, which were still in force after the war – two million sheep were killed, a week's meat ration for the nation, and 500,000 acres of wheat were damaged, equating to a month's bread rations.

Also this year...

International Civil Aviation Organisation formed

In Japan, Soichiro Honda fits war-surplus engines to pedal cycles

The Queen Elizabeth runs aground at Southampton

The government plans a flat-rate car tax of £10 a year and proposes regular compulsory inspections for cars

Ettore Bugatti dies

Henry Ford dies aged 83

Easy Rider

This little girl looks very pleased with herself at not having to pedal. Ever since Baron von Drais discovered how much more quickly two wheels could move than two legs, cycling has been popular as a sport, as a pastime and as a means of transport. Here, members of a cycling club are riding tandems on a day's outing through the country.

All modern bikes are derived from the 'safety bicycle' which had wheels of equal sizes, overcoming many of the dangers of its predecessor, the Penny-Farthing. The saddle of a Penny-Farthing was up to 4½ feet off the ground, which made them very difficult to mount, and the large front wheel meant that there was not only a greater danger of being thrown over the handlebars but also a long way to fall! The Penny-Farthing had been designed in order to gain more distance for each turn of the pedals at a time when the pedals were part of the front wheel, but the 'safety bicycle' was made possible when designers realized that the pedals could drive the rear wheel indirectly by a chain. On the first safety bike, designed by the nephew of the Penny-Farthing's inventor, the rear wheel was geared up by a ratio of 2:1. Effectively this meant that the wheel could be half the size to achieve the same distance, removing the need for a large front wheel.

The arrival of the safety bicycle in 1885 started a boom in the cycling industry because at last there was a machine that could be ridden by everyone. The basic design of bikes has remained the same ever since, although there have been many improvements and innovations along the way. Pneumatic tyres were the first big improvement, quickly followed by the free wheel, which allowed the wheels to turn while the pedals were stationary; this led to a need for better brakes because riders could no longer back-pedal to slow the bike down. The next big breakthrough was the arrival of gears, which allowed enthusiasts like those in the photograph to cope with hills as well as the flats.

Cycling has also had an indirect impact on transport and travel because not only have many of the developments invented for bikes been used on other forms of transport but many of the pioneers of the car industry started out making bicycles, including Armand Peugeot, Adam Opel, Vincenzo Lancia, Soichiro Honda, and the Dodge brothers. The Wright brothers also began with bicycles, although they took off in a different direction.

Also this year...

Britain's railways are nationalized

15 die when a British European Airways plane collides in mid-air with a Soviet fighter

Austin, Morris, Ford, Rootes, Standard and Vauxhall agree to standardize motor parts

Orville Wright dies

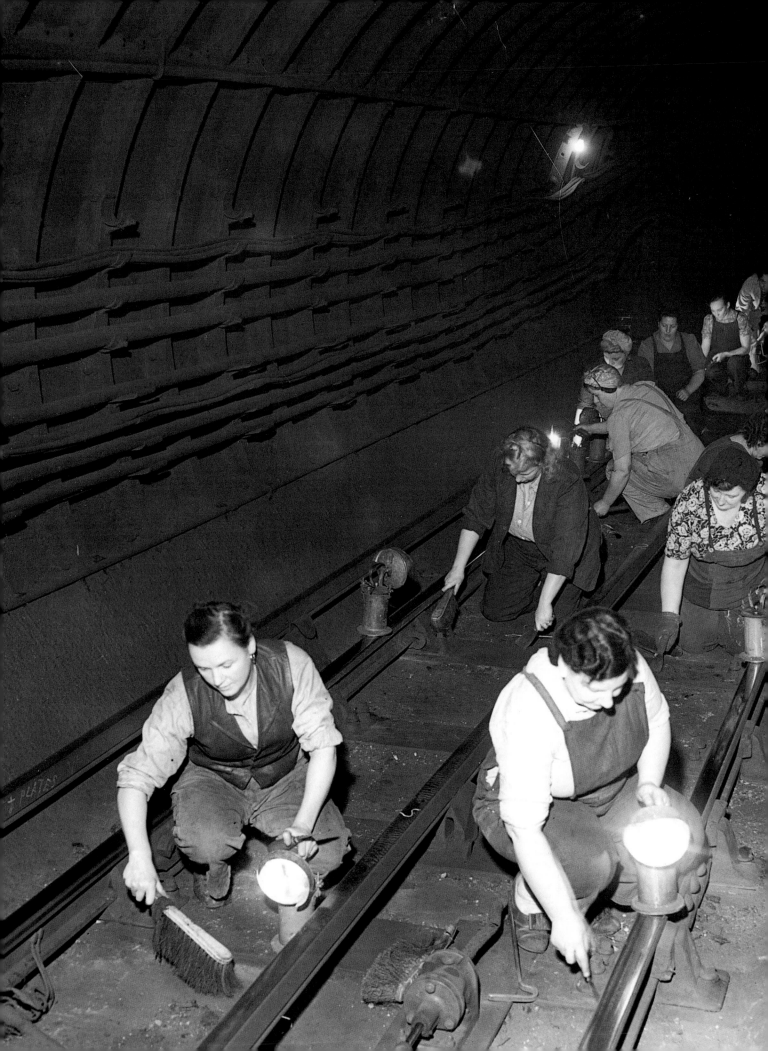

Fluffers

One of the strangest jobs behind the scenes on the underground is carried out by fluffers – the nickname given to gangs of women who swept out the lines and tunnels of the tube system. Fluffing was vital to clear out the build-up of dust and rubbish between the tracks which would otherwise become a dangerous fire hazard, and it was carried out by teams of about fifteen women whose shifts would cover approximately two miles of track and tunnel every five weeks.

Fire precautions are vital on any public transport system but most particularly on an underground railway. Fortunately there have been very few fires on the underground, partly due to the valuable work of the fluffers. When fires have occurred they have usually been caused by the arcing of electrical equipment, which is what happened at Holland Park in 1958. However, a build-up of fluff under the escalators was blamed for Britain's worst underground fire, at King's Cross in 1987, which killed 31 people.

As on the main line railways, women have been employed on the underground since the 19th century but usually in clerical and support jobs and often under different conditions to men – for example, women were not entitled to the free travel passes which were issued to men. Both World Wars saw women being allowed to do 'men's work', and during the Second World War London Transport employed women to do nearly all jobs except driving, although they were allowed to drive empty buses to and from the depots. Other jobs included working as conductors and guards, cleaning, maintenance, heavy engineering and munitions work as well as the tedious job of fluffing. In modern times the fluffers have been replaced by mechanical cleaning trains which drive through the tunnels sweeping, scrubbing and collecting rubbish as they go.

Also this year...

A US B-50A bomber flies non-stop around the world, refuelling four times in mid-air

The Citroën 2CV makes its first appearance

A test pilot makes the first British escape by ejector seat

The world's first jet airliner, the de Havilland Comet, makes its maiden flight; the plane had been kept secret to prevent the US aircraft industry stealing the British lead

The Transport and General Workers Union bans Communists and Fascists from office

A gallon of petrol goes up 2½d to 2s.3d

Michelin introduce radial ply tyres

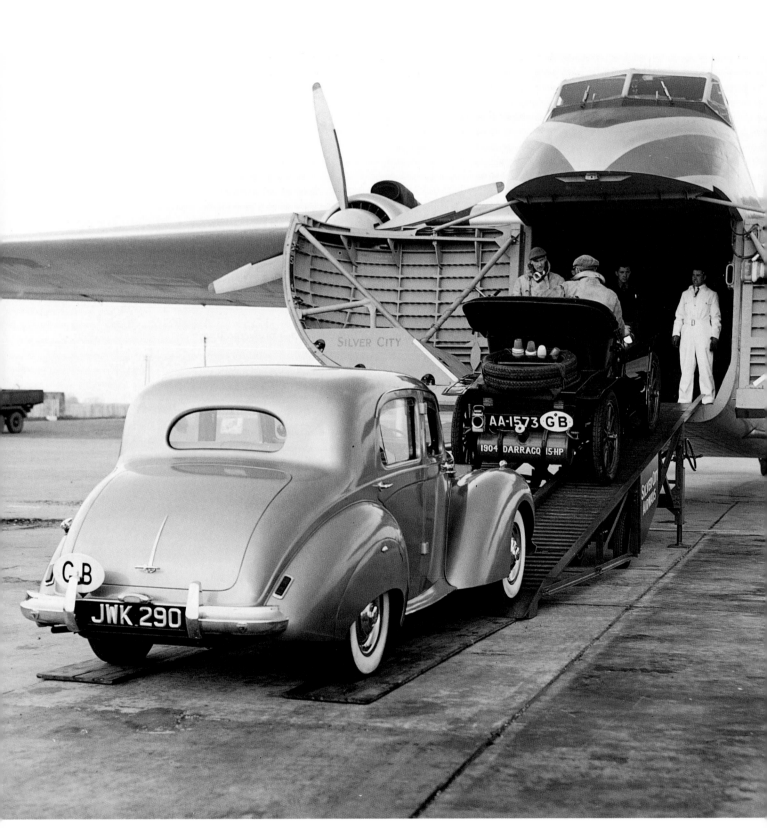

Auto pilot II

The next best thing to Chitty Chitty Bang Bang is to fly with your car to France. Here a vintage 1904 Darracq and a brand new Alvis load up for the short flight to Le Touquet. Silver City Airways opened this unique air link to France in 1948, with a flight from Lympne Airport near Folkestone in Kent (pictured here) to Le Touquet, using a Bristol Freighter.

By 1955, Silver City had built its own specialized terminal at Ferryfield, from where journey times to France were a mere 20 minutes. At that time the company had 15 aircraft in operation and in one year carried 44,670 cars, 8,774 motorbikes and 166,219 passengers. The fare for a small car was £5 and up to three cars could be carried on each flight.

The vintage car, although it is carrying a GB plate, was built by the French company Darracq. Alexandre Darracq had a passion for mechanical objects and built a great number of bicycles, tricycles and cars but ironically he did not like driving and hated being driven. At the age of 36 he formed the Gladiator cycle company and when that was bought out he began to design electric cabs; sadly, he was so far ahead of his time that they proved to be a complete failure. He did well for a time building tricycles and then turned his hand to cars, which were an immediate success, particularly on the racing circuit. However, this success was short-lived and Darracq was, in any case, already pursuing an interest in the growing sport of flying, resigning from his own company in 1912.

The car following the Darracq up the ramp is a brand new Alvis TA21, the first one off the production line. Alvis was founded in Coventry by T.G. John in 1919 and the company became renowned for its sports cars. Their later road cars proved too expensive to sell well and during the Second World War the company concentrated on building aero engines and military vehicles. From then on, these kept the company afloat, while cars became a secondary activity. In 1950 Alvis designed a new independent front suspension chassis and a three-litre engine for the TA21, seen here. The company merged with Rover in 1965 but plans for new models never came to fruition. The last Alvis was built in 1967, after which the company concentrated solely on military vehicles.

Also this year...

Petrol rationing ends after 10 years

Rover produces the first gas turbine car

80 Welsh rugby fans die when a charter plane crashes on its way home from a Wales v. Ireland rugby union international

The budget adds 9d to petrol tax, taking the price to about 3s per gallon, its highest price since 1920

Ford launches the Consul and the Zephyr

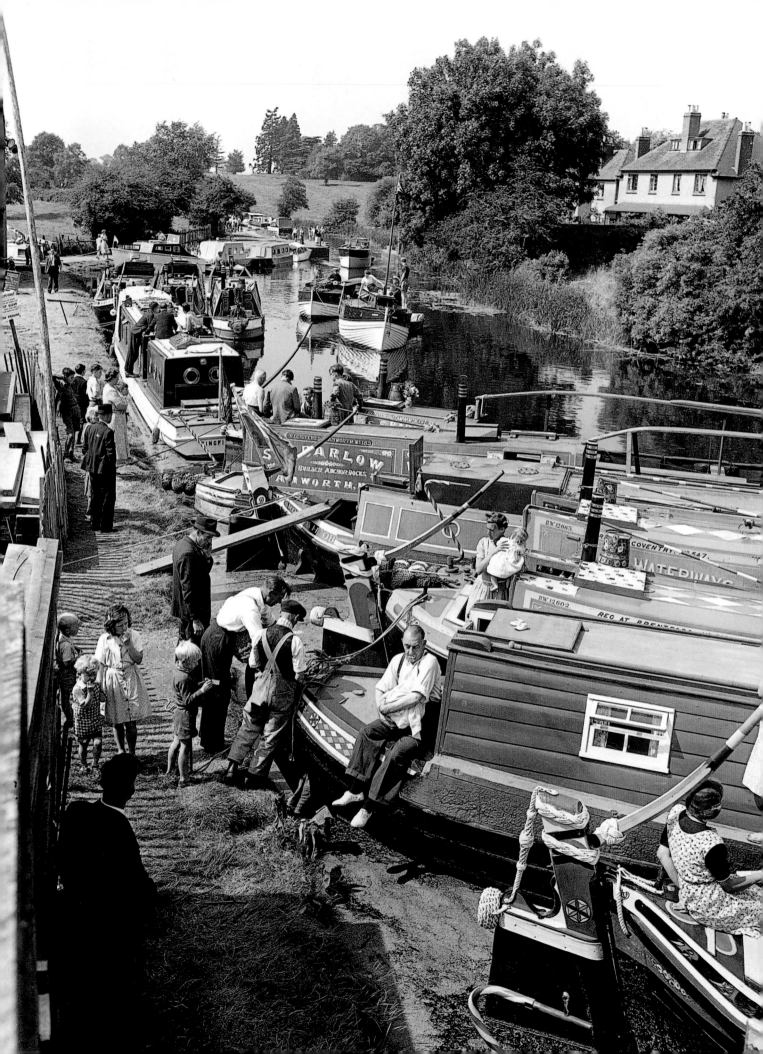

Canal dreams

A festival of inland waterways craft on the Welland and Union Canal at Market Harborough. Today Britain's canals are used mainly for recreation, and the brightly painted narrow boats conjure up images of slow, leisurely trips along quiet waterways, but it wasn't always this way. The canals were originally built to carry bulk freight at a time when horse-drawn vehicles could only carry relatively small loads by road. Where the rivers stopped being navigable, canals gave access to mines, mills, industries and farms. Canals became part of a world-wide infrastructure of water transport, with Indian cotton and Australian wool being transported by barge to the mills of Lancashire and Yorkshire. Birmingham's manufacturing industry exported its goods by canal, London imported timber and ice, and South Wales exported coal and iron.

It was the canals that made the industrial revolution possible, and they were vital to its growth, carrying raw materials to mills and factories, and finished products away again. The canals also spread to the country, carrying wheat, barley and cheese to the towns and returning with coal and groceries. By 1830 some 4,000 miles of inland navigation had been created in Britain. There was a pioneering spirit to their construction because, unlike the builders of the railways which followed, the canal builders had no ordnance survey maps to refer to, and local surveyors had to work from scratch. The early railway builders learned a lot from the canal builders, with their expertise in building embankments, cuttings, tunnels, and aqueducts, which became the model for railway viaducts.

The coming of the railways was effectively the end of the use of canals as an industry. Many were bought up for conversion into railways, others, having been bought by railways eager to control the competition, were neglected, and some endeavoured to compete with the railways but saw their trade gradually dwindling. In the end the *coup de grâce* was delivered not by the railways but by a common enemy – the lorry. In 1963 the surviving canals came under the control of the government-subsidized British Waterways Board, which divided them into commercial, cruising and 'remainder' waterways. Commercial traffic was very limited but the cruising canals became increasingly popular with a growing leisure market.

Also this year...

Heathrow's first terminal is built

Chrysler introduce the first power steering, on their Imperial model

The drive-in movie makes its mark in America

Ferdinand Porsche dies

Spies Burgess and Maclean send a telegram saying that they are taking a 'long Mediterranean holiday'

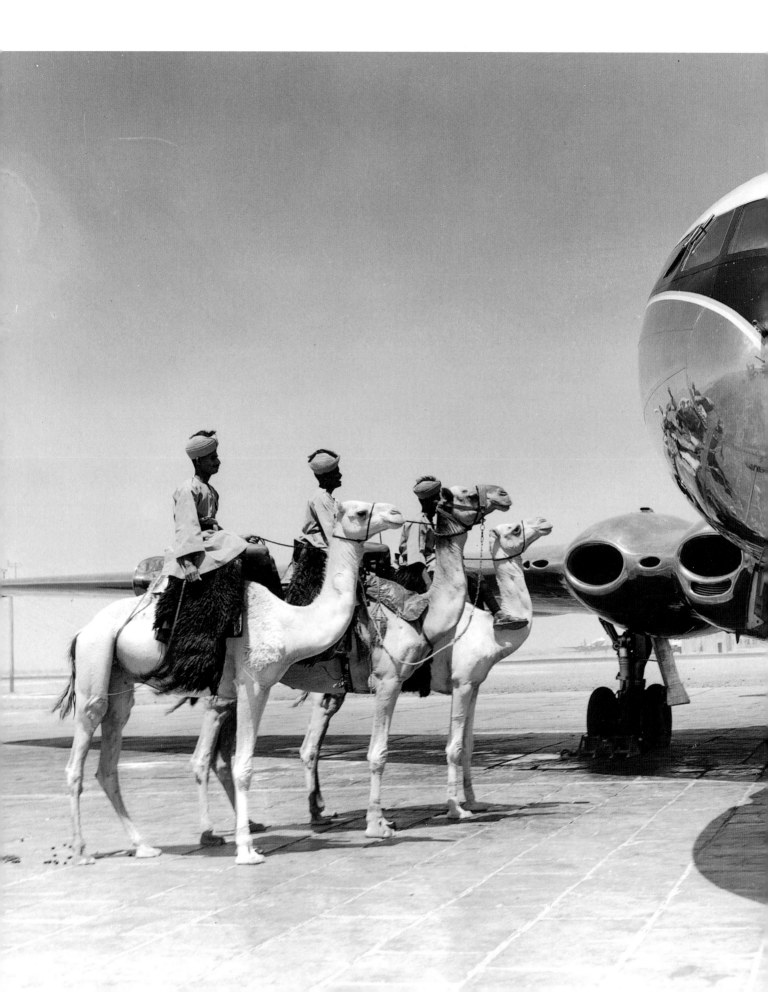

Camels and Comet

The jet set arrived in 1952, ushering in a new era of passenger air travel. The British de Havilland Comet was the world's first jet airliner, and is photographed here on her maiden flight from London to Johannesburg. It was a complex route, with stops at Rome, Beirut, and Khartoum (pictured, where the Comet cuts a remarkable contrast with the locals on their vintage all-terrain vehicles). There were further stops at Entebbe and Rhodesia before the last leg of the 18½-hour journey to South Africa.

The Comet was the plane with which Britain hoped to gain world leadership in passenger transport design and was the result of some surprising forward thinking; the Brabazon Committee had been set up in 1942 to examine Britain's transport needs after the Second World War, and one of the results was the Comet. The plane first flew in 1949 and entered service in January 1952, initially as a freighter and then, with its inaugural flight on 2 May, as a passenger plane. Britain had pioneered a world first, and the 490mph Comet heralded a new age concept of air travel, with a fleet of these 36-seater jets taking over on several of BOAC's scheduled routes and in many cases halving journey times.

However, one crash in 1953 and two in 1954 led to the Comet being grounded. It was subsequently discovered that the crashes were the result of the hitherto unknown problem of metal fatigue due to the pressurized cabin. Cracks at the corners of the rectangular window frames were to blame, and so rounded windows were introduced on the slightly larger Comet 2. Other design problems were ironed out and in 1958 the Comet 4 became the first transatlantic jet airliner, just beating the Boeing 707 which went into service 22 days later with PanAm. However, it was the 707, not the Comet, which set the standard for jet airliner design. The Comet looks dated compared with modern airliners which followed Boeing's design of having the engines slung below swept-back wings. The Boeing outperformed the Comet in all aspects, with 189 seats compared to 78, a cruising speed of 550mph compared to 503, and a range of 4,300 miles compared with 3,225. Britain had lost its lead in the field of jet airliners and Boeing has dominated the market ever since.

Also this year...

The government announces that zebra crossings will be marked by blinking orange beacons

26 spectators die at the Farnborough Air Show as a fighter breaks apart after breaking the sound barrier

112 die as a high-speed train crashes into two other trains near Harrow and Wealdstone station

John Cobb dies on Loch Ness trying to set a water speed record

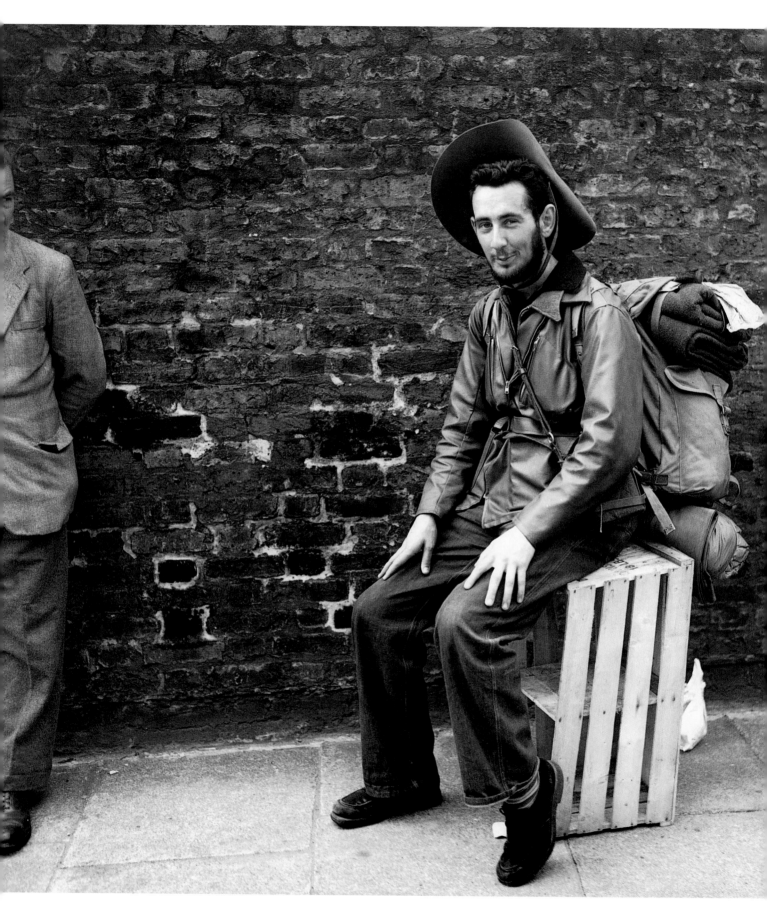

Travelling fan

Backpacker Jack Perry travelled all the way from Melbourne to watch the cricket, and he was obviously expecting a long wait as he queued outside the Oval for the fifth test of the 1953 series between England and Australia. The Kennington Oval was the venue for the first ever test match between England and Australia in 1880, which England won by five wickets, and traditionally the Oval stages the last match of any full test series in England. In the fifth test, Jack Perry watched famous names such as Fred Truman, Len Hutton and Dennis Compton as they steered England to an eight-wicket victory and regained the Ashes for the first time in 20 years.

Backpacking has had several connotations, and purists insist that it only refers to those who take to the wilds with a pack on their back. Modern backpackers would say the opposite, and one manual even cautions its readers, 'You're a backpacker, not a rambler.' Jack Perry was among the first of those who have given backpacking its modern, urban meaning: travelling light, hitch-hiking or using public transport, and sleeping in hostels or cheap hotels. Perry was a pioneer of something that now seems *de rigueur* for young Australians, and which has earned the bedsits of Earl's Court the nickname 'kangaroo valley'. But it would have taken Jack a lot longer to get here than the modern backpackers. He would have travelled to England by boat and he wouldn't have had the advantage of all the guidebooks and backpacking manuals which are now available.

Some things Jack was no doubt aware of without needing a handbook: 'Your backpack is your home... look after your pack and it will look after you' is rule number one. And he's obviously realized that it's easier to grow a beard than to carry razors. But it is difficult to know what he would make of the idea that it is now possible to buy a backpack that will convert into a holdall by zipping the straps away and carrying it by a handle on the side – just in case a backpacker needs to not look like a backpacker.

Also this year...

Edmund Hillary and Tenzing Norgay conquer Everest

A British Rail car ferry sinks off Belfast Lough with the loss of 128 lives after sailing with the cargo doors open

Austin, Standard and Ford start a car price-cutting war

BOAC grounds all its Stratocruisers after finding an engine defect

The cost of air travel at Easter increases by 20% on the previous Easter

The Queen (now HM The Queen Mother) launches the Royal Yacht Britannia

The government announces plans to cut London's airports from seven to three and to expand Gatwick

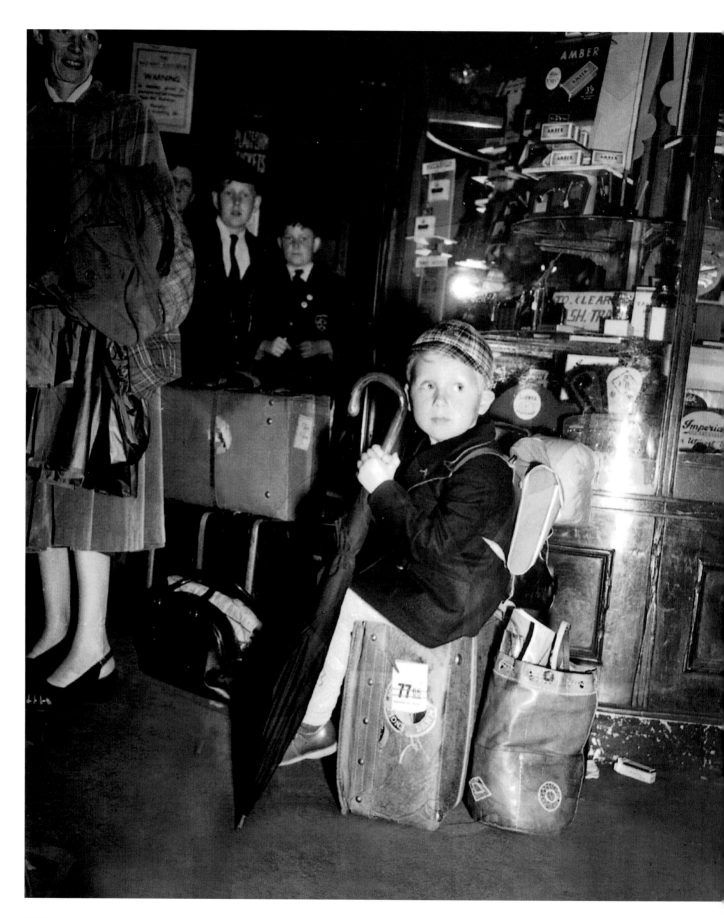

The waiting game

This young Danish tourist from Sundby in Copenhagen must have been warned about the English weather, and came with the biggest umbrella he could find. Surrounded by luggage, he is waiting in London for a train to the West Country. The amount of luggage carried by travellers steadily decreased during the 20th century, from heavy trunks to soft suitcases and wheelie-bags. This came about partly because of social changes since the days when travellers on a cruise liner would expect to change clothes at least four times daily, and partly because of the type of transport available; it was possible to carry far more luggage on a train or a ship than it is on an aeroplane.

Before the arrival of the railways travelling was a rough, uncomfortable business and people would wear their oldest and warmest clothes. Stage coaches could carry only a small amount of personal luggage and anything bulky or heavy had to be taken separately by the much slower carriers' wagons. Rail travel changed that, with people now dressing more fashionably for travel and the trains able to carry far more luggage. Tailor's shops began advertising suits specially made for 'Tourists and Travellers', and luggage suddenly became fashionable as well as functional; previously trunks had been simple wooden crates but now they began to be adorned with brass and leather. Louis Vuitton even broke with the tradition of trunks having rounded lids by selling the first flat-topped trunks, which could be stacked much more easily in trains or ships.

Trains carried a lot of luggage, mostly in special luggage vans but some of it, in the early days, strapped under tarpaulins on the carriage roofs. This practice did not continue for long because bags often dropped off if not fastened properly and luggage would often catch fire because of sparks and cinders from the engines. Usually 'personal luggage' up to a certain weight was carried free on the railways but this led to many arguments. In 1869 the courts decreed that a child's rocking-horse did not qualify as personal luggage, but in 1873 that a sewing-machine did; and in 1899 it was decided that bicycles must be paid for. According to one Victorian writer, the London Brighton & South Coast Railway weighed its passengers' luggage with a precision 'which would have done credit to the troy methods of a dispensing chemist in the poison business'.

Also this year...

Flashing indicator lights become legal on cars in Britain

America enters the era of jet air travel as the Boeing 707 makes its first test flight

In Britain, the Rolls-Royce 'Flying Bedstead' shows that vertical take-off is possible

Lost in France

A group of young Scouts and Guides put their scouting skills to the test in trying to find the right platform at the Gare de Lyon in Paris. The *Société Nationale des Chemins de Fer Français*, or National Society of French Iron Roads, was bracing itself for the Easter rush as trains left the station on Good Friday packed with holidaymakers; the same thing was expected on Easter Saturday. SNCF was formed in 1937 and took over the operating concessions of all the major individual French railway companies on 1 January, 1938; in 1983 the organization became a public corporation.

The Boy Scout movement was founded in England in 1908 by Robert Baden-Powell to promote independence and self-reliance. Baden-Powell's background brought to scouting a strong imperial influence; in his own words, 'scout-craft includes the qualities of our frontier colonists, such as resourcefulness, endurance, pluck, trustworthiness etc'. With his sister Agnes, Baden-Powell formed the Girl Guides two years later with a similar outlook and the same motto, 'Be Prepared'. Robert Baden-Powell joined the British Army in 1876 and specialized in reconnaissance and scouting, and in 1897 he took command of the 5th Dragoon Guards in India. While posted in India he developed training for military scouts using methods based on observation, deduction and initiative, and explained the principles in a book, *Aids to Scouting*. It was the interest of younger boys in this manual, and the example of the Boys' Brigade, that inspired him to form the scout movement after his return to England.

He held a trial camp on Brownsea Island in Poole Harbour in 1907, and this was such a success that he established the Boy Scouts the following year and wrote *Scouting for Boys*. Scout groups were formed all over the country and within two years there were 100,000 members; 80 years later the movement has spread to 150 countries and has about 16 million members.

Also this year...

Christopher Cockerell patents the hovercraft

80 people die as three cars crash at 150mph at Le Mans and plough into the spectators' grandstand

Donald Campbell, son of Sir Malcolm, breaks the world water speed record on Ullswater, Cumbria

Petrol goes up 5d to 4s.6d a gallon

London Transport announces plans for a new tube line from Victoria to Walthamstow

In February 70 main roads are impassable because of snow and ice

A new Highway Code is published

The Association of British Travel Agents, ABTA, is founded

James Dean dies when he crashes his Porsche Spider

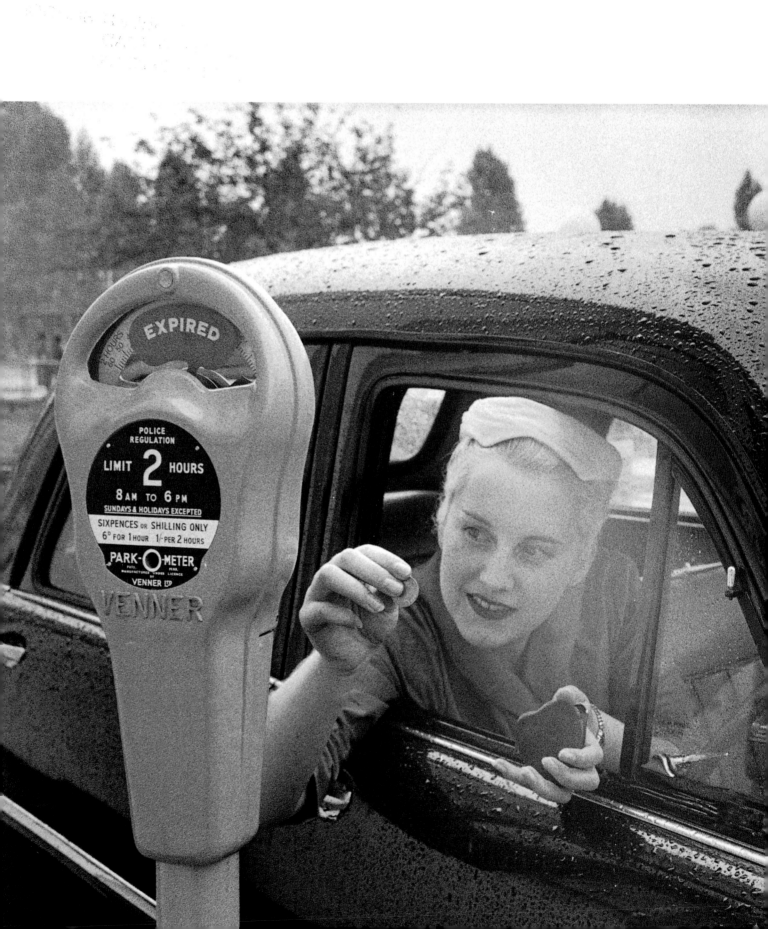

EXPIRED

POLICE
REGULATION

LIMIT **2** HOURS
8 AM TO 6 PM
SUNDAYS & HOLIDAYS EXCEPTED

SIXPENCES OR SHILLING ONLY
6ᵈ FOR 1 HOUR 1/- PER 2 HOURS

PARK-O-METER
PATS. PEND.
MANUFACTURED UNDER LICENCE
BY
VENNER LTD

VENNER

Lovely Rita

A London motorist uses one of the new Venner parking meters, which were introduced in the West End and Mayfair this year in an attempt to solve the problem of parking. The writing on the meter shows that instead of the modern problem of trying to find £1 coins or 20p pieces, drivers in the 1950s had to stock up with sixpences and shillings.

We have American journalist Carlton Magee to thank for this scourge of all motorists. Magee was the part-time Chairman of Oklahoma City's Business Traffic Committee, which was set up in 1933 to discuss ideas for how to control parking. It was Magee's idea for meters which won the day, and parking meters duly came into operation in Oklahoma City on 16 July, 1935. The first order was for 150 Park-O-Meters, the contract being won by a company called the Dual Parking Meter Company, which was run by... Carlton Magee. From that first 150, millions of parking meters have been spawned worldwide, with their dual purpose of controlling parking and raising revenue.

The need for parking meters was not felt in Britain until the late 1950s. After this experiment in 1956, parking meters were installed in earnest from July 1958, when Westminster Council led the way with meters imported from America. By the early 1960s meters were being made in Britain and in 1967 they and parking wardens entered popular culture for ever when the Beatles released 'Lovely Rita (meter maid)' on their 'Sergeant Pepper's' album.

Also in the 1960s, a new crime wave swept Britain with the introduction of the newly invented ring-pull can. It didn't take long for people to realize that a ring-pull would fit the coin slot of a parking meter and jam it – and in those days a jammed meter meant free parking. Sadly, changes in the parking rules, updated meter design, and the advent of snap-top instead of ring-pull cans conspired to end this false dawn for motorists.

Towards the end of the century there were signs that the meter had had its day as pay-and-display machines began to take over, and by 1998 there were no parking meters at all in Birmingham.

Also this year...

British Rail abolishes third-class carriages

The world's first regular hydrofoil service begins, between Sicily and Italy

The Chairman of the British Transport Commission announces that electric services will be *introduced on all Britain's railways, replacing steam trains*

The Suez Canal is closed after an Anglo-French attack on Egypt; the Suez crisis results in petrol rationing, with motorists restricted to 200 miles per month

Lovely bubbly

If the front door of this bubble car opened the other way it would reveal a surprising feature – the blue and white symbol of BMW. And not only did BMW make bubble cars, but these miniature runarounds actually kept the company afloat in the late 1950s and early 1960s when their luxury sports cars went through a sales slump. The 1950s were boom and bust for car drivers. The end of wartime petrol rationing in 1950 led to a resurgence of driving for pleasure – and record traffic jams. But soon afterwards came the Suez Crisis; petrol went up 5d to 4s.6d a gallon in 1955, and by 1957 rationing was back. *Autocar* magazine ran a feature on motorscooters as an alternative to cars, and in Europe the bubble car was born.

The tiny BMW Isetta was based on a design by the Italian organization Iso, and was powered by a 247cc BMW motorbike engine. At a stroke it solved the problems of fuel consumption and parking; if there's no room, drive it in end-on at right-angles to the pavement like the gentleman in the photograph. The problem of fitting doors onto such a small vehicle was easy; simply open the entire front, which took the steering column with it making room to get in and out. This created problems of its own, however, because some bubble cars didn't have a reverse gear, which meant that after it had been driven up against the back wall of the garage it was impossible to get out!

The wide wheels at the front gave the car stability, with the rear wheels much closer together; some export versions of the Isetta only had one rear wheel because in certain countries the tax system favoured three-wheelers, while other countries only required a motorcycle licence for three-wheelers. Starting the Isetta was a matter of putting it in first gear and then turning the key; it immediately started to roll, and changing gears then meant forgetting a clutch pedal and crashing through the gears using a lever on the inner wing of the car. Variations of the Isetta came later, including a mini-van and a larger, 600cc version with which the bubble car came of age – Stirling Moss still uses his 600 to beat the London traffic.

Also this year...

The space age begins as the Russians launch the world's first artificial satellite, Sputnik 1

A dog called Laika becomes the first living creature in space, on Sputnik 2

Vauxhall launches the Victor, Cresta and Velox models

British Rail announces a loss of £16.5 million for the previous year

A £17-million expansion scheme for Heathrow Airport is unveiled

The government proposes building a motorway from London to Dover

A heavy price to pay

Road safety campaigner Michael Price stands outside the Houses of Parliament wearing a sandwich board bearing the traffic accident statistics for 1958. Road safety has been a concern since the first cars took to the roads and the well-intentioned but totally impractical Red Flag Law dictated that all motorized vehicles should be preceded by a man on foot carrying a red flag. It is difficult to know whether Mr Price would be pleased to know that there were fewer road deaths at the turn of the millennium than in his day, despite the increased number of cars, or dismayed that they have not been reduced to nil. Deaths in road accidents now average 3,600 a year, considerably less than in 1958, but the total number of casualties has increased to 320,000.

The Green Cross Code was introduced in 1958 to help reduce accidents involving pedestrians crossing the road, and now forms part of the Highway Code. In 1916 the country's first accident prevention organization came into being as the London 'Safety First' Council, set up by the operating manager of the London General Omnibus Company. This may have been a response to the fact that in 1913 a House of Commons select committee heard that street deaths involving 'motor buses' had risen five-fold since 1907, the number of deaths rising at twice the rate as the number of buses. Amongst other things, the committee recommended more attention to speed limits in busy areas; the speed limit at Hyde Park Corner in 1913 was 10mph.

The London 'Safety First' Council – now known as the London Accident Prevention Council – is still active, but as accident prevention became a national issue a new organization was established which eventually took on the title 'Royal Society for the Prevention of Accidents' (RoSPA) in 1941. RoSPA's work on road safety includes campaigning and education; it organizes training schemes for local councils and road safety officials, every year trains 250,000 children in cycling proficiency, and runs defensive driving courses and a National Safe Driving Award Scheme.

Also this year...

Yellow lines are introduced in Britain to denote parking restrictions, and the first parking tickets are issued

The Boeing 707 makes its first commercial flight and becomes 'the first truly intercontinental airplane'

The Munich air crash claims 23 lives including 7 Manchester United football players

The first US satellite is launched

Britain's first motorway is opened, the Preston by-pass, which later becomes part of the M6; special signs are designed for motorways, with white lettering on a blue background

The first radar speed checks are introduced in London

Bold, exciting and scientific

One of the huge signs for the new M1 motorway is wheeled out of its Borehamwood factory. Britain's first motorway was the eight-mile Preston by-pass, opened by Prime Minister Harold Macmillan in December 1958 and later to become part of the M6. New signs were tested on this short motorway, requiring letters up to a foot high so that they would be visible to high-speed drivers. It was decided that the letters should be white on a blue background, as is still the case today. In November 1959, a 75-mile stretch of the M1 costing £22.5 million was the country's first major motorway to be opened. This time the job was left to Transport Minister Ernest Marples, who announced that, 'This motorway starts a new era in road travel. It is in keeping with the bold exciting and scientific age in which we live.'

Marples had good reason to speak so highly of the new motorway: he owned a road construction company. As Transport Minister he was not permitted to retain ownership of his company Marples Ridgeway, so he transferred his shares into his wife's name. This was viewed by the Conservative government of the day as eliminating any personal interest he might have in overseeing Britain's transport policies.

But the origins of the motorways went back long before Ernest Marples. The concept of segregated roads was first mooted by Lord Montagu of Beaulieu in 1906 and proposed by a private member's bill in 1924. A route was surveyed in 1938 but the war curtailed any further progress. Another problem was that a road which was only open to certain types of traffic broke the principles of open access to the king's highway and required a Special Roads Act, which was passed in 1949, finally opening the way to building the first motorways. The network grew slowly at first, with only 194 miles of motorway open by 1963; 1,731 miles had been built by 1984 but only 200 more miles were added in the next ten years. Later motorways were opened amid great protest, unlike the M1; on the first Sunday sightseers flocked to look at the new motorway, many of them picnicking on the approach roads.

Also this year...

Volvo patents the car seat belt but in a philanthropic gesture does not enforce its rights to the invention

The British Motor Corporation launches the Mini

Soviet rocket Lunik II *makes the first impact landing on the moon;* Lunik III *sends back the first pictures of the dark side of the moon*

The St Laurence Seaway opens, linking the Great Lakes with the Atlantic, 2,400 miles away

SRN1, the world's first hovercraft, is launched at Cowes

The M1 motorway opens, linking London and Birmingham

Racing driver Mike Hawthorn is killed in a car crash on the Guildford by-pass

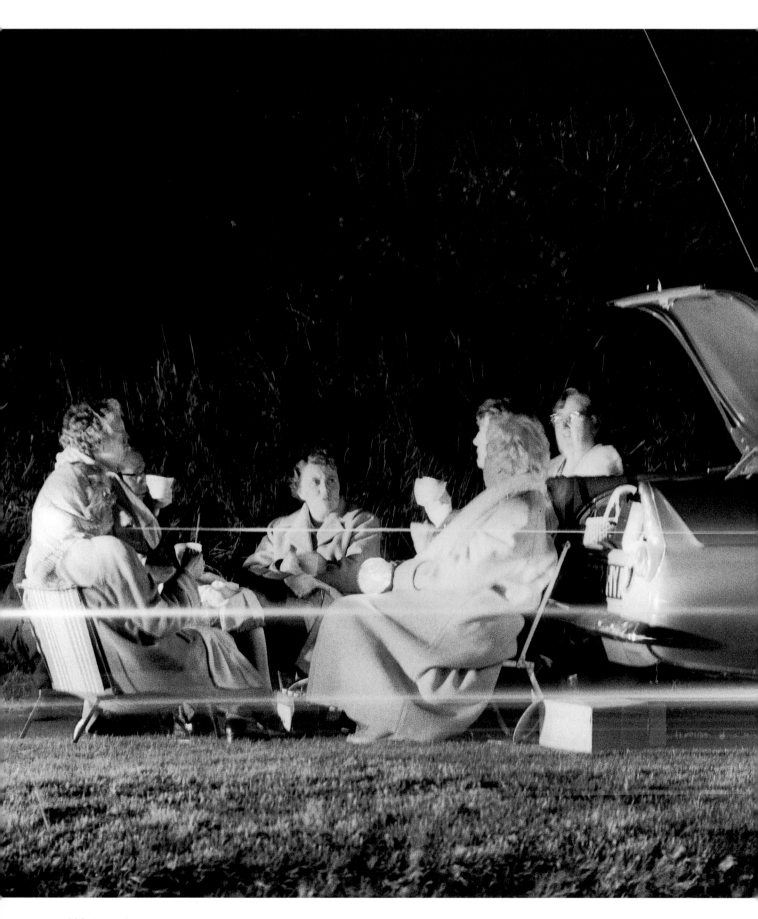

Tiredness can kill – take a break

Passing traffic is just a blur of tail-lights as one family stops for a welcome break and a cup of tea on the hard shoulder. In the 1960s the August Bank Holiday exodus was an infamous traffic nightmare as thousands of families took to their cars and drove all night on journeys to the countryside or the coast. The roads were packed with cars, many of them fully laden with luggage piled up on the roof, and as night drew in roadside verges were lined with cars and camper vans parked up as people settled down to sleep for the night – or to picnic, as this family is doing.

Picnic comes from the French *pique-nique*, and originally meant a fashionable party at which all the guests contributed food towards the meal. Often these parties were held in the open air, and later the word came to mean a meal which was eaten in the open, or one which was packed up to be eaten on an excursion. Although the family in the photograph is no doubt heading for a relaxing bank holiday weekend at the coast or in the country, travelling there with so many people and so much luggage can have been no picnic.

Since the Bank Holidays Act of 1871, the mass movement of people, particularly on the August Bank Holiday, has reflected the dominant mode of travel at the time. At the end of the 19th century working-class holidaymakers packed onto excursion trains, with the rise of the internal combustion engine they began to travel by charabanc or coach, and by 1960 people were travelling by private car. In the days of horse-drawn travel, private carriages were an exclusive symbol of wealth but from the 1950s onwards private cars came within reach of the masses and the roads were used as never before for leisure travel as well as business. In 1960 passenger miles by private means outstripped those by bus, coach and rail for the first time.

Also this year...

Gary Powers is shot down in the U-2 spy plane; the Russians claim he was spying while the Americans maintain that he was carrying out weather research and strayed off course. At his trial in a Russian court, Powers pleads guilty to spying, saying he was acting on the orders of the CIA

Jaguar buys Daimler with the assurance that Daimler cars will continue to be built, along with buses and armoured cars

Britain's first nuclear submarine,

HMS Dreadnought, *is launched*

The Aviation Minister announces that Britain will work with France or the US to develop a supersonic airliner

The first weather satellite is launched by the US

The USSR sends two live dogs into orbit and brings them back alive

The US Navy's nuclear submarine Triton *goes around the world in 85 days, without surfacing*

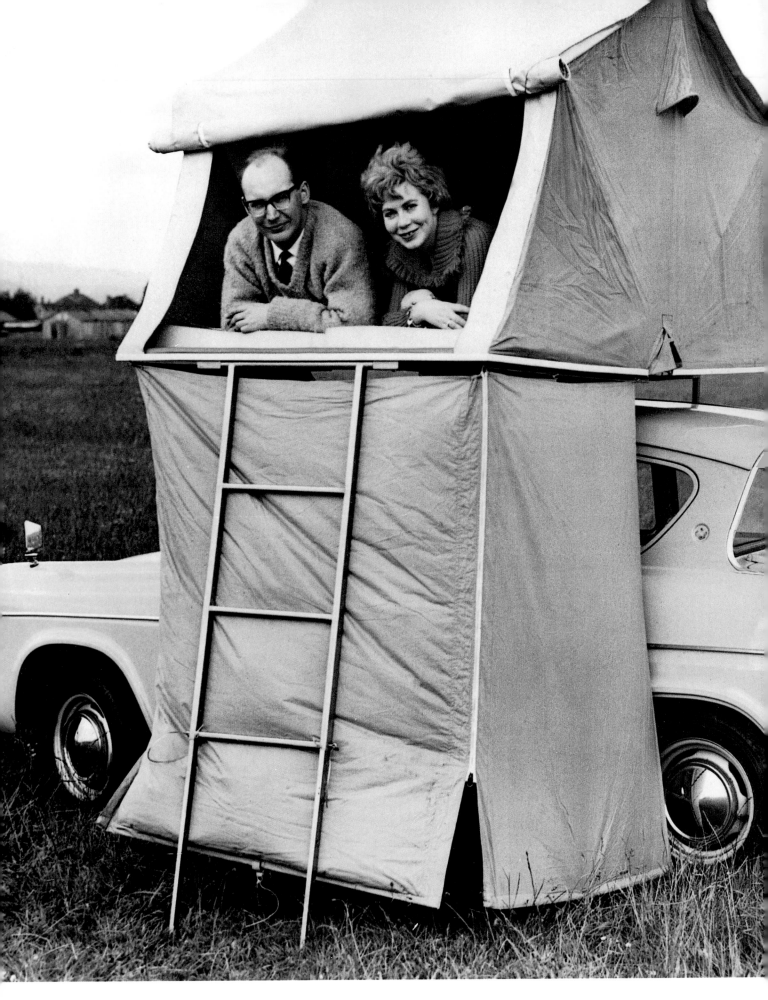

Room with a view

Many weird and wonderful new camping gadgets have gone on show over the years at the Camping and Outdoor Leisure Exhibition (COLEX) at Alexandra Palace, and the International Caravan Exhibition (ICE) at Earl's Court. Seen here is the 'Trotent', star of the ICE in 1961; the tent is supported by the roof of the car, sleeps two people and even has what is rather grandly described as 'a ground floor apartment for dressing or use as a loggia'.

Similar contraptions were made by Lightfoot Caravans, who showed a fibreglass 'Mo-bed' at COLEX in 1959, which folded down to 12 inches high for travelling on the roof of the car and opened up to 4 feet, 6 inches for sleeping in; like the Trotent, it had a ladder leading up to the first floor accommodation. Nearly twice as expensive, at over £60, was the 'Tent-o-matic', exhibited at COLEX in 1962. This was a frame tent which, like its competitors, was built around the roof rack of the car which would be used to carry it to a camp site. Once on site, the Tent-o-matic was the height of luxury because it would unfold itself automatically at the press of a button. Telescopic legs could then be added, which meant that, after releasing the roof clips, the car could be driven out from underneath the tent.

Also this year...

East Germany closes Berlin border and erects the Berlin Wall

Yuri Gagarin circles the earth in Vostok 1, *becoming the first man to travel in space*

Alan B. Shepard becomes the first American in space in a 15-minute, sub-orbital flight

Jaguar launches the E-Type at a cost of £2,196

The millionth Morris Minor rolls off the production line

British Rail launches an inquiry as to why the royal train broke down, delaying the Queen for more than an hour

A chimpanzee called Ham travels to 150 miles above the earth in an 18-minute flight to test the American Mercury space capsule; a month later a USSR rocket containing a dog is launched and lands safely

Dr Richard Beeching is appointed head of British Railways

The last steam train runs on the London underground

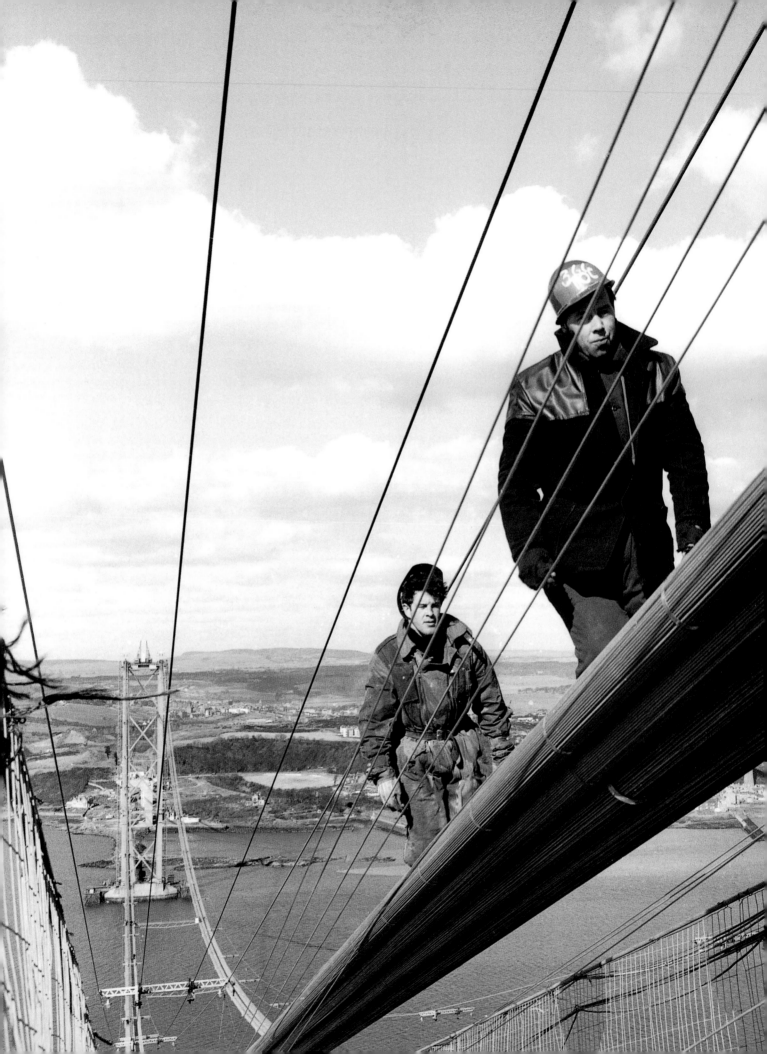

Walking the high wire

John Wann and Terry O'Connell walk nonchalantly up the suspension cable at the top of the Forth Road Bridge. A press release at the time of this photograph pointed out that 'winds can be ferocious but to date only one worker has been swept off the bridge to his death'. The Forth Road Bridge was built to alleviate severe traffic problems in the area which had previously been served by a narrow road that shared the Forth Rail Bridge (which can be seen in the background) and a ferry service that had become inadequate for modern traffic demands. Increased industry in the region led to the demand for a new bridge and work began in 1958; the bridge was opened in 1964.

A suspension bridge is a remarkable piece of engineering, breaking the vicious circle by which a long bridge will sag and to stop it sagging it must be stronger but strengthening it makes it heavier and therefore it sags more. Because of the way it is built, a suspension bridge need only be half the weight of an arch bridge of the same span, which is why the world's longest bridges are suspension bridges. Suspension bridges also exploit the properties of the materials used to build them. Steel is stronger when under tension than compression, so the bridge is hung from steel cables, while the opposite is true of concrete, so the downward forces of the bridge are carried by huge concrete towers: in the Humber Bridge, the tops of the towers are actually further apart at the top than the bottom to account for the curvature of the earth.

John and Terry are 'spinners', whose job is the spinning and tensioning of the suspension cables. A complete cable is far too heavy to be dragged over the towers in one piece, so each cable is spun out of thousands of lengths of much finer wire. To do this, a guide wire is passed over each tower and a wheel attached below it to carry a loop of fine wire to the other side, where it is checked for tension and fixed into an anchorage. This tedious process is repeated thousands of times and may take several months; the cables of the Bosporus suspension bridge are made up of 10,450 separate strands of 5mm wire. This is the stage that the Forth Bridge had reached in 1962, seen here with no roadway between the towers; the final stage of building is to attach steel hangers to the finished suspension cables and then attach the deck to the hangers.

Also this year...

The first passenger hovercraft service opens, run by British United Airways and operating between Wallasey in Cheshire and Rhyl in North Wales

The first push-button controlled

'Panda crossings' are introduced in London

The last trolley-buses are taken out of service in London

The Hyde Park underpass opens

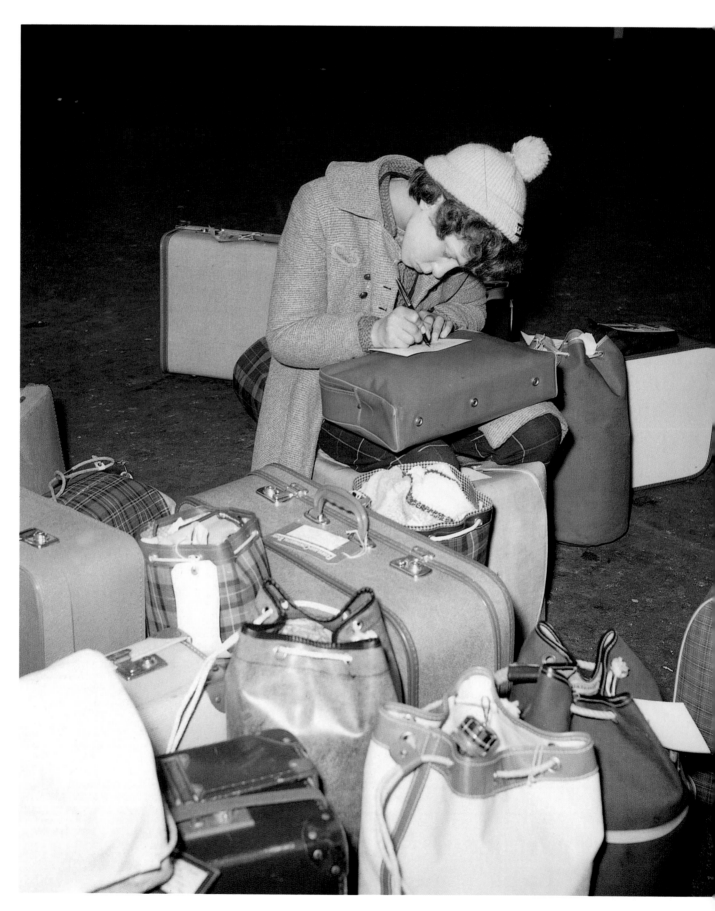

Wish you were here

Schoolgirl Julia Santer, of Ilmington Girls' School in Birmingham, writes a postcard home before she has even left England, as she sits surrounded by luggage at Victoria Station en route for a school trip to Germany. Travel had become far less formal since the early years of the century, with a bobble hat replacing the smart hats worn by Edwardian travellers, and suitcases and soft duffle bags taking the place of the heavy trunks which were once unloaded from cabs at London's stations.

However, postcards had been an element of holidays for over a hundred years. The world's first postcard went on sale in Austria during the 19th century but it was not especially pretty – a plain, cream-coloured card known as a *Correspondenz-Karte*, it had a primrose-yellow two kreuzer stamp printed on it and no other adornments. This was copied elsewhere and soon afterwards came the more familiar picture postcards showing local views – the first were made in 1872 by Locher's of Zurich. The growing use of postcards and international post called for an agreement between countries on postage rates, and the Universal Post Office was set up in 1874 to organize matters. Stamps were the obvious proof of postage, and had been used for inland post in Britain since the world's first stamp, the Penny Black, had been issued by the General Post Office in 1840. The UPO adopted the use of stamps and decreed that all stamps must bear the name of the issuing country. Britain was, and still is, exempt from this rule, in deference to the fact that stamps were invented in the UK.

Until 1924 Victoria Station was actually two stations side by side, one operated by the London Brighton & South Coast Railway and the other shared by the London, Chatham & Dover and the Great Western Railways. After the railways were grouped together, the new Southern Railway combined the stations by making a huge arch in the dividing wall and numbering all the platforms consecutively. Julia is waiting in the relatively spacious eastern part of the station, which is where most of the European services left from and which was known as 'The Gateway to the Continent'.

Also this year...

Valentina Tereshkova becomes the first woman in space, on Vostok 6

The Beeching Report recommends that over 2,000 railway stations should close

Mailbags containing £2.6 million are stolen in the Great Train Robbery

Britain's worst learner driver, *Margaret Hunter, is fined for driving on after her instructor jumped out shouting 'this is suicide'*

The first automatically controlled tube trains are introduced in London

A 50mph speed limit is introduced, but is ignored by most drivers

Lord Nuffield dies

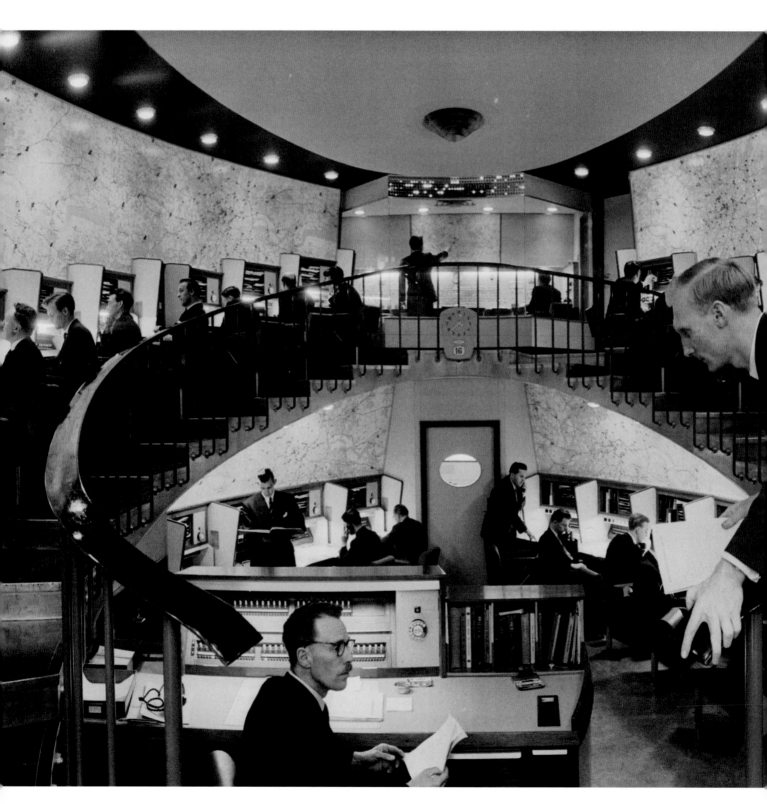

AAHQ

A dramatic view of the operations room at the AA's headquarters in Fanum House, Leicester Square. The operations room was on two levels, with tiered ranks of telephonists (all male) leading up to the glass-fronted radio room. The building was designed specially for the AA in 1923 close to where the organization was founded at the Old Trocadero restaurant in 1905. In 1940 it had been rendered almost uninhabitable when hit by two large bombs during an air raid but Fanum House was subsequently repaired and extended, and re-opened with this impressive new control room at its heart. The building still dominates the western side of Leicester Square, although the AA moved to the new Fanum House in Basingstoke in 1973.

A new control room was necessary for several reasons, not least the fact that there had been a huge growth in membership after the war. This was due to increasing numbers of cars on the roads and the introduction of an AA Breakdown Service Card which boosted membership still further. Meanwhile the AA was keeping up with the times by equipping its patrols with two-way radios, a scheme which began in London and was gradually extended until most of Britain was covered by 24-hour radio-controlled patrols. Today the AA operates a £30-million Command and Control system with a nationwide network of control centres which handle 5 million calls a year. A far cry from suited telephonists with paper and pencil handy, today's control system immediately inputs information into a computer system and each patrol van has its own mobile data terminal to download information from the control centre.

The AA's modern network of control centres not only co-ordinates the breakdown service but fulfils many other functions including broadcasting traffic information on the AA Roadwatch system, providing information for TrafficMaster and commercial radio traffic bulletins, and operating security measures such as Tracker, the stolen vehicle tracking system.

Also this year...

Bullet trains enter service in Japan

The first ticket collecting machine is installed on the London underground

Britain and France agree to build the Channel Tunnel

84 die as a British holiday plane crashes in the Alps

The Forth Road Bridge opens, Europe's longest bridge

It's a lot less bovver wiv a hover

The hovercraft SRN2 is seen reflected in the windows of a car at the Browndown Hovershow, near Portsmouth. Hover travel was a revolutionary form of transport which never quite fulfilled the excited dreams of its pioneers. At this show it was announced that plans were under way to build a gigantic 5,000-ton transatlantic hovercraft powered by jet engines from the then-embryonic Concorde. This enthusiasm may have been fuelled by the fact that Bristol Siddeley, who built the engines both for Concorde and for the first cross-channel hovercraft, still under construction at the time, were facing a take-over bid from Rolls-Royce.

The hovercraft was invented 10 years earlier by Sir Christopher Cockerell, an electronics engineer and amateur boat-builder who worked on radar during the Second World War and later on hydrodynamics, which led him to experiment by using air to reduce drag. He began by using two tin cans of different sizes, one inside the other, and, using a nozzle from a vacuum cleaner, blowing air into the gap between them. He discovered that the downward pressure under the tins was three times that of the air coming out of the nozzle. He patented his idea on 12 December, 1955 and the world's first hovercraft, the 3.5-ton SRN1, was launched for trials in 1959 at Cowes. This and subsequent hovercraft were built by Saunders-Roe, hence the notation.

That same year, on the 50th anniversary of Bleriot's cross-channel flight, the SRN1 made a channel crossing from Calais to Dover, but the jets of air which supported the craft did not give enough clearance to cope with the waves. Three years later this problem was overcome by means of a flexible skirt which raised the hovercraft much higher, allowing it to cope with rough terrain and waves of up to 7 feet. In 1968 the first cross-channel Hoverferry service opened between Dover and Boulogne; this meant that less than ten years after the tentative launch of the first prototype, a 200-ton hovercraft was in service, carrying 254 passengers and 30 vehicles across the channel at a speed of 60 knots.

Also this year...

Aeronautical engineer Owen Maclaren patents the Maclaren baby buggy

Soviet cosmonaut Alexei Leonev becomes the first man to 'walk' in space, even performing a somersault outside his craft; three months later, American Ed White follows suit

The millionth Mini is produced and is bought by Mr and Mrs James of Cheshire

A 70mph speed limit is introduced on British motorways

13 die in North Sea oil rig disaster

My car will still be in fashion when I'm dead

As part of a transatlantic craze for cramming people into a Mini, 15 young women bring the world record back to Britain, beating the old record which had been set by American college students. The Mini was a phenomenon from the moment it was launched, and the words of its designer, Alec Issigonis, have proved true: speaking to Italian stylist Pinin Farina, he commented that 'In two years' time your car will be like a lady's clothes – out of date. My car will still be in fashion when I'm dead.' A year after Sir Alec's death in 1988, Rover planned a revival pilot run of 1,000 Mini Coopers after their absence from the production line of 18 years – they were sold almost immediately, leading to production of about 600 cars a week.

It all started on 26 August, 1959, when the British Motor Corporation launched the Mini under two badges, Austin and Morris. In 1952, the two companies had merged to form BMC, the biggest car company in Britain. The creation of the fuel-efficient Mini was prompted by the threat of petrol shortages after the Suez Crisis, and was advertised as providing 'more room in less space'. This deceptive amount of room was created by the distinctive 'wheel-at-each-corner' design, rubber suspension, and a transversely mounted engine which BMC described as the 'east-west engine'. The tiny wheels gave the small body a muscular look and, being mounted at the corners, made for excellent roadholding. Various versions of the Mini followed, including the van, pick-up, estate car (Morris Traveller and Austin Countryman), Mini-Cooper, and much later the Clubman and the Metro. But it was the simple, minimal design of the classic Mini which caught the imagination of the world.

The Mini has played a starring role in several films, most recently 'The Avengers' and most famously 'The Italian Job'. It has been the chosen car of many celebrities – Marc Bolan died in one, Peter Sellers bought one as a birthday present for his wife Britt Ekland (as well as owning his own), John Lennon painted his, Paul McCartney didn't, Lord Snowdon did his bit for the class divide by driving one, Paul Smith added the designer touch and Enzo Ferrari eventually owned three, although he refused the first one because Issigonis had forgotten to move the steering wheel to the left.

Also this year...

Freddie Laker sets up his own airline to cater for the booming package holiday market

Jack Brabham wins the world drivers' championship in a car which he built himself

20 Argentinian nationalists 'invade' the Falkland Islands by hijacking an airliner and forcing it to land there

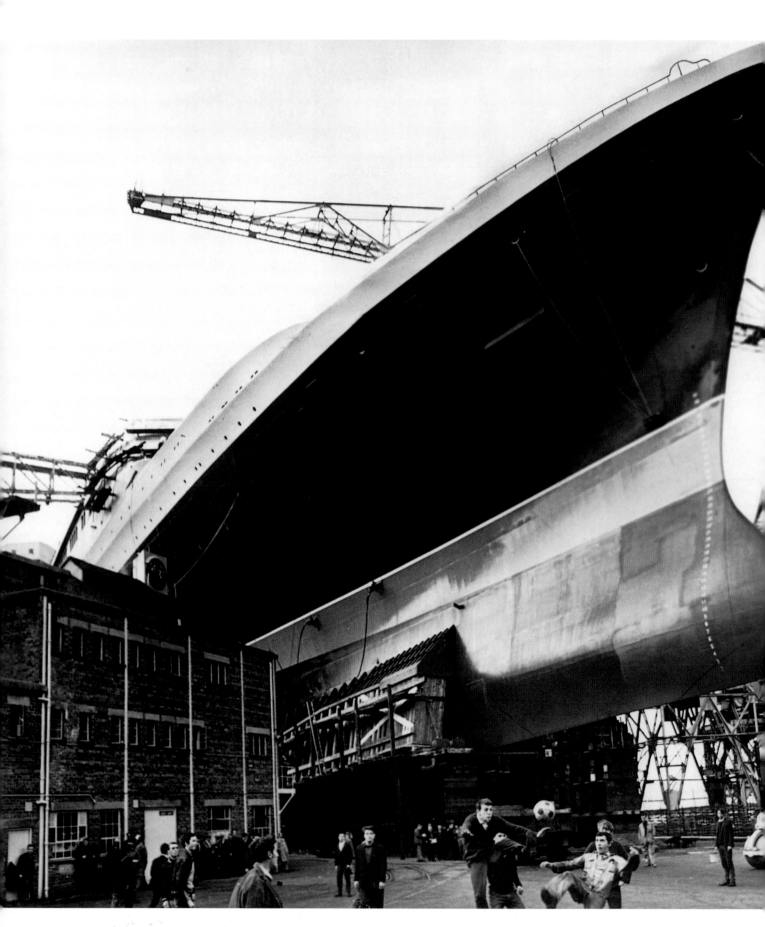

QEII launches QE2

The massive bows of the new £29-million Cunard liner Q4 at John Brown & Company's shipyard on Clydebank tower above off-duty shipyard workers playing a game of soccer. Just two weeks later, on 20 September, the ship was launched by Queen Elizabeth II and given the name Queen Elizabeth 2 – and there is a difference. Several possible names had been suggested but the Queen's own name was considered to be low down the list. At the launch ceremony Her Majesty was handed an envelope containing the name of the new ship – a traditional precaution ever since one elevated dignitary had forgotten the name of the ship being launched – but the Queen refused the envelope. 'I won't be needing that!' she said, and then announced, 'I name this ship *Queen Elizabeth the Second*. May God bless her and all who sail in her.' The Queen was the first reigning monarch to launch a liner but she had left Cunard with a problem – the name in the envelope was *Queen Elizabeth*.

The Chairman of Cunard discussed the matter with the Queen's Private Secretary and it was decided that the suffix 'Second' would be written as '2' rather than 'II'. It was a diplomatic solution to the problem that Queen Elizabeth II of England was in fact only Queen Elizabeth I of Scotland, where the ship had been built. 'II' would have been considered an insult to the Scots. The ship was also the second to be named *Queen Elizabeth*, and the '2' was a neat deference both to the Queen and to the Queen Mother after whom the first *Queen Elizabeth* had been named. The fact that the ship is now universally known as the QE2 removes the problem of whether to refer to her as the *Queen Elizabeth the Second* or the *Queen Elizabeth Two*.

Also this year…

Donald Campbell dies on Coniston Water in Cumbria while setting a world water-speed record; he achieved 328mph before his boat somersaulted out of control. His body was never found

Sir Francis Chichester completes his solo round-the-world yacht voyage

The Breathalyzer is first used on Britain's roads

Britain, France and West Germany agree to work together on a new airliner, the Airbus

British cyclist Tommy Simpson dies on the Tour de France

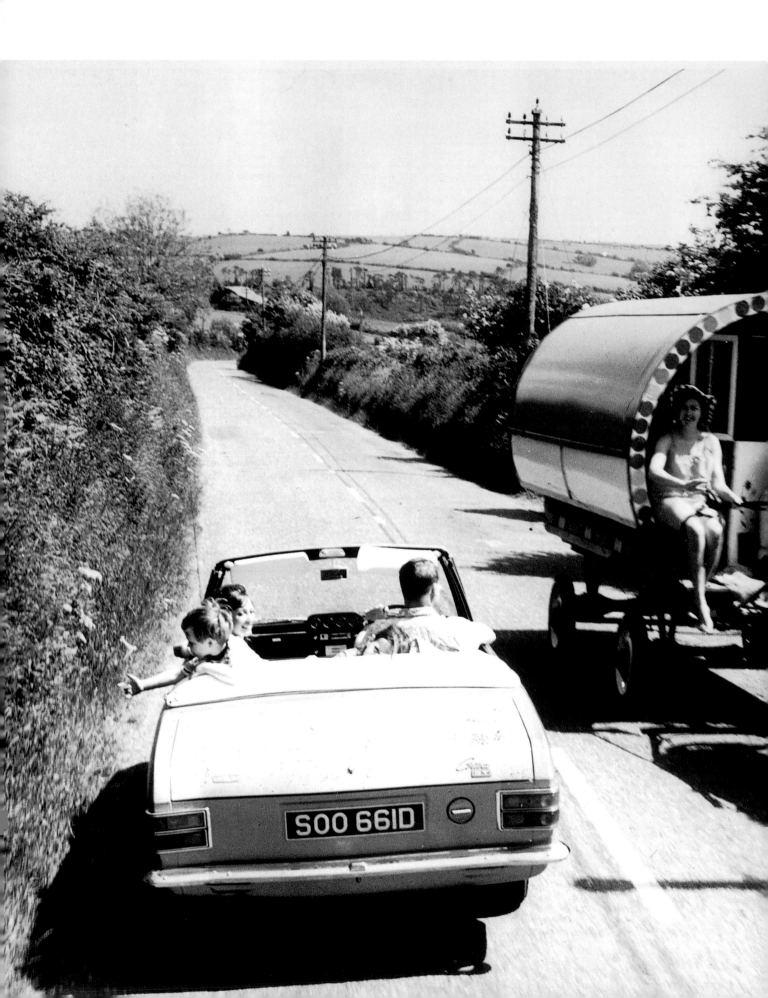

Holidays ancient and modern

Two ways to see the Irish countryside – one family enjoys the leisurely pace of a horse-drawn, gypsy caravan while another prefers the more modern approach of speeding around in a convertible. The unhurried peacefulness of the gypsy caravan was very popular with English holidaymakers, although this return to past modes of travel did not extend to the entire trip; it was part of an Irish Flyaway Holiday promoted by Aer Lingus.

Touring in a horse-drawn caravan was not only a trip around Ireland but a trip back in time. It was a very different experience from towing a caravan to a site because the gypsy caravan was a mode of transport as well as being a place in which to sleep. The slow pace of the horse-drawn caravan suited the lanes and the countryside of Ireland, and the romanticism of the gypsy caravan made for a holiday with a difference. Meanwhile, modern caravans were appearing in all sorts of strange guises, including an amphibious caravan called the Otter. This plywood-panelled caravan was powered by a 1.5hp outboard motor and was said to be capable of 4 knots when it had been unbolted from its chassis and launched on the water.

The uncrowded, twisting lanes of Ireland were also perfect for an enthusiastic car driver, particularly if the weather was good and the top was down. The Ford Cortina was the most famous family Ford of all time, possibly now being challenged by the Escort. The Cortina was first introduced in 1962 and sales had reached a million before it was restyled as the Mark II, seen here, which appeared in 1966 and was just as successful. Production of the Cortina lasted 20 years before the Mark V was finally replaced by the Sierra in 1982.

Also this year...

A hoverferry service between Dover and Boulogne opens, run by British Rail

Yachtsman Alec Rose returns home after sailing round the world

American astronauts orbit the moon in Apollo 8

The US introduces laws to reduce vehicle exhaust fumes

'Concordski', the Tupolev Tu-144, becomes the first supersonic airliner to fly; however, it never goes into full service

Leyland and the British Motor Corporation say they will merge as the British Leyland Motor Corporation

1,000 trains are cancelled as the National Union of Railwaymen begins a work-to-rule

The first part of the Victoria Line is opened, between Walthamstow and Highbury

Jaguar unveils the XJ-6

Yuri Gagarin is killed in a plane crash near Moscow

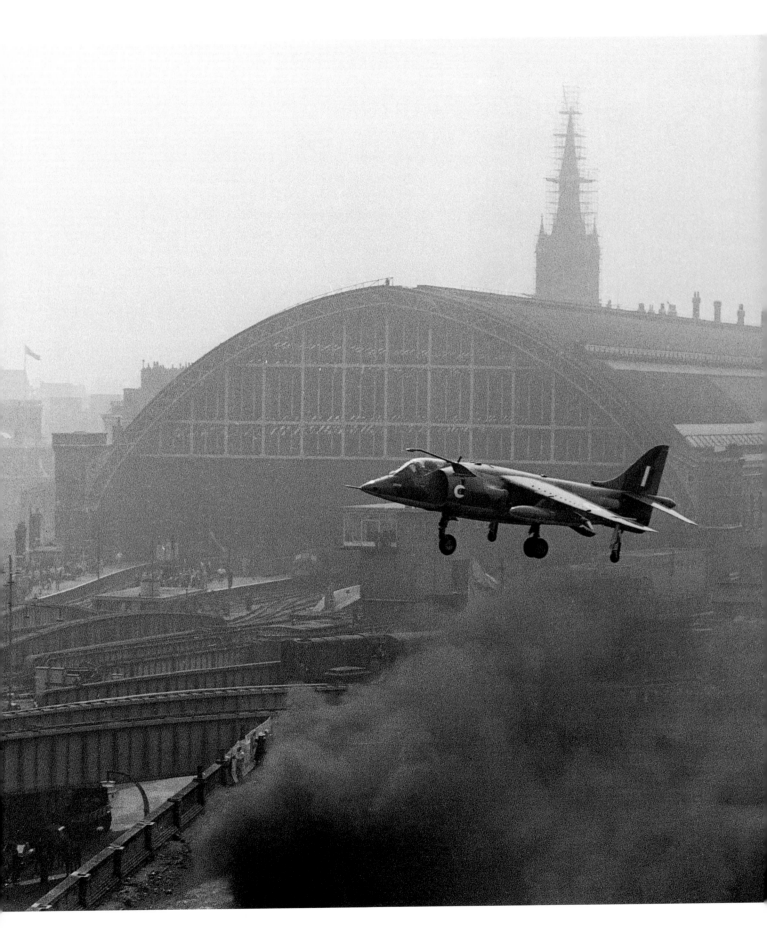

I will not jump with common spirits...

A Hawker Harrier jump-jet takes off from a disused coalyard near St Pancras station. Engineers at Hawker-Siddeley may not have been thinking of the Merchant of Venice but they certainly produced a plane that set itself apart from the multitude. The quest for a V/STOL (vertical/short take-off and landing) aircraft had been ongoing for years, with companies trying to produce an aircraft that would combine the usefulness of a helicopter's vertical take-off with the speed and performance of a conventional aeroplane.

Several companies produced strange-looking aeroplanes with tilting propellers on their wings. They took off with the propeller shafts vertical and the rotors turning horizontally above the plane, and the propellers then tilted into a conventional position during flight. But as early as 1954 Rolls-Royce had built the famous 'Flying Bedstead' with which they successfully demonstrated the potential of using jet engines to provide vertical lift. Hawker-Siddeley designed the P.1127 Kestrel, which first flew in 1961, and from that they developed the famous Harrier, seen here, which made its first hovering flight in 1966 and entered service in 1969.

In some ways the design is no different to the tilting rotors of the propeller planes; the Harrier's four Pegasus turbofan jet engines can be directed downwards for take-off or hovering flight, and backwards for high-speed conventional flight. The Harrier is built jointly by McDonnell Douglas (Boeing) and British Aerospace, and is now so advanced that not only does it dispense with the need for a runway with its vertical take-off, but it can stop, hover, and turn on the spot in mid-flight.

Also this year...

Neil Armstrong becomes the first human to set foot on the moon

Jackie Stewart becomes world motor racing champion

Concorde 001 makes its maiden flight at Toulouse

Czechoslovakia becomes the first country to make the wearing of seat-belts compulsory

The QE2 makes her maiden

Atlantic crossing four months late after trouble with the turbines

The Boeing 747, aka the Jumbo Jet, makes its first flight

Nearly 50 people die when an airliner crashes into houses near Gatwick Airport

Ford unveils the Capri; British Leyland launches the Austin Maxi

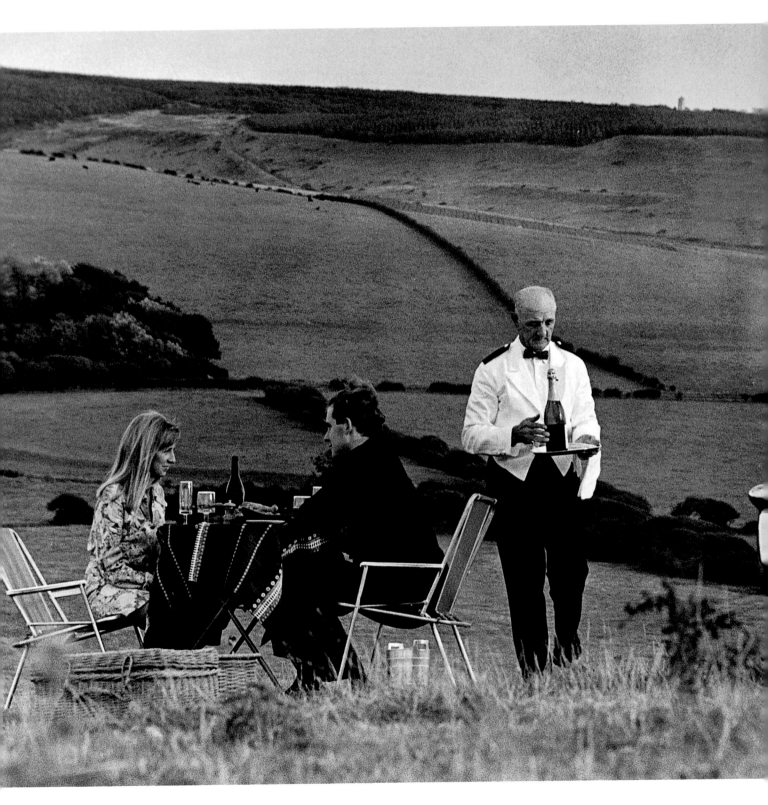

The Hungry Monk

Rolls-Royce has been a synonym for quality almost since Henry Royce became dissatisfied with his Decauville and decided to build his own car. He later teamed up with Charles Rolls and in 1906 a legend was born, although there was still the problem of what to call the car. The story goes that Rolls suggested giving it their two names and Royce replied delightedly, 'I like that. Royce-Rolls! Yes, it has a ring to it.' Even royal chauffeurs went to Rolls-Royce for tuition, and came away with a copy of the *Rolls-Royce Chauffeur's Guide*, complete with helpful hints on how to handle 'royal personages'. There could be no other choice of car, therefore, for a company offering a luxury champagne picnic service complete with uniformed butler.

Nigel Mackenzie set up the Hungry Monk restaurant when he was just 22, and since he lived close to Glyndebourne the idea of a luxury picnic service was too good to resist. He bought three Rolls-Royces, of which his favourite was the Silver Cloud, and employed Frank Clarke to play the role of James. Frank was a fully trained chauffeur and butler, and when the Rolls-Royce arrived at its destination he would change into his butler's uniform, set up the picnic and serve the champagne; afterwards he would change back into his chauffeur's uniform and drive his passengers home.

If one apocryphal story is indeed true, Rolls-Royce had already become a superlative noun by the time of Labour MP Aneurin Bevan, who described one Tory MP's maiden speech as 'the Rolls-Royce of speeches – it was smooth, inaudible and seemed to go on forever.' Michael Caine bought his first Rolls-Royce before he could drive. His accountant told him that he was now a millionaire and he thought he ought to have a Rolls-Royce so he added it to his weekend shopping list. The scruffy-looking young actor was turned down by a snobbish salesman at the first dealership and tells in his autobiography how he bought a convertible at the next Rolls-Royce dealer and then took great delight in being driven slowly past the original showroom giving V-signs to the salesman.

Also this year...

Heathrow airport welcomes its first Jumbo Jet; airport facilities can barely cope with the number of passengers and luggage is lost in the confusion

The crew of Apollo 13 *survive for four days after an oxygen tank bursts, before returning safely to earth*

A 2,460-mile trans-Australia railway opens, from Sydney to Perth

P&O ceases services to India after 130 years

The minimum fare on the London underground rises by 50% to 1s

Rover launches its new four-wheel drive, the Range Rover

Next services 240,000 miles

David Scott, Commander of *Apollo 15*, takes the Lunar Rover for a spin on the surface of the moon. He is seen here after completion of 'extra-vehicular activity' and is driving back to the lunar module, *Falcon*, with samples of rocks and soil. The Space Race, fuelled by the enmity between the US and the USSR, meant that space travel developed very quickly after the launching of the first unmanned satellite in 1957. Yuri Gagarin became the first man in space in 1961 and only eight years later, in 1969, the Americans succeeded in putting men on the moon. Two years later, astronauts had the luxury of taking a car with them to the moon on a one-way hire.

The Lunar Rover was a collapsible buggy in which David Scott and James Irwin were able to travel several miles across the moon's surface, steering their way carefully between boulders and craters to collect samples of moon rock from much further afield than previous missions had been able to do. Although *Apollo 15*'s landing site was the Sea of Rains, that is not an umbrella on the front of the buggy but a communications aerial which successfully sent back to earth high-quality colour pictures of the excursion. The buggy's wire-mesh wheels would have collapsed under the vehicle's weight on Earth (463lbs) but under the moon's gravity its weight was only 77lbs. The Lunar Rover was designed to steer with all four wheels but the astronauts discovered that the front wheel steering wouldn't work – fortunately they were able to manoeuvre the vehicle using the rear wheels.

Scott and Irwin were the seventh and eighth men to walk on the moon and the first to drive there, while the third member of the crew, Alfred Worden, had the frustrating task of waiting in orbit above the moon. *Apollo 15* splashed down safely on 7 August but the Lunar Rover, like equipment from other missions, was left in the eerie silence of the moon, where it remains to this day.

Also this year...

Rolls-Royce is declared bankrupt

London Bridge is sold and removed to Arizona; legend has it that the Americans thought they were buying Tower Bridge

Ted Heath skippers Britain to victory in the Admiral's Cup at the helm of his sloop Morning Cloud

The USSR launches the first space station, Salyut I, *which remained in orbit for six months*

The USSR lands the first probe on the surface of Venus

Foreign airlines flying into Seoul threaten to ban tourist flights there after a hotel fire kills 156 people

The UK Civil Aviation Act is passed, establishing the Civil Aviation Authority (CAA) and the British Airways Board

Spaghetti car-bonara

Spaghetti Junction the day after its official opening, seen as it rarely has been since, almost empty of cars. Built at Gravelly Hill near Birmingham, this is Europe's biggest multi-level interchange and cost £30 million to construct. Sadly the junction is renowned not for making journeys faster and easier but for being confusing and often gridlocked with traffic.

Although Britain's motorways are now hopelessly overcrowded they have cut journey times; for example, in 1960 the M1 halved the time of coach journeys to and from Birmingham. They also reduced fatal accidents to less than half the level on ordinary roads, although two lorry drivers were killed in the M1's first fatal accident within a week of it opening. Motorways are notorious for the effect they have had on the landscape but one of the hidden effects of the motorway network is the way it has altered the demographics of cities. Commuting zones have become much wider, industry has relocated to motorway corridors, particularly along the M4, and city suburbs have been demolished and reshaped in a way not seen since the arrival of the railways. Urban motorways led to huge protest, beginning in the western suburbs of London with the arrival of the M4, continuing with the destruction of southern Leeds in the 1970s for the extension of the M1, and building to fever pitch in the 1980s with the rise of the 'green' movement, culminating in direct action against the extension of the M11 through the east of London.

As this photograph shows, motorways need an enormous amount of space and resources with their access roads, service areas, lighting and drainage. Even in 1972 the cost of building a motorway was about £2 million per mile and attracted huge public criticism of both the environmental impact and of the amount of money being spent.

Also this year...

118 die in Heathrow's worst air crash to date

Arson is suspected as Cunard's Queen Elizabeth, *now a floating university, catches fire in Hong Kong harbour*

John Fairfax and his girlfriend Sylvia Cook arrive at Hayman Island off Australia, having rowed across the Pacific

Travel firm Thomas Cook is denationalized after 24 years and is bought by a consortium of Midland Bank, Trust House Forte and the AA

Bomb disposal experts parachute onto the QE2 *in mid-Atlantic after a bomb warning and ransom demand are made to Cunard's New York office*

Ford launches the Granada

A Uruguayan plane crashes in the Andes and 16 survivors are forced to eat the bodies of the dead to survive

Sir Francis Chichester dies

Whicker's wheels

Instead of queueing for his petrol coupons, Alan Whicker is out and about on his bicycle, and he didn't even have to queue up for that – it was presented to him by Raleigh Industries in a ceremony at the Dorchester Hotel, London.

On 26 November, 1973 Peter Walker, the Trade and Industry Secretary, announced to the Commons that the government was printing 16 million petrol ration books in response to the OPEC crisis which had seen oil prices rise by 70%. He stressed that it was a precaution and that rationing would not necessarily be imposed but that the ration books had to be issued before the Christmas postal rush. There had been no shortfall of crude oil reaching Britain but companies were stockpiling oil in case the crisis worsened, and 200 petrol stations had already closed in Britain due to a shortage of petrol. On 5 December a compulsory 50mph speed limit was introduced in order to save fuel and on the 12th Raleigh made their presentation to Alan Whicker; the message was to save a few pounds on petrol and lose a few pounds in weight at the same time.

Alan Whicker's travels began long before he became a travel journalist. He was born in Cairo and served in the Devonshire Regiment during the Second World War, where he was part of the Army Film and Photo Unit. He then became a war correspondent, reporting from Korea, before joining the BBC for 11 years, from 1957–68. He worked on the *Tonight* programme and began *Whicker's World*, his famous series of documentaries, in 1958. Whicker was described as 'television's most travelled man' and in *Whicker's World* he reported from all over the globe, interviewing the ordinary people that he met on his travels as well as celebrities and the rich and famous. Other programmes included *Whicker Down Under*, *Whicker Within a Woman's World*, and *Whicker's World Aboard the Orient Express*. His programmes became so popular that they even warranted a sketch by the Monty Python team. He received numerous awards for his work, including the Royal Television Society Silver Medal and the Richard Dimbleby Award.

Also this year...

US space station Skylab *is launched*

Israeli jets shoot down a Libyan Boeing 727, killing 74 passengers and crew

OPEC increases oil prices by 70% and smaller, more efficient cars start to become popular

A suspension bridge opens across the Bosporus, linking Europe and Asia

Jackie Stewart quits motor racing immediately after his team-mate François Cevert is killed during practice for the US Grand Prix; he has already amassed enough points to ensure his third world championship

'Concordski', the Russian supersonic airliner, crashes at the Paris air show

She's a junkyard angel

At the beginning of the century a car such as this one would have seemed like science fiction, and in 1923 when it was built it was the height of modernity – yet by 1974 it is being dug out of the ground by archaeologists as a piece of history. This Canadian Buick was found along with another vintage car on a dig at Petersfield, near Portsmouth.

The Buick company was formed by David Dunbar Buick in 1903 but got off to a slow start, not producing any cars until 1904 and then being almost immediately bought out by William Durant. Durant reorganized the company, bought a new factory and produced the Model C, which became such a success that by 1907 Buick was second only to Ford in US car sales. In 1908, the year that Ford released the Model T, Buick became the mainstay of Durant's business empire, General Motors. Indeed, Buick helped to keep the parent company afloat when GM hit financial problems in 1910, a year when Buick sales outstripped those of all other car manufacturers worldwide. By 1914, Delco electric lights and starter motors were standard on all Buicks and the company released a six-cylinder model. It was the six-cylinder range, such as the car being exhumed in this picture, which became Buick's strength in the 1920s, and which gave Bob Dylan the title for his song 'From a Buick 6'.

Also this year...

A new 55mph speed limit in the US results in a dramatic reduction in road deaths

General Motors introduces the first catalytic convertor

A bomb blows up a coach carrying servicemen and their families on the M62

23 people are killed as three car bombs go off during the rush hour in Dublin

Four-star petrol rises to 50p a gallon

40,000 British holidaymakers are stranded after the leisure group Court Line, owner of Clarksons and Horizon Holidays, goes bankrupt; another 100,000 have holidays booked and are unlikely to get their money back

A rail strike cripples train services in the UK

The Harland and Wolff shipyard is taken over by the government

Tilting at windmills

The famous Tilting Train never actually made it into full service, being superseded by other high-speed trains before its many problems were ironed out – and there were manifold technical problems as well as the apocryphal stories of crockery crashing off tables and people being seasick as the train went round corners.

In terms of passenger travel, speed had historically been the key to the success of the railways, allowing people to travel further, and faster, than ever before. The concept behind the Tilting Train, or Advanced Passenger Train (APT) as it is officially known, was to design a train which could travel at high speed on existing track rather than building new lines at a huge cost, as had been done in Japan. British Rail research in the 1960s into the dynamics of rail vehicles showed that speed was related to the train's suspension and the severity of curves in the track. Given that the idea was to avoid re-laying track, this led to the development of the APT, whose tilting suspension would theoretically make it possible to travel at top speeds of up to 155mph and, more importantly, to maintain high speeds on curves. The APT was designed to travel up to 40% faster on curves than conventional trains could do, which was crucial given that half of British Rail's routes ran over curved track.

This photograph shows an experimental APT, whose promising results in tests led to the construction of three 25kV electric APT prototypes which began trials in 1979. The APT made an unsuccessful start in public service in 1981 which led to modifications and further tests but the unreliability of its hydrokinetic braking system and failures in the tilt mechanism and gearboxes meant that the whole idea was abandoned in 1986. By then InterCity had commissioned the IC 225 and embarked on a programme of track modernization which included easing the curvature of the lines.

Also this year...

35 die in the Moorgate Underground crash as a train runs at high speed into a dead-end tunnel

The world's first regular jetfoil service starts in Hong Kong

The Suez canal reopens eight years after Egypt's defeat by Israel

Russian and American astronauts shake hands in space as Apollo *and* Soyuz *dock 140 miles above the Atlantic*

British Leyland, the maker of

Austin, Morris, Rover and Jaguar cars, is nationalized

The US introduces a petrol-saving law requiring all cars to achieve at least 27.5 miles to the gallon by 1985

Unleaded petrol goes on sale in the US

Graham Hill, twice world motor racing champion, dies with five members of the Lotus grand prix team when the plane he is piloting crashes near Elstree Airport

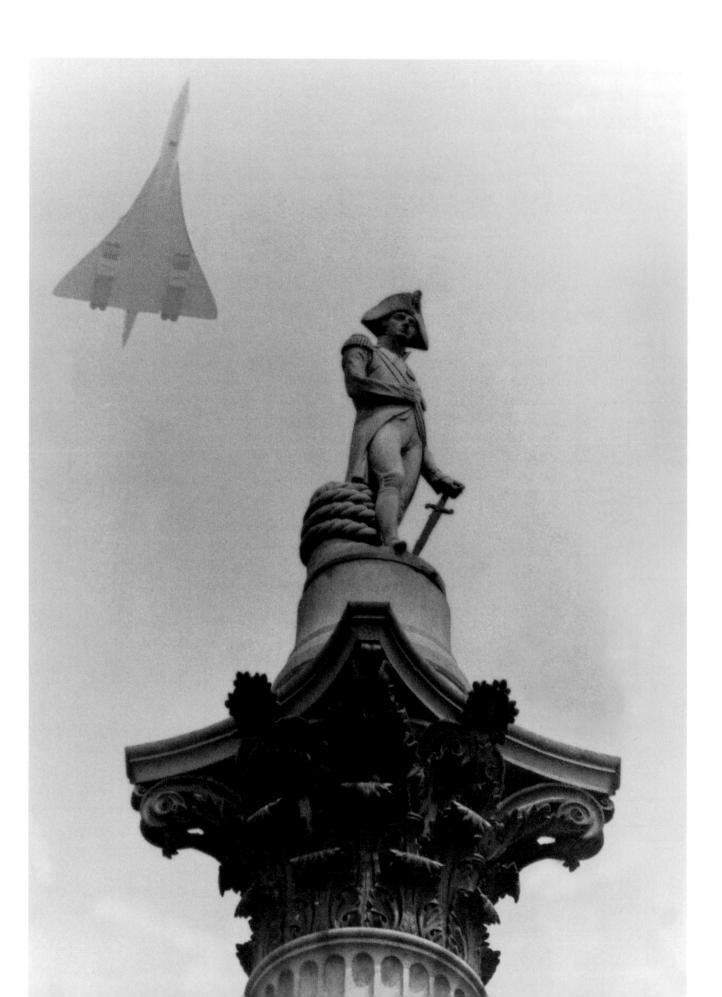

I see no planes

Nelson never actually said 'I see no ships': his actual words, as he put his telescope to his blind eye, were 'I have a right to be blind sometimes... I really do not see the signal.' What he would have made of the idea of a supersonic passenger airliner is not known but, even if he had turned a blind eye to it, he could hardly have ignored the deafening roar of Concorde's four Rolls-Royce Olympus engines as it flew overhead.

Concorde is still the world's only supersonic passenger plane and was hailed as a triumph of international co-operation, although there was a squabble as to whether the name should end in an 'e'. Concorde originated from separate British and French projects that were too expensive to be undertaken by a single nation, so in 1962 they were amalgamated and the result was the distinctive delta-winged plane we see today, with its famous 'droop snoot', a nose section which can be lowered to provide better visibility for take-off and landing. Concorde 001 made its maiden flight at Toulouse in March 1969 amid great excitement over projected sales of more than 400 Concordes to 16 different airlines. A month later the British-built prototype, Concorde 002, made a 20-minute flight from Filton, near Bristol, piloted by Brian Trubshaw who described it as a 'wizard flight'. However, celebrations were tempered when noise complaints greeted Concorde's first landing at Heathrow, and noise levels were recorded at twice the US limit.

Supersonic passenger travel became a reality in January 1976 when Concorde went into service with simultaneous take-offs from London to Bahrain and Paris to Rio de Janeiro; four months later transatlantic services began, flying from London and Paris to Washington's Dulles International Airport. Concorde can carry 144 passengers across the Atlantic in as little as three hours, travelling at 1,450 knots or Mach 2.05, more than twice the speed of sound. The plane has been hailed as an outstanding technical success but political and environmental objections meant that only 2 pre-production and 14 production aircraft were ever built, and Concorde has only ever been operated by British Airways and Air France. Early hopes of being allowed to fly into America slumped when the lawyer hired to win landing rights publicly announced 'Concorde is noisy as hell.'

Also this year...

Niki Lauda crashes in the German Grand Prix and is seriously burned

An Air France airliner is hijacked at Entebbe

Howard Hughes dies in the air of a stroke en route from Mexico to Texas in his private jet

Percy Shaw, the inventor of Catseye's road studs, dies at the age of 86

Come fly with me

On 26 September, 1977 Freddie Laker launched his Skytrain service to New York. Laker started in the airline business using his £40 RAF pay-off in 1946, and succeeded in turning British United Airways into Britain's largest independent carrier. With Skytrain, he promised: 'I will make possible cheaper and longer holidays by efficiency and speedier travel.' During the inaugural flight he walked through the cabin and personally thanked all 272 passengers for 'helping to prove me right' and for having faith in his ability to provide a service which promised cheap flights for all.

He accused the major transatlantic airlines of trying to make Skytrain fail before it had even begun, saying that they 'dared to go for me with a knife and tried to slit my throat... all they have managed to do is to improve our licence and open the flood-gates for lower-price air travel all over the world.' He then announced that even with such low fares he had made £2,176 clear profit from the first flight. Six scheduled airlines almost immediately launched cut-price fares of their own.

In June of the following year Freddie Laker was knighted and by July his 'no frills' service was so popular that it was causing scenes of chaos at Heathrow. Most passengers for the inaugural flight had queued for more than 24 hours to pay £59 for this, the first walk-on transatlantic flight – a normal single fare to New York at the time was £186, more than three times Laker's fare. For an extra £1.75 passengers were served a meal of pâté, beef in red wine, apple pie, cheese and biscuits and a small bottle of wine, and the only frills were that the cabin was decked out with Union Jacks.

Sadly, the airline collapsed in February 1982, its demise blamed on the recession, high interest rates on the cash borrowed to buy his fleet of DC-10s, and the rise in value of the dollar against sterling. Offers of help came from an anonymous businessman, who said that Sir Freddie had done more for British enterprise than anyone in the last 25 years, a merchant bank, suggesting it could raise £25 million, and a ten-year-old boy offering his savings of 16p.

Also this year...

The space shuttle makes its maiden flight, launched from the back of a 747

574 are killed when two Jumbo jets collide on the ground in the Canary Islands

Rocket engineer Wernher von Braun dies; during the Second World War he developed the V2 rocket and later worked in America on the Saturn 5 moon rocket

German anti-terrorist troops storm a hijacked Lufthansa jet at Mogadishu, freeing all the hostages

Airport sleepers

Two would-be holidaymakers sleep in the passenger lounge at Heathrow airport during delays caused by a go-slow among French air-traffic controllers, which sadly was all too common an occurrence in the 1970s and 1980s.

Minister of Aviation Lord Winster officially opened 'London Airport – Heath Row' on 31 May, 1946 but the story goes back further than that. In 1929 Richard Fairey bought 150 acres at Heathrow from the vicar of Harmondsworth in order to set up an aerodrome. Local residents were worried about the environmental implications but placated by the fact that it was a test aerodrome and there would be very few flights! During the Second World War the Air Ministry decided that Heathrow should be developed as an airport, initially for carrying troops and then, after the war, as a civil airport. The Ministry used emergency wartime powers to draw up a compulsory purchase order for land which included Fairey's aerodrome, and work began. When Heathrow was transferred from military to civilian control after the war it had 'few facilities apart from a row of huts and tents and a few telephone boxes', but work progressed quickly on new runways, control towers and the first terminal, which was called the Europa Building.

The present Terminal 1 was opened in 1969 and now handles 24 million passengers a year from 14 different airlines. At the same time the Europa Building became Terminal 2 and what had been an annexe for domestic flights became Terminal 3. The arrival of the first Boeing 747 jumbo jet at Heathrow in 1970 caused havoc because of the number of passengers. The sheer size of the plane meant that Terminal 3 had to be extended and the runways lengthened from 9,000 to 12,000 feet. As the airport expanded bigger car parks, a bus station, rail links and eventually an Underground station followed. By 1977 Heathrow had overtaken the Port of London as Britain's busiest port in terms of the value of goods carried, and still the airport continued to expand. Prince Charles opened Terminal 4 in 1986, and planning permission has been requested for a fifth terminal.

Also this year...

3 Americans achieve the first Atlantic crossing by balloon, a 137-hour journey in the helium balloon Double Eagle II

A solar-powered car runs at 8mph in England

Nearly 200 holidaymakers are

killed when a liquid gas tanker lorry crashes into a crowded Spanish camp site, where it explodes

Freddie Laker is knighted

11 die in a fire on the Penzance-London sleeper

Holy hitchers

One way of travelling is to use your thumb; here two nuns and a monk are praying for a ride in Denmark, having hitched there from Ireland. It is ironic that the word hitchhike stems from an old English dialect word meaning 'to walk a long distance' when the whole point of hitchhiking is to walk as short a distance as possible. In the countryside people have hitched rides to speed up their journeys since the days of the horse and cart, but the idea of standing at a busy roadside and thumbing a lift as a planned means of travel is a 20th-century phenomenon. And it is not as easy as it seems.

The key to success is for the hitchhiker to remember that they only have about eight seconds to convince a driver to pick them up; eight seconds to persuade someone who is safe and secure in their car, without even speaking to them, that it is worth stopping to give a ride to a total stranger. There are techniques to increase the chances of hitching a ride, most of them to do with looking trustworthy and clean. Rule number one is: hitchiking is not about just standing at the side of the road and sticking your thumb out: the nuns seem to have forgotten that one. Suggestions on dress for hitchers are: don't wear a hat, drivers don't trust people who cover their head, and don't wear black, it is seen as a danger signal. Wrong again! A hitcher's sign should be written clearly in large letters, stating the destination and prominently showing the word 'please' in the local language. Sign? Oh, and don't stand in a place where the traffic is moving quickly. Right...

The holy trinity in the photograph have ignored most of the basic rules of hitchhiking and yet they have succeeded in making it all the way from Ireland to Denmark. There must be something about them that drivers perceive as trustworthy.

Also this year...

The 'Winter of Discontent' sees Britain paralyzed by industrial action including a series of one-day rail strikes

18 people are killed and 25 boats wrecked in the Fastnet Race

US racing cyclist Bryan Allen flies a pedal-powered aircraft across the channel from England to France

Brighton becomes the first British resort to provide a nudist area near the town centre, after a campaign from grandmother Eileen Jakes

The year begins with a series of one-day rail strikes

British Leyland announces that it will cease production of all MG models

Who are you?

Almost two decades after the infamous seaside clashes between mods and rockers, 1980s mods still visit Brighton on their Vespas. At the centre of the picture, one helmet proclaims the name of mod band The Who. The band cut their last album just two years later; singer Roger Daltry went on to become a respectable country gent with his own farm, and guitar-smashing Pete Townsend became a poetry editor.

In the early 1960s teenage gangs of mods on their trademark scooters, and rockers on more powerful motorbikes, had made it something of a Bank Holiday ritual to do battle on the beaches of England's south coast resorts. In August 1964 police were flown to Hastings to break up rival gangs, and other clashes occurred at Southend, Bournemouth, Clacton, Margate and, most famously, at Brighton. The newspapers gleefully reported 'an orgy of hooliganism', prompting the Home Secretary to promise 'firm action', while the magistrates were more realistic and simply dismissed the brawlers as 'little sawdust Caesars': one young rebel paid his fine by cheque.

The first motor scooter was a curious-looking machine called the Auto-Ped, which appeared on the streets of New York in 1915. It had a top speed of 35mph and looked very much like a child's scooter, with no seat and a platform for the rider to stand on. But it wasn't until 1946 that the first commercially successful motor scooter arrived – the Vespa, the Italian word for wasp. The Vespa was one of the quirky technological results of the Second World War, and was conceived after the RAF had destroyed the Piaggio aircraft engine works at Pontedera. Enrico Piaggio asked one of his engineers to come up with a simple means of getting round the wrecked plant and Corradino d'Ascanio came back with a machine that had all the characteristics of a modern scooter: an open frame with flat footboard, a completely enclosed engine, small wheels on stub axles... and a sound like a wasp.

Also this year...

The Greek cargo ship Athina B *runs aground near Brighton*

The space probe Voyager 2 *sends pictures revealing the 15th moon of Saturn*

The 10-mile St Gotthard tunnel under the Alps opens to traffic

Transport Secretary Norman Fowler unveils plans to sell off Sealink and British Rail Hotels

British Leyland agrees to sell its MG works to a consortium headed by Aston Martin-Lagonda but the consortium fails to find the money to buy the plant

British Leyland launches the Mini Metro

146 people die when a Boeing 727 crashes in Tenerife

Soichiro's dream

A report in September 1973 showed that foreign cars were outselling British Leyland for the first time; sales figures for August had showed that foreign cars made up 32% of the British market, with Datsun making nearly 1 in 20 of all cars sold in Britain. British Leyland chief Lord Stokes asked the government to take action against the tide of imports, and Trade and Industry Secretary Peter Walker said that he was willing to discuss export restrictions with the Japanese. But this picture of Honda Civics waiting for shipment on the docks at Yokohama shows that far from being stemmed, eight years later the tide was rising.

The story of Soichiro Honda is that of a determined rise from poverty to president and then 'supreme advisor' of a worldwide business empire. Born in 1906, one of nine children of whom only four survived, he was the son of a blacksmith who also repaired bicycles to supplement his earnings. After leaving school he joined a car repair shop in Tokyo, and a few years later he had set up his own shop with one assistant. Before long he had built this up into an extremely profitable business employing 50 people. After the Second World War, with petrol in short supply, Honda recognized a need for cheap personal transport and began fitting small war-surplus engines, designed for generators and radios, to bicycles. In 1949 he produced his first motorbike, which he called the *Dream* because of his dream for speed, and from those beginnings Honda went on to become the world's biggest motorbike manufacturer.

It wasn't until 1962 that Honda produced their first four-wheeled vehicle, and in 1967 the company produced a micro car that took the Japanese market by storm. Soichiro Honda was particularly worried about pollution, and he personally joined a team working on the compound vortex controlled combustion engine, or CVCC, an acronym and an engine which were both used in the Honda Civic. His mechanical skills, hard work, insight, and the business acumen of his right-hand man, Takeo Fujisawa, made Honda what it is today and helped Japan to become the world's second-largest car manufacturing nation.

Also this year...

The Humber Bridge opens, the longest single span suspension bridge in the world

The French TGV, or high speed train, goes into service, travelling the distance from Paris to Lyons in half of the old journey time

16 people die as the Penlee lifeboat struggles heroically to save passengers from a wrecked coaster

The APT, or tilting train, is tested on Britain's railways

Former world motorbike champion Mike Hailwood dies in a car crash

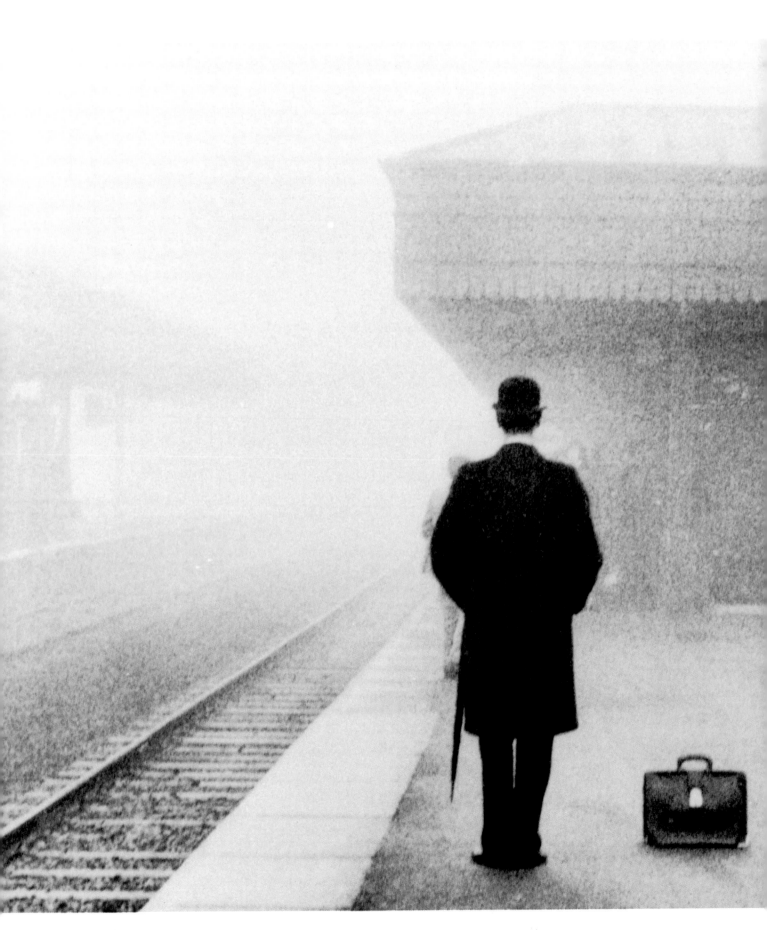

The spirit of adventure

Looking like the model for a Magritte painting, this anonymous commuter waits at an anonymous station in the fog for his train. To commute actually means to exchange, usually in the sense of exchanging one form of obligation for another, and in 19th-century America it came to mean travelling regularly by public transport to and from work – the commutation, or exchange, was the payment in advance for the journeys. The first commuters in Britain to be so called travelled on the Liverpool & Manchester Railway, where 'commutation' tickets were sold in 1842, but the term did not become common until 1960, by which time the word commuter had been generalized to mean anyone who travelled regularly between home and work, even if it was by car.

In its original sense, the only true commuters are season-ticket holders; these were first offered on the railways in 1835, before the term commutation came into use, and the idea was probably borrowed from steamboat services on the River Thames. Various terms were used for season tickets, including 'free' tickets and 'composition' tickets; some railways even offered special rates to outlying areas to encourage house-building in the suburbs. Season tickets did not become popular until 1917, when all fares other than season-tickets were increased, and it wasn't until 1917 that railway bye-laws required season tickets to be shown on demand; it is thought that before that time there were so few season-ticket holders that they would be known by sight at their local stations. Originally, season tickets were individually produced, engraved on ivory or metal medallions; later ones were folding passes, covered in leather or linen and usually stamped in gold, but after they became truly popular they were simply printed on card, although much larger than ordinary tickets.

The arrival of the railways in cities allowed the suburbs to flourish, with people now able to travel easily to work, but for the railways the advent of commuters was a mixed blessing: commuter peaks at rush hours made life difficult for railway managers and some of them even talked of 'the suburban incubus'. The railways and suburban growth went hand in hand to create a new phenomenon which many people despise but nonetheless have no choice but to be part of: commuting.

Also this year...

The wreck of the Mary Rose *is raised*

Laker Airways collapses

Townsend Thoresen's European Gateway *car ferry collides with* another ship, killing five people

De Lorean goes into receivership

Princess Grace of Monaco is killed in a car crash

Sir Douglas Bader dies

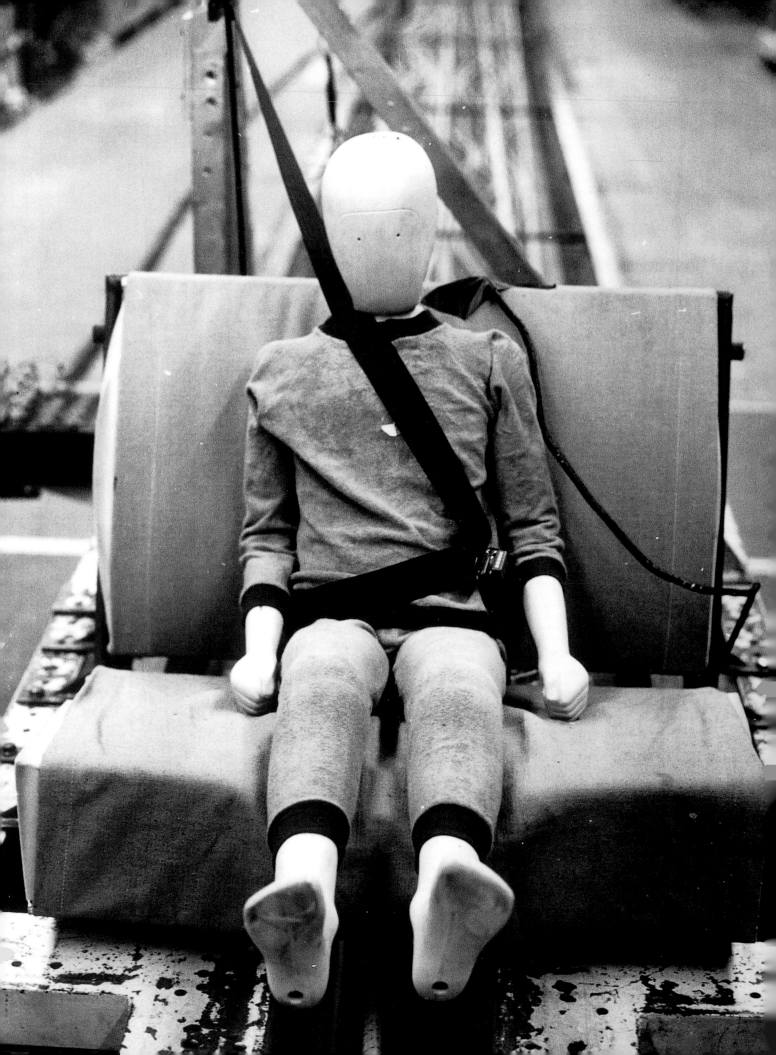

Clunk click every trip

The three-point adjustable safety belt was patented by Volvo engineer Nils Bohlin in 1959 but Volvo did not enforce its rights to the invention, believing that all motorists should have the right to its potentially life-saving benefits. However, many drivers and passengers saw it not as a life-saver but as an inconvenience. Advertising campaigns failed to convince motorists to buckle up and eventually, in 1983, the wearing of seat belts in the front seats of cars was made compulsory in Britain.

The first car to have seat belts fitted as standard was the Volvo PV544, since when safety features have been one of Volvo's strongest selling points. Other manufacturers quickly followed Volvo's lead, and seat belts are now seen as being as much a part of a car as the seats themselves, but making the wearing of seat belts compulsory was not without controversy. The AA and RoSPA were strong campaigners in favour but many people felt that it was an infringement of their personal rights to be told what to do in their own car; some even claimed that seat belts made escape from the car difficult in the event of an accident.

Whether children should be made to wear seat belts was even more of an issue. In 1981, when the Transport Bill was being debated in parliament, Britain, Italy and Ireland were the only countries in Europe that allowed children under 12 to travel in the front seat of a car. One clause of the new bill was due to make it illegal for children under 13 to travel in the front seat unless they were wearing a seat belt, but an independent study showed that a child wearing an adult seat belt was in almost as much danger as a child not wearing one at all. One of the major problems was that the belt passed across the neck instead of the shoulder, as demonstrated in this photograph, causing 'submarining' and severe neck injuries. The law as it was passed required that the driver and passenger must wear seat belts in the front of the car, with certain exemptions; this was amended in 1989 to make it compulsory for children to wear seat belts in the rear seats, and again in 1991 for adults in rear seats.

Also this year...

Wheel clamps are introduced in Britain

Sally Ride becomes America's first woman in space, aboard the Challenger *space shuttle*

People Express becomes the first 'no frills' airline since the collapse of Freddie Laker's Skytrain, offering Gatwick to New York for less than a first-class return from London to Edinburgh

The Thames Flood Barrier is used for the first time

Robert Noble sets a new land speed record of 633mph in his jet-powered car Thrust 2

London tube driver Christopher Hughes wins Mastermind

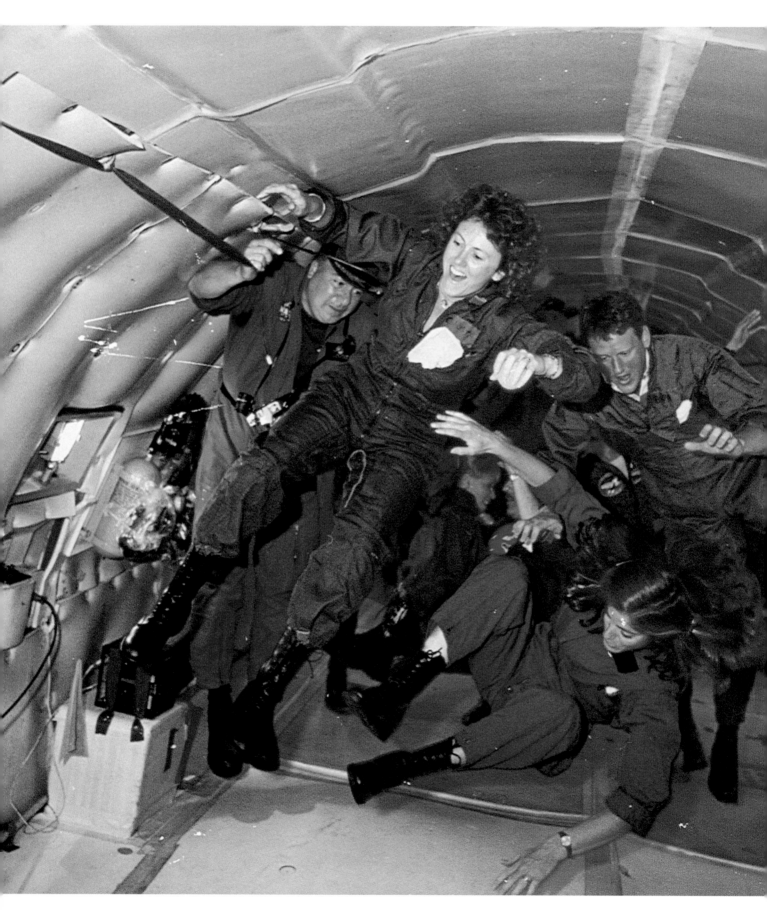

The Vomit Comet

The fastest steel rollercoaster in the world is the Fujiyama in Japan, which reaches 86mph through swoops, bends, loops and corkscrews. Others plunge through drops of over 200 feet, sometimes into natural ravines, but none of them come close to NASAs KC-135 training flights, during which a plane repeatedly climbs to a height of over six miles and then makes a parabolic dive towards earth, putting its occupants into a state of weightlessness for up to half a minute at a time. Engineers, scientists and trainee astronauts experience 20–30 seconds of weightlessness for each parabola, which provides an effective and relatively cheap means of training personnel and testing equipment and experiments before they go into space.

The weightlessness that astronauts experience in space is not really zero gravity – technically, it is free-fall. When a spacecraft orbits the earth it is actually falling endlessly in a circle (or ellipse) that is a delicate balance between the craft's forward motion and the planet's gravitational pull. Because everything is falling together nothing has any weight, although this is only strictly true of objects at the exact centre of the spacecraft's mass: anything off-centre will fall in a slightly different orbit, appearing to drift within the craft as a result of what NASA scientists call micro-gravity.

Free-fall can be experienced on earth by jumping off a high enough cliff or building, the problem being the sudden stop at the bottom. But NASA found a way of replicating free-fall using the KC-135, a military tanker plane based on the Boeing 707. The plane flies on a carefully designed parabolic trajectory, climbing sharply to about 40,000 feet and then throttling back and 'nosing over', letting the plane dive and giving its occupants the experience of free-fall, as seen here. During this time experiments are conducted and astronauts taught to manoeuvre; then, as the plane starts to climb again, everyone is dumped unceremoniously back on the floor. This climb-and-dive is repeated up to forty times on each flight, giving a total of about thirteen minutes of micro-gravity time. Many NASA staff find the experience as exhilarating as a rollercoaster ride but enough of them are so sick that the plane has been dubbed the Vomit Comet.

Also this year...

Donald Campbell's daughter, Gina, breaks the women's world water speed record

The first untethered space walk takes place from the US shuttle

Challenger

The first Virgin Atlantic flight to New York leaves Gatwick Airport; a one-way ticket costs £99

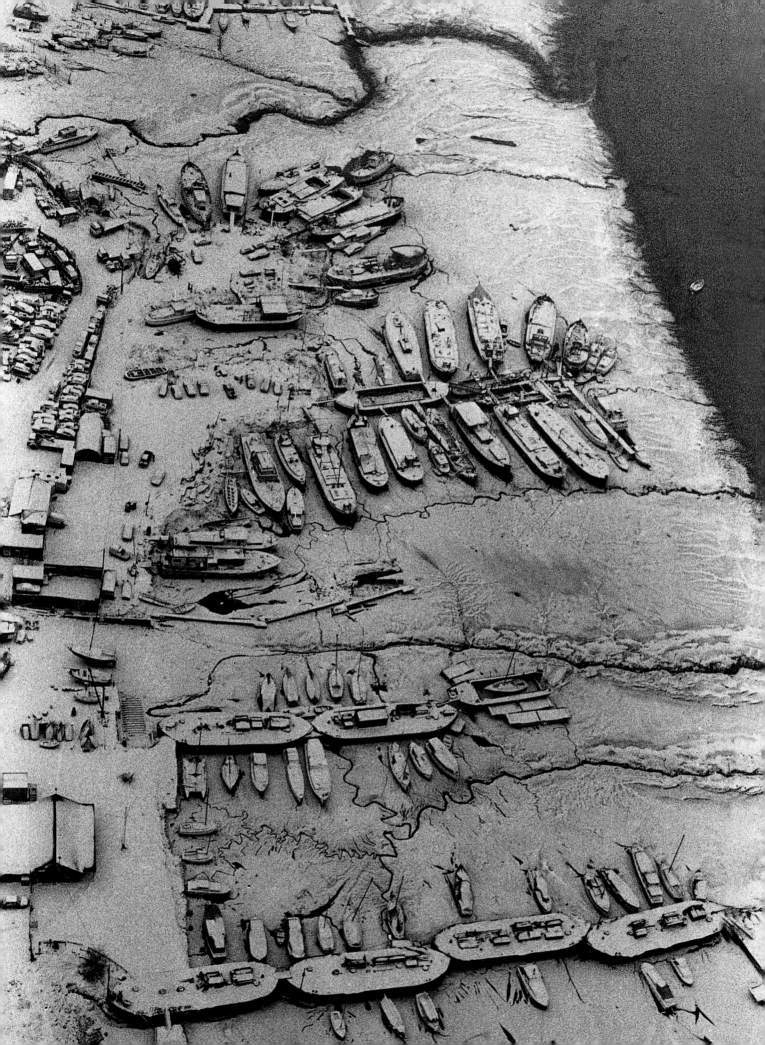

In the bleak midwinter

Rochester harbour lies under a blanket of snow during the winter of 1985. The harbour seems fossilized, or as if white ash has drifted down from a latter-day Vesuvius. The arctic weather left even the beach at Nice, in the south of France, white-over, with the palm trees along the promenade dusted with snow.

The town of Rochester has been an important destination for travellers since the Middle Ages, when Rochester Cathedral became a place of pilgrimage to rival Canterbury. The town was also the starting point for pilgrimages abroad; Rochester's saint is St William of Perth, a Scottish baker who was murdered outside the town after he had spent the night there at the start of a pilgrimage to the Holy Land. Another traveller to have departed from Rochester is James II, who spent his last night in England there before fleeing the country after William of Orange had landed at Brixham and marched on London. The King stayed at what has since become known as Abdication House, whose owner's crest was the head of a black horse; ironically the building is now the local branch of Lloyd's Bank under a more modern sign of the black horse. The symbol of the black horse also adorns Rochester bridge on the old London to Dover road; when the bridge was built it was the sole Medway crossing between the south coast and London, and was so important that Henry I built Rochester Castle to defend it.

Charles Dickens had a strong association with Rochester and the town is mentioned in his books more frequently than any other place apart from London. In *Great Expectations*, the convict Abel Magwitch had been incarcerated in one of the prison ships which were moored on the Medway close to Rochester; these 'hulks' as they were known, were used as depots for convicts awaiting involuntary foreign travel – transportation to Australia.

Also this year...

Sir Clive Sinclair launches the C5 and predicts that by the end of the century 'the petrol engine will be seen as a thing of the past'; by October, his company has called in the receivers

The wreck of the Titanic *is located*

Three air crashes in a month kill 711, including 55 people on a holiday flight which aborted its take-off at Manchester Airport; 80 passengers managed to slide down chutes to safety

13 people are killed in Britain's worst motorway accident when a coach bursts into flames in a crash on the M6

P&O sells its cross-channel car ferry fleet to European Ferries (Townsend Thoresen)

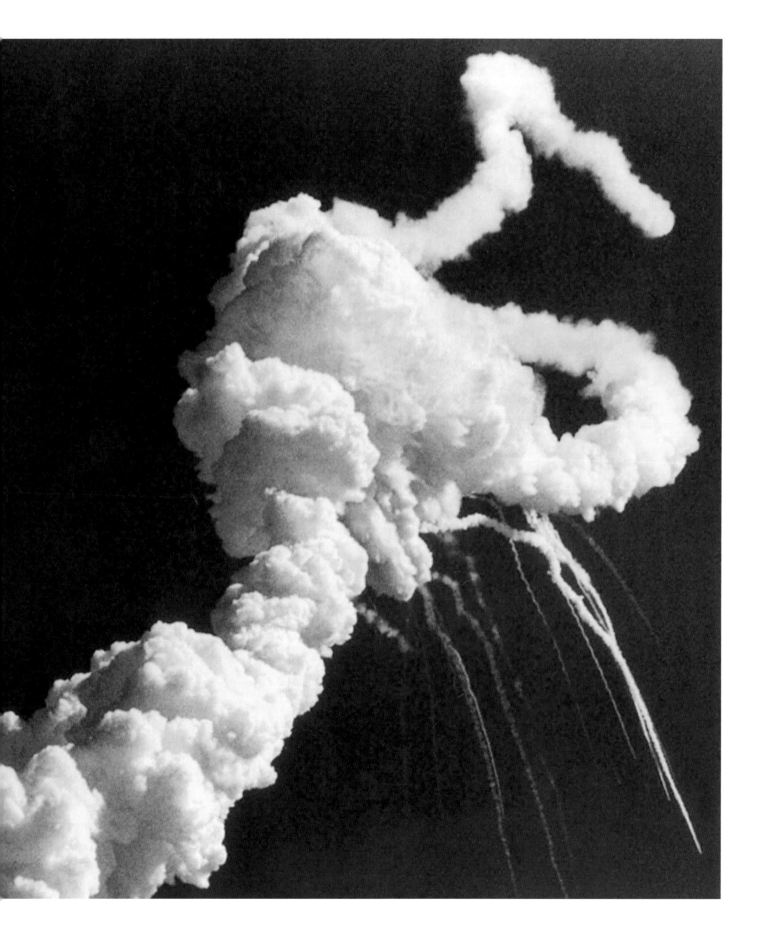

Fire in the sky

Christa McAuliffe was a schoolteacher who had been selected as the first person to fly in NASA's 'citizen in space' programme. Her husband and children watched with the rest of the world in horror and disbelief as the *Challenger* space shuttle exploded at 2,000mph, just 72 seconds after lift-off. She and six other crew members were the first American fatalities in space, although three astronauts died on the ground in a launch-pad fire in 1967.

The launch of the first space shuttle in April 1981 heralded a new dimension in space travel, being a re-usable vehicle whose payload and manoeuvrability made new tasks possible – such as repairing satellites in orbit at speeds of 17,600mph. The shuttle is shaped like an aeroplane but is essentially a manoeuvrable rocket with two huge solid-fuel boosters for lift-off which are jettisoned along with the large fuel tank after the shuttle is in the air. Its own engines take it into space and once it re-enters the atmosphere the stubby wings come into play and the shuttle lands as a glider at speeds of over 200mph.

By 1986 shuttle flights were fairly routine but on 28 January something went horrifically wrong. Just over a minute into the flight, at a height of 10 miles, the shuttle was enveloped in a fireball as thousands of tons of liquid oxygen and hydrogen fuel exploded. Photographs taken by chaser planes revealed a small flame on one of the booster rockets shortly after lift-off, which spread just before the explosion; strangely, the crew reported nothing unusual. NASA later revealed that the booster rockets had no sensors to warn of trouble.

Further shuttle missions were cancelled while investigations took place. A report later pinpointed the cause of the disaster as a faulty seal on one of the booster-rockets, which should have allowed hot gases to escape. The report blamed both the manufacturers of the booster-rocket and NASA, who it said should have changed the seal design after previous warnings of the hazard.

In a moving tribute from the nation which had once been America's bitter enemy in the space race, the USSR named seven asteroids after the crew members of the *Challenger*.

Also this year...

Mrs Thatcher and President Mitterand sign a treaty to build a Channel Tunnel

Four people are sucked to their deaths out of a TWA plane which managed to land after a bomb went off in the hold

Divers report that a split seam, not a hole, caused the Titanic *to sink*

Unleaded petrol goes on sale in Britain

Richard Branson crosses the Atlantic in record time in the Virgin Atlantic Challenger II

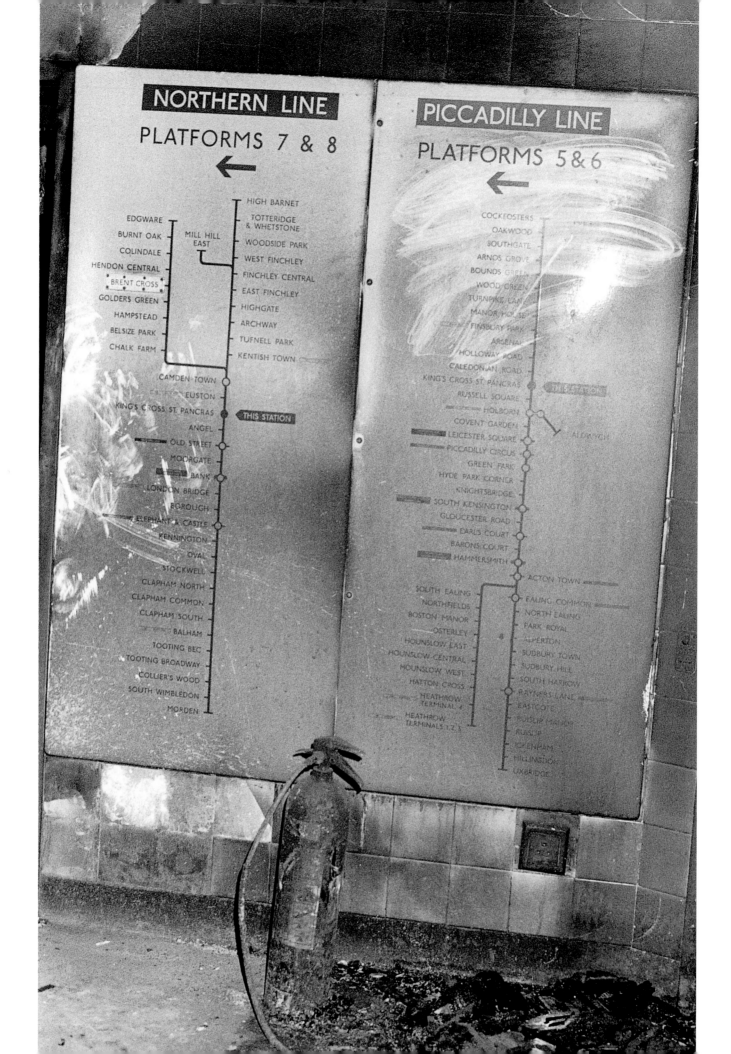

Underground ash

A soot-covered fire extinguisher is left abandoned next to a pile of ash; it would have been pitifully ineffectual against the flash fire which engulfed King's Cross underground station on 18 November, killing 31 people. The only positive thing to come out of this terrible incident was the immediate adoption of stringent new policies for dealing with fires: better escape routes, the prohibition of smoking anywhere on the underground, and automatic alarms and extinguishing systems in plant rooms and under escalators.

On the night of Wednesday 18 November, Euston Road was packed with ambulances, fire engines and police cars as the emergency services fought to deal with the result of the blaze. Only later did it become clear what had happened – a fire had started on a wooden escalator and caused a 'flashover', filling the ticket hall with searing heat and thick smoke. The escalators carried on moving, taking passengers towards the heart of the blaze, and death. Meanwhile on the platforms below, trains continued to disembark passengers onto the smoke-filled platforms. One doctor at University College Hospital said, 'I think the fact that we only have seven patients is a reflection of the severity of the accident. So few survived to reach hospital.'

A public inquiry into the disaster subsequently discovered that there had been 182 fires on escalators between 1983 and 1987, usually caused by dropped matches or lighted cigarettes igniting years of accumulated grease. Previously these fires had died down when the grease had burned itself out without actually setting the escalators alight but a disaster was waiting to happen, and on 18 November it did. At the time, London Regional Transport strongly denied that its recently privatized cleaning methods were inadequate and had allowed fluff to build up under the escalators, where it then became soaked in machine oil. But the inquiry did find many failings: staff had been taking extended meal breaks when they should have been on duty, often leaving platforms unattended; LRT had been slow to modernize outdated equipment including wooden escalators, and staff had not even used the sprinkler system and other firefighting equipment which could have prevented the flashover.

Also this year...

Matthias Rust lands a plane in Red Square

The flotation of British Airways begins; in July BA announces that it is buying British Caledonian for £237 million

Four people die when a train falls off a bridge swept away by a swollen Welsh river

Over 200 people die in the Herald of Free Enterprise *Zeebrugge ferry disaster*

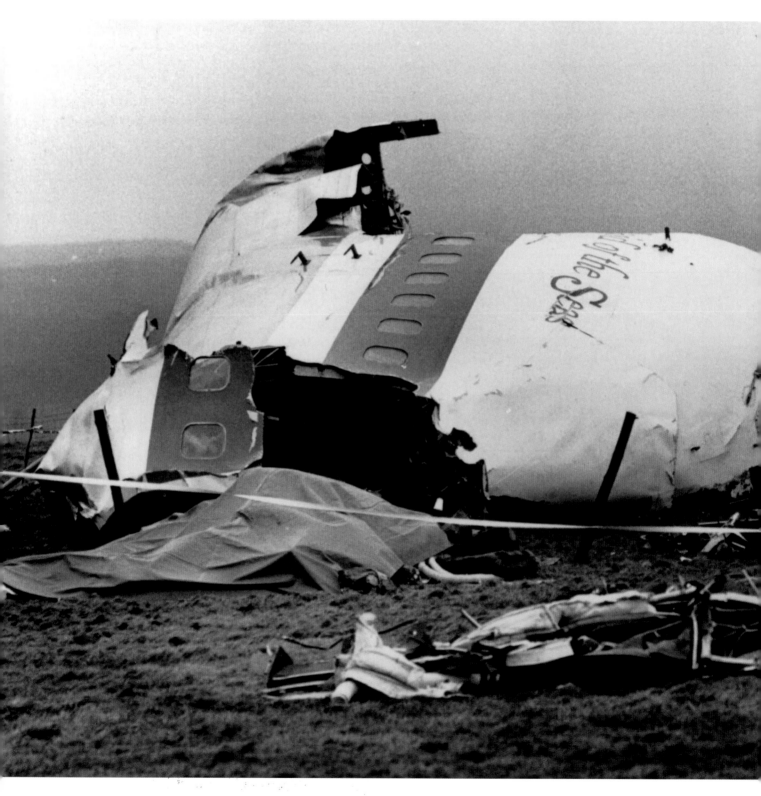

Maid of the Seas

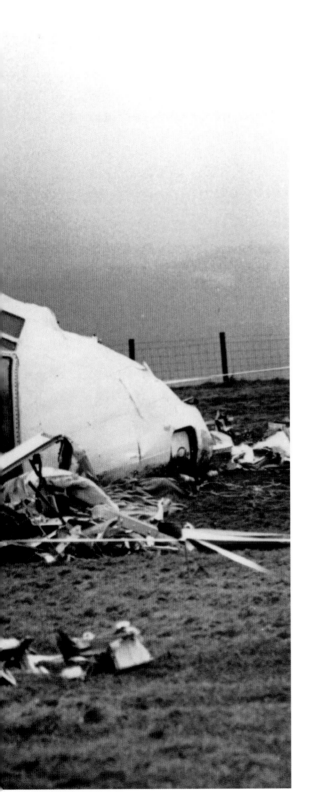

On 22 December this PanAm jumbo jet was en route to New York with 259 people on board, mostly Americans flying home for Christmas. The plane had been in the air for nearly an hour when it simply disappeared from air traffic control radar screens; it broke up so quickly that the crew was unable to send any distress message, and the explosion was so severe that the wreckage was spread over large areas of the Scottish countryside. Burning wreckage also fell on the small town of Lockerbie, destroying several houses and killing a further 11 people on the ground. The nose section of the plane, seen in this photograph, was found three miles away from the town with the crew dead inside.

PanAm Flight 103 had started in Frankfurt and then stopped at Heathrow; at 6.25p.m., 25 minutes late, it took off from Heathrow for New York. It had already reached its cruising height of 31,000 feet and was crossing the Scottish border towards the North Atlantic when a bomb exploded at 7.19p.m., blowing the aircraft out of the sky. It is assumed that the bomb was timed to explode when the plane was over the sea but the late departure meant that it was flying over a populated area. Shortly after the explosion a fireball fell from the sky over Lockerbie; one eyewitness said that 'the whole sky lit up and it was virtually raining fire'. One wing of the plane gouged a deep crater out of Sherwood Crescent, destroying several houses and blocking the A74 with rubble. A resident of the crescent said, 'I just heard this thin screaming sound. The ground shook. It was like an earthquake.'

The emergency services were joined by teams from the armed forces as RAF helicopters flew medical teams to Lockerbie and the army joined police in the hunt for wreckage, bodies, and clues to the cause of the disaster. It was quickly established that a terrorist bomb had been the source of the explosion, but bringing the perpetrators to justice was not so simple; 12 years later the prime suspects have only just been brought to trial after political wrangling over extradition and whether or not a fair trial would be possible.

Also this year...

An explosion on the Piper Alpha oil rig claims 167 lives

USS Vincennes shoots down an Iranian civilian airliner

35 die and 113 are injured in the Clapham rail disaster

A report by Which? magazine says that it takes only seconds for a thief to break into the average car

The Home Office announces the phasing out of the traditional blue passport in favour of the burgundy EC passport

The Central Transport Consultative Committee accuses British Rail of poor services, over-priced fares and overcrowding

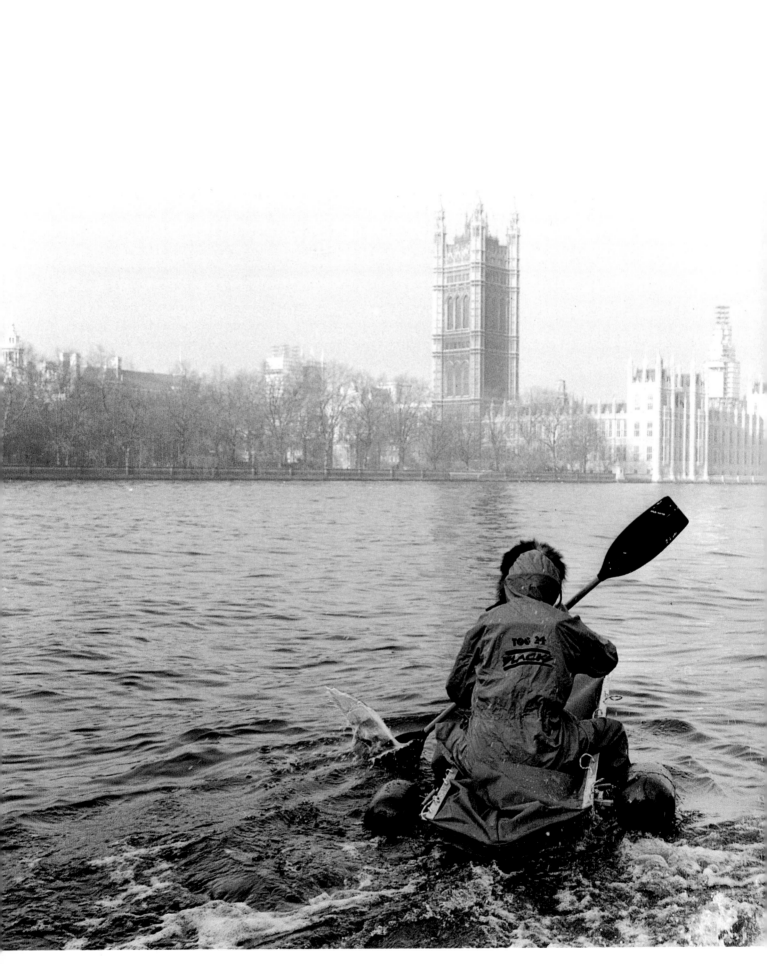

Living dangerously

Explorer Sir Ranulph Twisleton-Wykeham Fiennes test paddles a floating sledge in the relatively safe surroundings of the Thames opposite the Houses of Parliament. Sir Ranulph was born in 1945 in Windsor and educated at Eton before joining the army, in which he served with the Royal Scots Greys and the SAS. He also fought with the Sultan of Oman's armed forces.

Between 1969, when he was just 24, and 1986, he was the leader of six major expeditions which included a hovercraft journey up the White Nile, parachuting onto the Jostedal glacier in Norway, travelling 4,000 miles up rivers in northern Canada and Alaska, and heading towards the North Pole over land. He has also made several unsuccessful attempts to reach the North Pole unsupported and in 1993 he made the first ever unsupported crossing of Antarctica on foot, a 1,350-mile journey which he and his partner, Dr Michael Stroud, completed in 88 days, dragging sledges of supplies behind them. Sir Ranulph's autobiography, not surprisingly, is called *Living Dangerously*.

Sir Ranulph Fiennes also organized the Transglobe Expedition, which from 1979–82 traced the Greenwich Meridian around the entire globe, crossing both the North and South Poles in the process. The importance of the Greenwich meridian in the measurement of time became the focus of much attention at the turn of the millennium, but it is also vitally important for navigators in establishing their position. Longitude sounds like a tool used by mariners in the days of sail, but even with the modern advantages of Global Positioning Satellites, a position can only be described by its co-ordinates. Unlike lines of latitude, which have a fixed starting point at the equator, the measurement of longitude is totally arbitrary. Most nations calculated longitude based on a prime meridian which ran through their own country, such as the Paris meridian or the Amsterdam meridian. It was only in the last decade of the 19th century that it was decided by international agreement to use the Greenwich meridian as the prime meridian, or $0°$ longitude.

Also this year…

51 die in the Thames when the pleasure cruiser Marchioness *crashes with the* Bowbelle

Exxon Valdes *runs aground in the Gulf of Alaska, spilling 32,000 tonnes of oil*

The American Stealth bomber makes its first flight

Guardian Angels begin to patrol the London underground

A Boeing 737 crashes into a motorway embankment near Kegworth, killing over 40 people. The plane was less than a mile from the runway

For the second year running, British holiday flights are disrupted by foreign air traffic control strikes

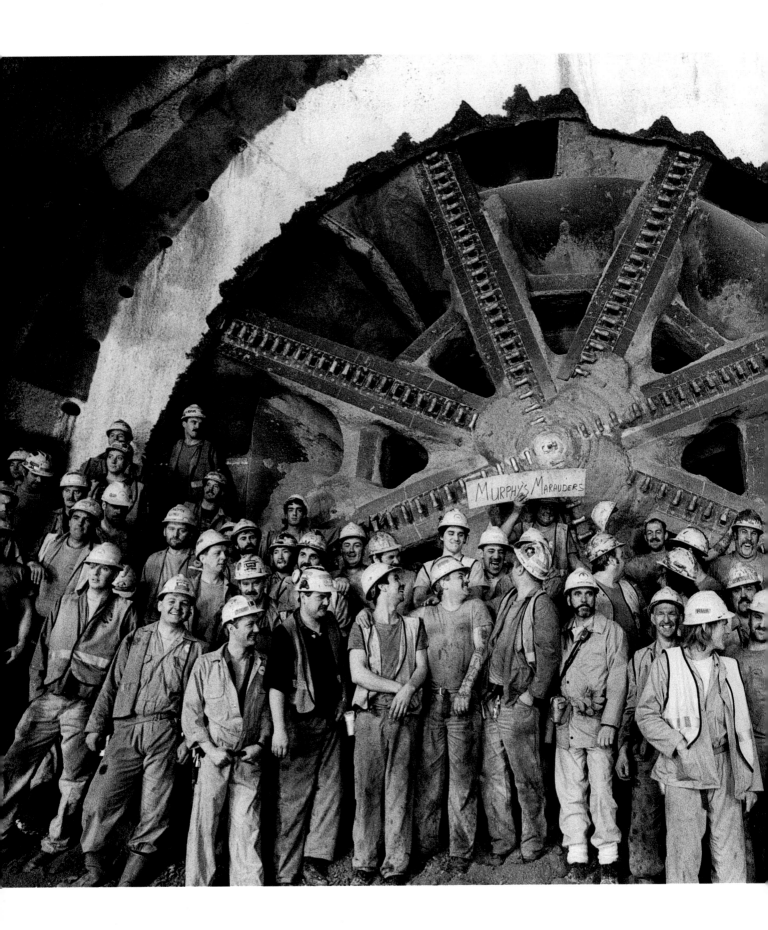

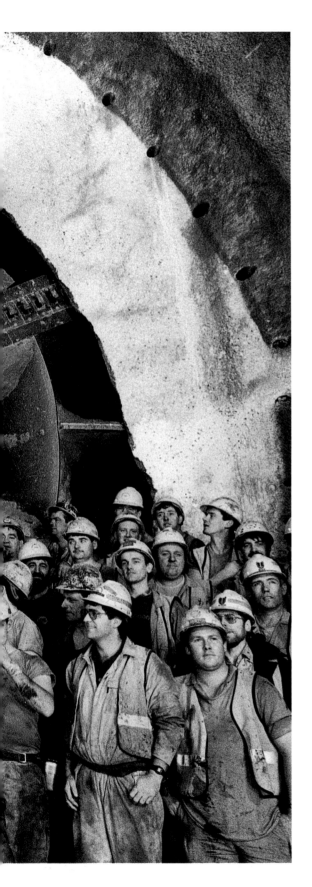

Murphy's Marauders

Just a few weeks before British and French Channel Tunnel workers met in the marine service tunnel, Murphy's Marauders completed their tunnel from Shakespeare Cliff in Dover to the Folkestone terminal a month ahead of schedule. The enormous tunnel-boring machine, or TBM – effectively a giant drill – took just over a year to tunnel 5 miles; a rate of 525 feet a week.

The completion of the Channel Tunnel saw the realization of a project first envisioned nearly two hundred years earlier. The first detailed proposals came after the 1802 Treaty of Amiens, a brief and uneasy peace in the war between Britain and France. The plans were for two tunnels which would meet on an artificial island mid-Channel, with stabling facilities for the horses drawing the coaches. It was never built, partly because war broke out again within a year and Napoleon began planning an invasion of England. The arrival of the railways made the idea more realistic and two railway companies actually began digging tunnels but both schemes were abandoned in 1883. The idea was then approved and abandoned several times in parliament until, in 1986, Prime Minister Margaret Thatcher and President Mitterand signed the Treaty of Canterbury and at last the project was under way.

Work began in 1987 and the breakthrough of the marine service tunnel came in December 1990, joining Britain and France for the first time. The Channel Tunnel is in fact three tunnels: two parallel rail tunnels with a smaller service tunnel between them which provides a continuous safe haven if passengers have to be evacuated from a train. The tunnel was officially opened in May 1994. Passenger trains regularly travel between London and Paris, while road vehicles can drive onto 'Le Shuttle' at Folkestone, which has a locomotive at each end so that it can be reversed out of the tunnel if necessary.

Also this year...

General Motors reveals the battery-powered Impact, which can travel 120 miles at 55mph before recharging

A French TGV (high speed train) reaches a record 320mph

A British Airways captain is sucked half way out of his cockpit when the windscreen blows out at 23,000 feet; a steward holds him in by the legs for 18 minutes before an emergency

landing can be made. The Captain suffers frostbite and broken bones

Two rail crashes in a week lead to calls for a national safety inquiry

A Conservative minister behind an official campaign against drinking at work resigns after being arrested for drink-driving

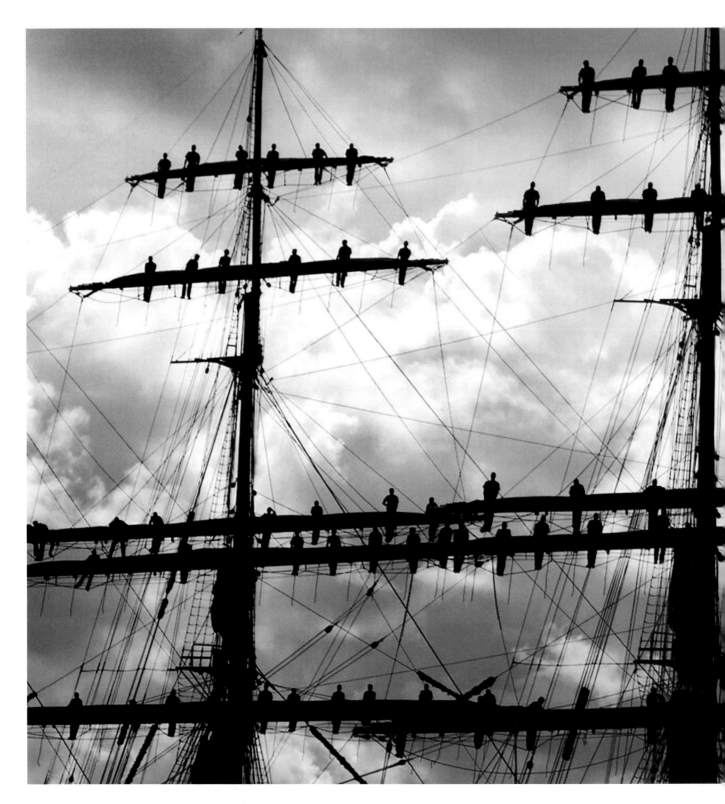

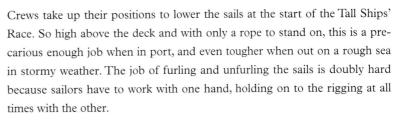
One hand for the ship, one for yourself

Crews take up their positions to lower the sails at the start of the Tall Ships' Race. So high above the deck and with only a rope to stand on, this is a precarious enough job when in port, and even tougher when out on a rough sea in stormy weather. The job of furling and unfurling the sails is doubly hard because sailors have to work with one hand, holding on to the rigging at all times with the other.

The Tall Ships' Races began in 1955 when Bernard Morgan, a London solicitor, decided to organize a race to bring together the last of the great square-rigged sailing ships. The first race took place in 1956, from Torbay to Lisbon, and was such a success that the Sail Training Association was set up in order to put the race on a permanent footing. Initially the intention was to run the race every second year but it proved so popular that today there are at least two races each year. The stated aim of the Tall Ships' Races is 'to enable young people of all nations to race together at sea under sail'; one of the rules of the competition is that at least half of every crew must be below the age of 25. The races bring together crews of all nationalities and backgrounds, and as well as the race itself there is a 'Cruise in Company' when crews mix by changing ships.

The main award at the end of each race series is a silver trophy of the famous clipper *Cutty Sark*, presented by Cutty Sark Whisky as part of Britain's longest-running sports sponsorship. The 1991 Tall Ships' Race comprised a series of races from Milford Haven to Cork and from Cork to Belfast, followed by a Cruise in Company to Aberdeen and a third race from Aberdeen to Delfzijl in northern Holland. The series became known among competitors as the Leek, Shamrock, Thistle and Tulip Races. Seventy-three sailing ships were berthed at Milford Haven before the first race, and 48 took part in the final race to Holland. In all, 101 ships took part in the 1991 series, with well over 2,000 young people from 10 nations taking part in this return to the romantic, if tough, days of travelling under sail.

Also this year...

Helen Sharman becomes the first Briton in space, travelling as a guest scientist on the Russian Mir space station

International air services are disrupted by the worsening crisis in the Gulf after a British Airways flight is stranded in Kuwait

In January bad weather causes chaos on the railways, prompting BR's famous comment blaming 'the wrong type of snow'; in November the excuse is 'leaves on the line'

25,000 holidaymakers are stranded abroad when the International Leisure Group collapses; ILG's subsidiaries include Air Europe, Intasun, Global and Club 18-30

Tubeway army

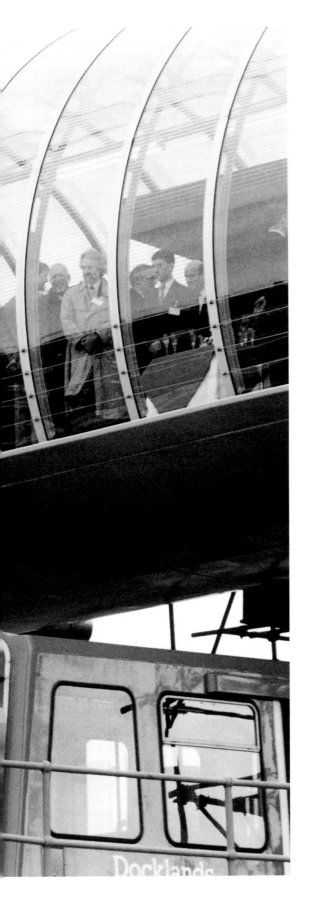

A Docklands Light Railway train passes beneath the £3.5-million Poplar Bridge, opened on 15 October by Inner Cities Minister John Redwood. The DLR was first opened in 1987 as a cheap alternative to building an underground line through the London Docklands, and although there is no official definition of a 'light railway', it is effectively a hybrid of a street tram and a standard railway.

Initially light railways were developed as a means of connecting rural or undeveloped areas at minimum cost. The differences from a fully fledged railway are that the track and engineering are lighter and there are fewer regulations governing signalling, fencing, level crossings, platforms, etc; the trade-offs for this are restrictions on speed and the weight of trains but in most cases, such as the DLR, this does not present a problem. The light railway has only relatively recently made an appearance in Britain, in the guise of the Light Rapid Transit systems which aim to provide fast, frequent services for city commuters, usually with unmanned stations, automatic ticketing and zoned fares. The first example in Britain was the Tyne & Wear Metro, which was opened in stages from 1980 onwards, and was soon followed by the DLR, which took the concept of light railways a step further by having driverless trains controlled by computer. This in turn was followed by the Manchester Metrolink in 1992, which uses a combination of old British Rail track and street tram tracks. The Sheffield Supertram opened in 1994 with about half its route on street tramlines, and other major cities are due to follow suit, including Nottingham, Bristol and Birmingham.

When the DLR first went into operation it proved unreliable and unable to cope with peak demands, but modifications and extensions have taken place so that it has now been built up into a successful network, with various mainline and underground connections. The City terminus at Tower Gateway was not connected to a tube station and it was recognized before services even began that this was going to be a problem, so a one-mile extension to Bank was built, which at the time was described as the most expensive mile of railway in the world.

Also this year...

For the third time, a BA Concorde loses part of its rudder in flight; it is thought that as the problem does not affect Air France Concordes it must be due to the extra heat generated by BA's dark blue paint

An American estate agent pedals a boat across the Atlantic

The QE2 *runs aground off Massachusetts and passengers are evacuated*

Don't be a stick-in-the-mud

A Land-Rover struggles to make it out of a bog during a Raleigh International expedition to Guyana; a winch eventually did the trick. Raleigh International has turned adventure travel for young people into an expeditionary force which provides practical help to communities around the world, conducting research, giving medical aid, and building schools, bridges and health centres. A Raleigh expedition brings together a group of young people, known as venturers, to work on a combination of environmental, community and adventure projects. Since 1984 the organisation has run 170 expeditions to 35 different countries, with over 20,000 venturers from 72 nations.

At the beginning of the century package tours were shifting the emphasis of travel away from the Victorian idea of educative trips abroad and towards the idea of leisure, creating a bubble around the tourists which often isolated them from the reality of the places they were visiting. Raleigh International does the opposite, using travel as a means of education and self-discovery, as well as making sure that its venturers mix with the local people and learn about the lives of those they meet. A week's training teaches the venturers the skills they will need for the expedition, such as navigation, first aid, the use of long-range radio equipment, and how to set up a camp site. Travelling to remote destinations is an adventure in itself, after which the venturers live under canvas for up to ten weeks while they work on their project. This may be anything from building a suspension bridge in Chile, or building nesting areas for giant turtles in Oman, to building medical clinics out of straw bales in Mongolia or carrying out eye testing in Malaysia prior to sight-restoring operations.

The expedition in the photograph was to south Guyana, where the group trekked between villages with two Land-Rovers in support. At each village the venturers took blood samples in order to diagnose and treat malaria, immunized local children against diphtheria, tetanus and polio, and conducted questionnaires with breastfeeding mothers. The information gathered was presented to the Guyanese government as part of an on-going diet and health programme which continued after the expedition had left.

Also this year...

An oil slick near the Shetlands, a result of the wreck of the tanker Braer, *is dispersed by wind and waves*

The crew of the space shuttle Endeavour *successfully repairs the Hubble Space Telescope*

An Antonov cargo plane carries a world-record 133-ton load from Dusseldorf to New Delhi

More than 20,000 Underground passengers are stranded in tunnels during a power failure

Taxi!

The black cab, along with the traditional routemaster bus, has become an internationally recognized symbol of London. The Austin FX4, seen here, has been for hire on the streets of London since 1958, although it is slowly being superseded by the ugly, box-like Metrocab and the more traditional rounded look of the TX1 – if the TX1 remains in service for as long as the FX4, its successor won't be around until 2037. London is unique in having a purpose-designed taxicab, which is why the black cab has become such an evocative icon of the capital; other cities around the world have to make do with production cars with meters attached.

One of the reasons why London's black cabs are so distinctive is that their development has been very strictly controlled by the Public Carriage Office since the Metropolitan Police first drew up a set of regulations in 1906. These included such stipulations as a turning circle of no more than 25 feet diameter, and to this day black cabs can perform a U-turn in less space than almost any other vehicle. Initially more than 45 manufacturers had designs approved but only 12 makes were licensed during the 1920s, and this had dropped to 3 by the 1950s, which explains the unity of design.

Coaches first became available for hire in London during the 17th century and were known as hackney coaches, although they had nothing to do with Hackney; the word comes from the French *hacquenée*, which was a strong horse hired out for journeys. In the 19th century, hackney coaches made way for a new type of carriage which was popular in Paris – the *cabriolet de place*, or cab. Motor cabs came in at about the turn of the century and the word taxi came into use in 1907, when taximeters were attached to cabs to measure the price of a journey in order to avoid arguments about the distance travelled and the amount due. It is a sign of the times that the traditional 'For Hire' sign on black cabs is gradually being replaced by the more internationally understood 'Taxi'.

Also this year...

The Channel Tunnel opens for business; the Queen opens Waterloo International terminal and then travels by train to meet President Mitterand in Calais; they return together on the car shuttle in the Queen's Rolls-Royce

A solar-powered car crosses Australia in 8 days, averaging 30mph

Ayrton Senna is killed in the San Marino Grand Prix

Navigationally challenged

Two hundred and forty-five people were stuck on board the car ferry *Stena Challenger* overnight when she ran aground on a sandbank near Calais. The ship was stranded off Bleriot-Plage, less than a mile from her destination, after developing engine trouble during high winds and heavy seas. Tugs tried unsuccessfully to tow the ferry off the sand bank and at low tide the next morning locals were able to paddle in the sea close to the beached ship. Free food and drink were provided for the stranded passengers and eventually, at the next high tide, the tugs were able to tow the *Stena Challenger* off the sand bank and she completed her journey to Calais.

Britain's first drive-on car ferry was the *Princess Victoria*, which went into service between Stranraer and Larne in 1939. Most cross-channel ferries at the time carried boat trains and it wasn't until 1952 that the first drive-on ferry appeared in the English Channel. This was the *Lord Warden* which operated between Dover and Boulogne, although for its first year in operation cranes were used at Dover to load and unload cars; a year later a linkspan was opened, allowing cars to drive straight on and off the ship. Similar services soon followed and gradually replaced almost all of the boat trains, although the railway companies were kept busy because they operated most of the early car ferries. At the time the government did not allow the railways to own their own ships but many of them simply created associated companies in order to get round the legislation. However, the London Brighton & South Coast Railway went too far in setting up a wholly owned subsidiary, the Brighton & Continental Steam Packet Company, which lasted just two years before being closed down following legal action from its competitors.

In 1967 the British Railways Act allowed the Railways Board to operate car ferries on any routes they chose, and in 1970 British Rail's shipping services were renamed Sealink. By that time they had developed from being a side operation of the railway into a major ferry operation in their own right, handling mainly roll-on roll-off cars and lorries. Sealink was subsequently sold to British Ferries Ltd and then sold again to the Stena Line, which in 1995 was operating the *Stena Challenger* as part of Stena Sealink.

Also this year...

Customs officers in Sweden arrest a woman trying to smuggle 65 baby snakes in her bra

The Aum Shinri Kyo cult murders 11 people and injures 3,796 by releasing deadly sarin gas on the Tokyo underground

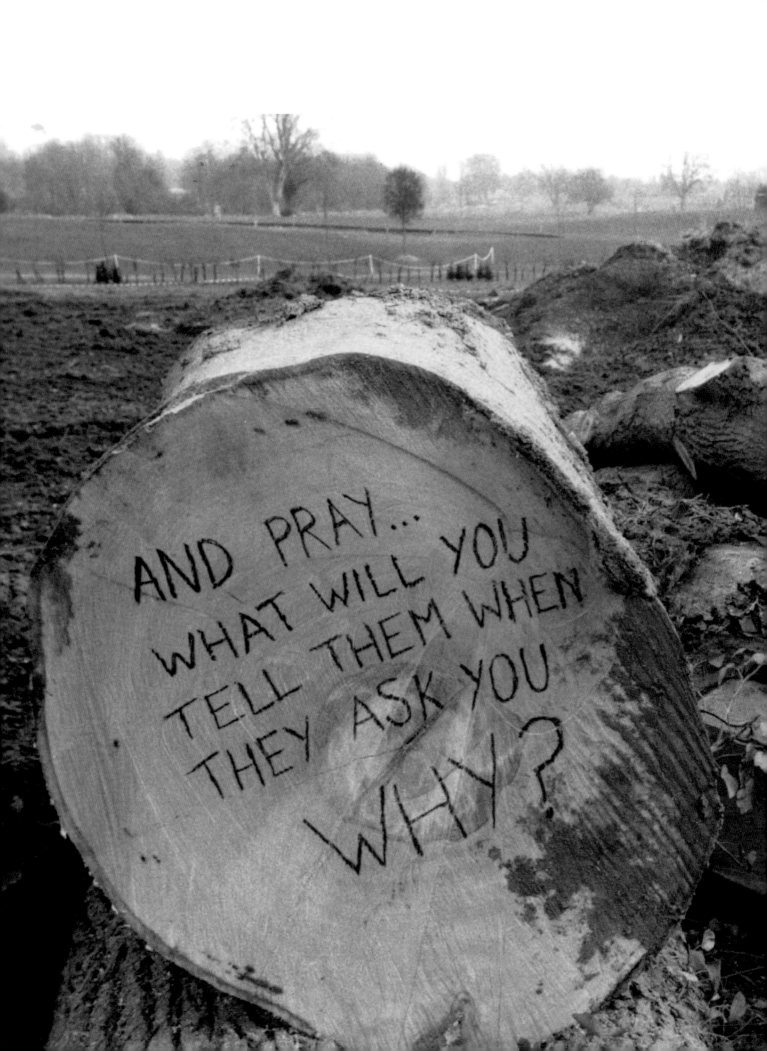

What will you tell them...?

A poignant message about the real cost of building new roads. These trees were once part of Snelsmore Common, home to a rare species of nightjar which may have nested in the branches that once grew from these very tree-trunks. The common is now home to the Newbury bypass. The simple eloquence expressed on the tree trunk asks more questions than it seems at first glance. Part of the question is why destroy a protected Site of Historical Interest, the home of a rare population of birds, the river habitat of an endangered species of snail, and risk pollution damage to a Grade-I listed building? The answer, to build a nine-mile section of road.

And the question was asked again, most famously during the extension of the M11 through east London and at the building of a new runway at Manchester Airport. Protests against industrialization and the development of transport infrastructures are nothing new; James Brindley and George Stephenson were mobbed when they visited towns to survey for canals and railways but, until Newbury in 1996, protests against road development had usually been paper protests from the middle class nimby – Not In My Back Yard, build it somewhere else. At Newbury the message was – not in anyone's backyard, don't build it at all.

Instead of waving placards and giving out leaflets the protestors took direct action, and they called it the Third Battle of Newbury; the first two had been 17th-century Civil War encounters on the battleground which was to be crossed by the road. They set up nine camps along the route of the bypass, and when the bulldozers came they took to the trees and a network of tunnels. A thousand people were arrested over nearly four months as bailiffs tried to clear the site for work on the road to continue. Protestors were now hoping that where the ecological arguments failed, economic ones might prevail; every day that they held up work was costing the developers money. Inevitably, they failed in their efforts and the Newbury bypass opened on 17 November, 1998.

Also this year...

230 people die when TWA flight 800 explodes between New York and Paris

A jumbo jet helps to rescue three fishermen by flying low and directing helicopters to the scene after a stewardess spots smoke

A businessman escapes conviction after successfully arguing in court that police had tampered with evidence by enlarging speed camera photographs

Sir Frank Whittle dies

Candle in the wind

At the beginning of the century the railways played their part in the final journey of a queen who had reigned for longer than any other monarch. Ninety-six years later it was the turn of the car, driven in splendid isolation along what is usually one of Britain's busiest roads, to perform the same honour for a queen who never actually made it to the throne. Tragically it was also a car that killed the woman who, in an instant, was elevated from the People's Princess to the Queen of Hearts.

This road journey was watched more closely by more people than any other since the invention of the car, as the Daimler carrying the coffin of Diana, Princess of Wales, made its way slowly from Westminster Abbey northwards through London towards the M1. Flowers thrown by the crowd formed a crown on the roof of the hearse, bounced from the windscreen or collected above the wipers which flicked occasionally to clear the driver's view. When the cortege reached the M1 it paused to allow attendants to clear the windscreen; a pall-bearer gently laid the pile of flowers by the roadside. Every bridge along the route was lined with mourners as the motorcade made its way up the empty motorway at a steady 45mph, escorted by police outriders.

Meanwhile the royal family, including Diana's two sons, were travelling by rail to the Spencer family home at Althorp. One of the locomotives that pulled the Royal Train was named Prince William. Four black Rolls-Royce Phantoms then conveyed the party to Althorp Park from the tiny station of Long Buckby. After the cortege arrived the flower-decked gates were closed to the world and the burial took place in the privacy of Diana's childhood home. Members of the Princess of Wales's Royal Regiment bore her flag-draped coffin across a simple wooden bridge to an island set in an ornamental lake in the grounds of Althorp Park. After a short service of committal, Diana was laid to rest in the peace and seclusion which she had been unable to find in life.

Also this year...

British air force pilot Andy Green achieves the first supersonic land speed record, averaging 763mph in his jet car Thrust SSC

Richard Branson, Per Lindstrand and Alex Ritchie set out from Morocco in the Virgin Global Challenger *in an unsuccessful attempt at the first non-stop circumnavigation of the world by balloon; two rival attempts are made within a week, both unsuccessful*

Pedal power

Sainsbury's introduces a taste of the Orient to Islington, London, and adds a splash of colour to the streets by providing a modern rickshaw to take customers home with their shopping. For a fee of up to £3.50, the pedicab service was available to customers living within a two-mile radius of the Islington store; each of the three pedicabs in the fleet could carry two passengers with a week's worth of shopping, and the driver would also transport goods for recycling back to the store.

The pedicab is a 'green' solution to the modern problem of pollution but it has its roots in one of the most ancient forms of transport. The rickshaw originated in Japan but is more often associated with India and China. In its earliest form it was a two-wheeled, hooded carriage which was pulled along by a person on foot. Later rickshaws were attached to a bicycle or motorbike, making for a speedier journey, while the pedal-operated pedicab in the photograph has the mechanics of a bicycle built in. The word rickshaw comes from the Japanese *jinrikisha*, which is a very suitable name given that *jin* means man, *riki* means power, and *sha* means carriage.

These modern man-power-carriages are fully equipped with lights, indicators and a hood which protects passengers from the weather, and they have a swivelling chassis which enables them to cross rough ground and to cope with potholes in the road. Pedicabs were being used in Belgium and Germany before 1998 but Sainsbury's were the first to introduce them to Britain, at the suggestion of cyclist and environmentalist Jonathan Edwards, who runs the service.

Also this year...

The Newbury bypass opens after considerable protest

The Royal Yacht Britannia *is decommissioned*

The film Titanic *is released*

John Glenn becomes the oldest man to travel in space

The Jubilee Line extension is delayed by vandalism

A jubilant smile

Prime Minister Tony Blair travels to the Millennium Dome on the newly built Jubilee Line extension. At the Dome he announced the final selection of Millennium Products which were to be featured in the exhibition.

The Jubilee Line had its origins in the Fleet Line, which was authorized in 1969 to run 2½ miles from Charing Cross to Baker Street and to take over the Bakerloo Line's Stanmore service. The name was changed in 1977 by the Greater London Council as a celebration of the Queen's silver jubilee, and the line opened in 1979. A proposed extension through the City along Fleet Street, which was the origin of the original name, was rejected in favour of a route south via Waterloo and then east via Greenwich to Stratford. Work began on the extension in 1993 and it was completed in time for the millennium night celebrations at the Dome in Greenwich.

The £3.2-billion Jubilee Line extension is the largest single addition to the underground in over twenty-five years and was one of the largest construction projects Europe has ever seen. The extension is approximately 10 miles long with 11 stations; three-quarters of the new track is in six deep-level tunnels running from Green Park to just south of Canning Town, from where the line runs above ground to Stratford. Six new stations have been built and the other five are being improved and modernized for the new Jubilee Line connections.

North Greenwich station, which serves the Dome, is the biggest underground station in the world and is capable of handling up to 50,000 passengers an hour. It incorporates park-and-ride facilities for up to 1,000 cars as well as a major bus interchange, and provides two new river crossings for the area, linking it with the rest of Docklands. The station is effectively a large box constructed using 70,000 tons of reinforced steel to create a sealed hull within the saturated ground; the entire box is anchored to the London Clay beneath. From this site two tunnels were dug to create river crossings linking the station with Canning Town and Canary Wharf; these were tunnelled out using two boring machines called Sharon and Tracy.

Also this year...

30 people are killed in the Paddington rail crash

John F. Kennedy Jr, his wife and her sister are killed when the plane he is piloting crashes off Martha's Vineyard; top golfer Payne Stewart is killed when his private plane crashes

Breitling Orbiter 3 becomes the first balloon to circumnavigate the globe, crewed by Bertrand Piccard of Switzerland and Brian Jones of Great Britain

Eileen Collins becomes the first woman to command a space shuttle mission

Je m'appelle Freddie

Freddie the labrador waits to travel back to Britain by ferry after a day trip to Calais. Freddie was one of the first animals to take advantage of a new initiative from the Ministry of Agriculture, Food and Fisheries – the Pets Travel Scheme, or PETS. He is seen here on 28th February, the first day of a pilot scheme which for the first time made it legal to bring pets into Britain from the Continent without quarantine.

For years Britain has protected its rabies-free status by not allowing any animals to enter the country without a six-month quarantine period. Recently there has been increasing pressure to find an alternative to quarantine, which is seen by many as cruel and unnecessary. In September 1998 the government published a report by the Advisory Group on Quarantine (AGQ) called *Quarantine and rabies: a reappraisal*, also known as the Kennedy Report. The AGQ recommended that the old system of quarantine could safely be replaced for certain animals because science has progressed to the point where it is now possible to introduce alternative arrangements which were not possible in the past; these include tagging animals with microchips, vaccination against rabies, and blood testing.

The pilot scheme, which only applies to certain routes into Britain, is being run to test arrangements for the full-scale scheme that is due to come into force in 2001. In order to qualify for the Pets Travel Scheme an animal must first have a microchip inserted beneath its skin, then be vaccinated against rabies and have its blood tested. To travel, the animal will have to remember to take its 'passport' – an official PETS certificate, which can only be issued by government-approved vets, to say that the requirements have been fulfilled.

Also this year...

Ford closes its Dagenham car plant, ending 70 years of car production in the town

Jockeys Frankie Dettori and Ray Cochrane have a narrow escape when the plane flying them from Newmarket racecourse to Goodwood crashes on take-off, killing the pilot

The 1900 1,000-Mile Reliability Trial for cars is re-enacted by the Veteran Car Club

Six British backpackers are killed in a hostel fire in Australia

Don Wales breaks the British land speed record for an electric car with a speed of 128mph; he is the grandson of Malcolm Campbell and the nephew of Donald Campbell

Thousands of flights across Britain are thrown into chaos as an air traffic control computer crashes

Index

Bibliography and Picture credits

BIBLIOGRAPHY

Barker, Theo & Gerhold, Dorian. *The Rise and Rise of Road Transport 1700–1990*. Cambridge: CUP, 1993

Brown, Mike. *A Child's War*. Stroud: Sutton Publishing Ltd, 2000

Cannon, John (ed). *The Oxford Companion to British History*. Oxford: OUP, 1997

Chant, Christopher & Taylor, Michael J.H. *The World's Greatest Aircraft*. Broxbourne: Regency House Publishing Ltd, 1999

Harris, Melvyn. *ITN Book of Firsts*. London: Michael O'Mara Books Ltd, 1994

Hillman, David & Gibbs, David. *Century Makers*. London: Weidenfeld & Nicolson, 1998

Horton, Chris. *Encyclopedia of the Car*. Rochester: Grange Books, 1998

Hutchings, David F. *QE2 – A Ship for all Seasons*. Blandford Forum: Waterfront Publications, 1988

Kent, Peter (ed). *The Oxford Companion to Ships and the Sea*. London: Paladin, 1979

Laban, Brian. *The Mini. Forty Years of Fun*. London: HarperCollins*Illustrated*, 1999

Mercer, Derrik (Ed-in-Chief). *Chronicle of the 20th Century*. London: Longman, 1987, 1988, 1989, 1990, 1991, 1992

Ramsden, John. *The Age of Balfour and Baldwin*. London: Longman, 1978

Simmons, Jack & Biddle, Gordon. *The Oxford Companion to British Railway History*. Oxford: OUP, 1997

Clew, Jeff. *Veteran Motorcycles*

Kaye, David. *Old Buses*

Lane, Andrew. *Motoring Costume*

Morris, Llyn E. *The Country Garage*

Pearson, Lynn F. *Lighthouses*

Pressnell, John. *Touring Caravans*

Shire Albums. Aylesbury, Shire Publications

Whitehead, Trevor. *Fire Engines*